Art and Experience in Classical Greece

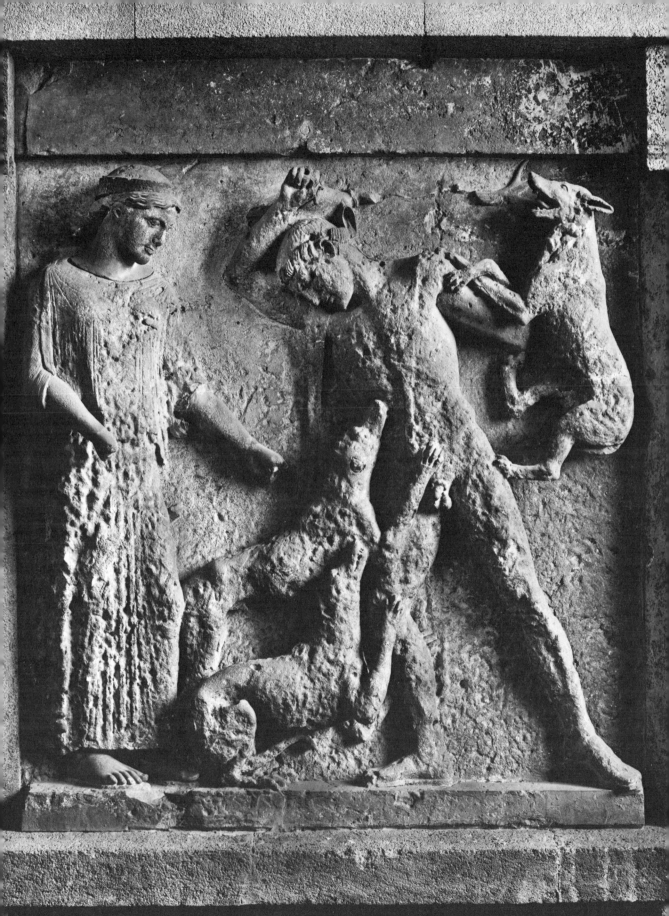

Art and Experience in Classical Greece

J. J. POLLITT

CAMBRIDGE
UNIVERSITY PRESS

PUBLISHED BY THE PRESS SYNDICATE OF THE UNIVERSITY OF CAMBRIDGE
The Pitt Building, Trumpington Street, Cambridge CB2 1RP, United Kingdom

CAMBRIDGE UNIVERSITY PRESS
The Edinburgh Building, Cambridge CB2 2RU, United Kingdom
40 West 20th Street, New York, NY 10011-4211, USA
10 Stamford Road, Oakleigh, Melbourne 3166, Australia

First published 1972
Reprinted 1973, 1974, 1975, 1976, 1978, 1979 (twice), 1980, 1981, 1982, 1983,
1984 (twice), 1985 (twice), 1986, 1987, 1988, 1989 (twice), 1992, 1993, 1994,
1995, 1996 (twice), 1997, 1999 (with new Preface and additional suggestions
for further reading, and supplementary references to the footnotes)

Printed in the United States of America

Typeset in Plantin

Library of Congress Catalog Card Number: 74-160094

ISBN 0-521-09662-6 paperback

Contents

FRONTISPIECE: *Death of Actaeon: Selinus, metope from Temple E*

List of Illustrations *page* vii

Preface xiii

Preface to the *1999 impression* xv

PROLOGUE: *On the meaning of 'classical'* 1

1 ANTECEDENTS AND FIRST PRINCIPLES 3
Order and chaos 3
Greeks and Persians 9

2 CONSCIOUSNESS AND CONSCIENCE 15
(The Early Classical period, c. 480–450 B.C.)
The new range of expression 15
Confidence and doubt 22
Art and drama 27
The new severity 36
Ethos and pathos 43
Movement and pictorial space 54
Archaism and mannerism 60

3 THE WORLD UNDER CONTROL 64
(The Classical moment, c. 450–430 B.C.)
Periclean Athens 64
Man and the measure of all things 68
The Parthenon 71
The Parthenon and the classic moment 95
The Pheidian style and spirit 97
Polykleitos: new versions of old formulae 105

4 THE WORLD BEYOND CONTROL 111
(The later fifth century, c. 430–400 B.C.)
The resurgence of the irrational 111
Refuge in gesture 115
Ancient cults in new shrines 125
Outside Athens 134

5 THE WORLD OF THE INDIVIDUAL 136
(The fourth century and its Hellenistic legacy, c. 400–323 B.C.)
Personal experience and the *polis* 137
The exploration of personal experience: human emotion 143
The exploration of personal experience: sensuousness and sense
 perception 157
The exploration of personal experience: religious emotion 164
Idealism and abstraction 170
Lysippos: an end and a beginning 174

EPILOGUE 195

Supplementary references for illustrations 197

Supplementary suggestions for further reading 199

Additional suggestions for further reading (1999) 202

Supplementary references to the footnotes 204

Index 206

Illustrations

1 Bronze horse. Geometric style. Berlin, Staatliche Museen Preussischer Kulturbesitz. (Museum photograph) *page* 7

2 Kleobis and Biton. Delphi, Archaeological Museum. (Photograph: N. Stournaras, Athens) 8

3 Strangford Apollo. London, British Museum. (Photograph: Courtesy of the Trustees of the British Museum) 16

4 Kritios Boy. Athens, Acropolis Museum. (Photograph: Deutsches Archäologisches Institut, Athens) 17

5 Aegina, Temple of Aphaia. Sketch restorations of the west and east pediments. (After Furtwängler, *Aegina*, pls. 104, 105) 18

6 Aegina, Temple of Aphaia, west pediment, fallen warrior. Munich, Glyptothek. (Photograph: Staatliche Antikensammlung und Glyptothek, Munich) 19

7 Aegina, Temple of Aphaia, east pediment, fallen warrior. Munich, Glyptothek. (Photograph: Staatliche Antikensammlung und Glyptothek, Munich) 20

8 *Hydria* by the Berlin Painter. New York, Metropolitan Museum of Art, Rogers Fund, 1910. (Museum photograph) 21

9 *Kylix* by the Penthesileia Painter. Munich, Antikensammlung. (Photograph: Hirmer Fotoarchiv München) 23

10 Olympia, Temple of Zeus, sketch restorations of the east and west pediments. 28

11 Olympia, Temple of Zeus, east pediment, central group. Olympia, Archaeological Museum. (Photograph: N. Stournaras, Athens) 28

12 Olympia. Temple of Zeus, east pediment, 'Old Seer'. Olympia, Archaeological Museum. (Photograph: N. Stournaras, Athens) 29

13 Olympia, Temple of Zeus, east pediment, 'Kladeos'. Olympia, Archaeological Museum. (Photograph: Deutsches Archäologisches Institut, Athens) 29

14 Olympia, Temple of Zeus, west pediment, Lapith and Centaur. Olympia, Archaeological Museum. (Photograph: N. Stournaras, Athens) 30

15 Aegina, Temple of Aphaia, west pediment, Athena. Munich, Glyptothek. (Photograph: Hirmer Fotoarchiv München) 37

16 'Aspasia' type. From Baiae, now in the National Archaeological Museum, Naples. (Photograph: Deutsches Archäologisches Institut, Rome) 38

17 'Blond Boy'. Athens, Acropolis Museum. (Photograph: Deutsches Archäologisches Institut, Athens) 40

18 Paestum, Temple of Hera II, from the southeast. (Photograph: author) 41

19 *Krater* by the Niobid Painter. Paris, Louvre. (Photograph: Hirmer Fotoarchiv München) 46

20 Charioteer of Delphi. Delphi, Archaeological Museum. (Photograph: D. A. Harissiadis) 47

21 Athena. New York, Metropolitan Museum of Art, Rogers Fund, 1942. (Museum photograph) 49

22 Striding God of Artemiseion. Athens, National Museum. (Photograph: National Museum) 51

23 Olympia, Temple of Zeus, heads of Herakles from the metopes. Olympia, Archaeological Museum. (Photographs: Deutsches Archäologisches Institut, Athens) 52

24 Olympia, Temple of Zeus, head of Athena from the Stymphalian Birds metope. Paris, Louvre. (Photograph: Deutsches Archäologisches Institut, Athens) 53

25 Selinus, metope from Temple E representing the Death of Actaeon. Palermo, National Museum. (Photograph: Anderson, Rome) 55

26 Portrait of Themistokles. Ostia, Museo Ostiense. (Photograph: Gabinetto Fotografico Nazionale, Rome) 57

27 *Diskobolos* of Myron. Rome, Museo Nazionale delle Terme. (Photograph: Deutsches Archäologisches Institut, Rome) 59

28 *Krater* by the Pan Painter. Courtesy, Museum of Fine Arts, Boston, James Fund and special contribution. (Museum photograph) 62

29 Acropolis of Athens as seen from the northwest. Restoration by Gorham P. Stevens. (Courtesy of the Agora Excavations, American School of Classical Studies, Athens) 73

30 Acropolis of Athens, plan by Gorham P. Stevens. (Courtesy of the Agora Excavations, American School of Classical Studies, Athens) 74

31 The Parthenon, from the northwest. (Photograph: author) 76

32 Diagram in exaggerated proportion of the horizontal curvature of the Parthenon. The upper diagram is based on N. Balanos, *Les Monuments de l'Acropole*, pl. 2, fig. 2. 77

33 Parthenon, south metope no. XXXI. London, British Museum. (Photograph: Courtesy of the Trustees of the British Museum) 81

34 Parthenon, south metope no. XXVII. London, British Museum. (Photograph: Courtesy of the Trustees of the British Museum) 82

35 Parthenon, west frieze. (Photograph: Deutsches Archäologisches Institut, Athens) 85

36 Parthenon, north frieze, slab no. XXXIX, detail of a rider. London, British Museum. (Photograph: Courtesy of the Trustees of the British Museum) 86

37 Parthenon, north frieze, slab no. XXXVII, detail. London, British Museum. (Photograph: Yale Classics Department) 87

38 Parthenon, north frieze, slab no. II. Athens, Acropolis Museum. (Photograph: N. Stournaras, Athens) 88

39 Parthenon, south frieze, slab no. XXX. London, British Museum. (Photograph: Courtesy of the Trustees of the British Museum) 91

40 Drawings by Jacques Carrey (?) of the east and west pediments of the Parthenon as they appeared in 1674. Paris Bibliothèque Nationale. (From H. Omont, *Athènes au XVIIᵉ siècle*, Paris 1898, pls. I–III) 92

41 Parthenon, west pediment, Iris. London, British Museum. (Photograph: Courtesy of the Trustees of the British Museum) 93

42 Parthenon, east pediment, perhaps Hestia, Dione, and Aphrodite. London, British Museum. (Photograph: Courtesy of the Trustees of the British Museum) 95

43 Parthenon, east pediment. London, British Museum. (Photograph: Courtesy of the Trustees of the British Museum) 96

44 Head of Zeus from Mylasa in Caria. Courtesy, Museum of Fine Arts, Boston, Pierce Fund. (Museum photograph) 101

45 Portrait of Pericles. London, British Museum. (Photograph: Courtesy of the Trustees of the British Museum) 102

46 *Krater* by the Achilles Painter. New York, Metropolitan Museum of Art, Rogers Fund, 1907. (Museum photograph) 103

47 *Amphora* by the Achilles Painter. Rome, Vatican Museum. (Photograph: Anderson, Rome) 104

48 *Krater* by the Kleophon Painter. From Spina, now in Ferrara, National Archaeological Museum. (Photograph: Hirmer Fotoarchiv München) 105

49 *Doryphoros* of Polykleitos. From Pompeii, now in Naples, National Archaeological Museum. (Photograph: Alinari, 11062a) 109

50 Nike adjusting her sandal, from the south side of the parapet of the temple of Athena *Nikē*. Athens, Acropolis Museum. (Photograph: N. Stournaras, Athens) 116

51 Nike, from the north side of the parapet of the temple of Athena *Nikē*. Athens, Acropolis Museum. (Photograph: Hirmer Fotoarchiv München) 117

52 Amazonomachy, from the frieze of the temple of Apollo *Epikourios* at Bassae. London, British Museum. (Photograph: Courtesy of the British Museum) 119

53 Female figure, perhaps an Aphrodite, from the Athenian Agora. Athens, Stoa of Attalos. (Photograph: Courtesy of the Agora Excavations) 120

54 Nike, by Paionios of Mende. Olympia, Archaeological Museum. (Photograph: Deutsches Archäologisches Institut, Athens) 121

55 *Hydria* by the Meidias Painter. London, British Museum. (Photographs: Courtesy of the Trustees of the British Museum) 124

56 Temple of Apollo *Epikourios* at Bassae. (Photograph: Yale Classics Department) 127

57 Temple of Apollo *Epikourios* at Bassae, reconstruction of the interior. From F. Krischen, *Die griechische Stadt* (Berlin 1938). 128

58 The Erechtheion from the southwest. (Photograph: author) 132

59 Head, probably Priam, from the east pediment of the temple of Asklepios at Epidauros. Athens, National Museum. (Photograph: Deutsches Archäologisches Institut, Athens) 145

60 Warrior from the west pediment of the temple of Asklepios at Epidauros. Athens, National Museum. (Photograph: author) 146

61 Heads, perhaps Herakles (*a*) and Telephos (*b*) from the west pediment of the temple of Athena *Alea* at Tegea. Tegea, Archaeological Museum (*a*); Athens, National Museum (*b*). (Photographs: (*a*) Deutsches Archäologisches Institut; (*b*) author) 148–9

62 Stele of Hediste from Pagasai. Volo, Archaeological Museum. (From Arvanitopoulos, *Painted Stelai from Demetrius – Pagasai*, pl. II) 150

63 Eirene and Ploutos. Munich, Glyptothek. (Photograph: Staatliche Antikensammlung und Glyptothek, Munich) 152

64 Hermes of Praxiteles. Olympia, Archaeological Museum. (Photograph: N. Stournaras, Athens) 153

65 Apollo *Sauroktonos* of Praxiteles. Paris, Louvre. (Photograph: Giraudon, Paris) 155

66 Attic grave stele found near the Ilissos. Athens, National Museum. (Photograph: author) 156

67 Aphrodite of Knidos by Praxiteles. Rome, Vatican Museum. (Photograph: Deutsches Archäologisches Institut, Rome) 158

68 Roman copy of the head of Praxiteles' Aphrodite of Knidos. Paris, Louvre. (Photograph: Giraudon, Paris) 160

69 *Pelikē* by the Marsyas Painter. London, British Museum. (Photograph: Courtesy of the Trustees of the British Museum) 161

70 Temple of Zeus at Nemea from the southeast. (Photograph: author) 162

71 Apulian *krater* depicting Orestes and Iphigeneia among the Taurians. Naples, National Archaeological Museum. (From Furtwängler–Reichhold, *Griechische Vasenmalerei*, III, Tafel 148) 163

72 Remains of the Tholos at Epidauros. Epidauros, Archaeological Museum. (Photograph: author) 165

73 'Asklepios Blacas'. London, British Museum. (Photograph: Courtesy of the Trustees of the British Museum) 167

74 Head of Serapis, Roman copy of a type attributed to Bryaxis. Rome, Villa Albani. (Photograph: Alinari, 27661) 169

75 Epidauros, the theatre, from the east. (Photograph: N. Stournaras, Athens) 171

76 Athenian votive relief. Athens, National Museum. (Photograph: Deutsches Archäologisches Institut, Athens) 173

77 Agias, possibly a contemporary copy of a work of Lysippos. Delphi, Archaeological Museum. (Photograph: Deutsches Archäologisches Institut, Athens) 177

78 *Apoxyomenos*, attributed to Lysippos. Rome, Vatican Museum. (Photograph: Deutsches Archäologisches Institut, Rome) 177

79 Sophocles, 'Lateran type'. Rome, Vatican Museum. (Photograph: Anderson, Rome) 179

80 Head of Alexander from Pergamon. Istanbul, Archaeological Museum. (From *Altertümer von Pergamon*, VII, pl. XXXIII) 181

81 The 'Azara herm', Roman copy of the head of a Lysippean portrait of Alexander. Paris, Louvre. (From *Encyclopédie photographique de l'art. Le Musée du Louvre. Grèce, Rome*, pl. 194A) 182

82 Demosthenes by Polyeuktos. Copenhagen, Ny Carlsberg Glyptothek. (Photograph: Courtesy of the Ny Carlsberg Glyptothek) 185

83 Portrait of Aristotle. Vienna, Kunsthistorisches Museum. (Photograph: Antikensammlung, Kunsthistorisches Museum) 186

84 Commemorative or votive relief by Archelaos of Priene. London, British Museum. (Photograph: Courtesy of the Trustees of the British Museum) 188

85 Herakles *Epitrapezios* of Lysippos. London, British Museum. (Photograph: Courtesy of the Trustees of the British Museum) 191

86 Herakles Farnese, version of a Lysippean type of *c*. 320 B.C., by the sculptor Glykon of Athens. Naples, National Archaeological Museum. (Photograph: Alinari, 11065a) 192

87 Colossal version of the Herakles *Epitrapezios* type, from Alba Fucens. Chieti Museum, archaeological collection. (Photograph: Deutsches Archäologisches Institut, Rome) 193

Note

For quotations from Thucydides I have used the Crawley translation (1876) with a few minor modifications. Other translations are my own.

Numbers in brackets in the text refer to illustrations. For information about photographs of works mentioned but not illustrated in this volume, see pp. 197–8.

Preface

This book is designed for 'general readers', students, and even Classical philologists, who are interested in Greek art but do not normally have occasion to read in the vast scholarly literature about it. Many such readers may already have read an introductory text in which the formal development of Greek art, particularly its mastery of an increasingly accurate representation of our optical experience of nature, is seen as its most interesting and noteworthy achievement. It would be idle to deny that a development in the direction of a more naturalistic representation of anatomy, drapery and the like, is a *fact* of Greek art; whether it was always its *aim* is more doubtful. In any case, it has often struck me as a teacher that a relentless concentration on the formal development of Greek art, while obviously unavoidable, has a way of obscuring the fact that, like most art in most ages, the visual arts in ancient Greece were vehicles of *expression*. The purpose of this study is to suggest some of the basic cultural experiences which the arts were used to express and to analyze how they were used to express them. My primary focus of interest will be on the Classical period, i.e. the period between *c*. 480 and 323 B.C., but since no particular phase of Greek art was ever totally unrelated to what preceded or followed it, I have begun with a prelude on the Archaic period, and in the final chapter I have tried to draw connections between later Classical developments and the subsequent Hellenistic Age.

It will be clear from what I have said above that this is not a handbook of Classical Greek art or even, in the usual sense, a history of it. Excellent handbooks and histories, which delineate the categories of existing monuments, present evidence for dating them, and describe the developmental relationships between groups of monuments, already exist; and these are supplemented by an ever-increasing corpus of articles and monographs on special subjects. In a study as brief as this, and with its stated purpose, one must of necessity take for granted many of the archaeological details to be found in handbooks and special studies.

Frequent references are made in the following chapters to Greek poetry and

philosophy, as well as to Greek history, because the same motivating forces which shaped Classical Greek art also shaped its literature. What Greek literature tells us about the nature of Classical experience is often of great help in understanding the nature of Greek art (and vice versa). But again it should be emphasized that there is no attempt here to create a comparative history of Greek art and literature. Superficial, if often interesting, parallels between the two in subject matter (e.g. representations of episodes from the *Iliad* in Greek vase painting) have often been pointed out; and T. B. L. Webster has undertaken the more serious and challenging task of writing detailed parallel stylistic histories of Greek art and literature. Here I shall be concerned not so much with the question of *how* Greek art and literature are related as with *why* they are related. To what experiences, or reactions to experience, do they both give expression?

In the course of thinking about this book I have benefited from conversations with many friends and colleagues. I wish to acknowledge my indebtedness in particular to Bernard Ashmole and Evelyn B. Harrison, although they should not necessarily be held accountable for any of the ideas which I propose. I would also like to express my gratitude to the American School of Classical Studies at Athens and to its former Director, Henry S. Robinson, both for making the facilities of the School available to me and for providing new photographs of Gorham P. Stevens' invaluable drawings.

New Haven J.J.P.
1971

Preface to the 1999 impression

When *Art and Experience in Classical Greece* was published in 1972, I certainly never expected that it would still be in print more than twenty-five years later. The only reason I can think of to account for its survival is that it poses and attempts, however inadequately, to answer two important questions: What is the meaning of ancient Greek art, and what is its value for us? These are questions that are not often posed in 'serious' scholarship because the scholarly mind tends to find them unscientific and ingenuous; and yet, in spite of changing intellectual fashions and scholarly 'progress', they abide.

When I began to write the book in the late 1960s its approach to the subject was, in a modest way, if not revolutionary, at least rebellious. At that time the reigning aesthetic was that Classical Greek art, and especially sculpture, was the end product of an impersonal evolutionary force that was thought to be largely unaffected by the often turbulent world in which works of art were made. Art and experience were, if not divorced, at least legally separated. Formal analysis was the scholar's primary task, and students were encouraged to appreciate the forms created by artists in Classical Greece either as the triumph of naturalistic representation over schematic formulae or, in a quite contradictory way, as 'pure form'. It seemed to me at the time, however, that if the principal achievement of Greek art was simply an optical trick or a celebration of 'pure' sense experience, it was not intrinsically more significant than clever conjuring or the tickle of champagne on the end of one's nose; and so, for better or worse, in *Art and Experience* I set out to approach the subject in a different way.

In the late 1990s things have changed considerably. Most scholars now devote considerable attention to interpreting ancient Greek art within its cultural context and recognize that understanding its context is a prerequisite for understanding its significance. In a way, if books have sentient souls, *Art and Experience* ought to feel more at home now than it did in the early 1970s (although admittedly its contention that art can have real meaning, in both an historical and an

immediate sense, and that meaning is not simply a 'construct', may make it unfashionable in some quarters).

This book was always intended as a protracted essay on the significance of Classical Greek art and not as a systematic, introductory textbook or as a report on the current state of archaeological research. A vast quantity of Classical scholarship has been produced in the last quarter-century, however, and some of it is directly relevant to the monuments, ideas, and problems discussed in this book. So, I have attempted to bring its bibliography up to date by appending lists of 'Supplementary References for the Footnotes' and 'Additional Suggestions for Further Reading' on pp. 204 and 202, respectively. As with the original notes and bibliography, these have been selected for their particular relevance to the themes and monuments discussed in the book, and since the audience for *Art and Experience* has been primarily students and the educated general reader, I have confined the latter list to works in English.

I feel I ought to confess to the reader that there are a few points in the text where I now disagree with opinions that I held in 1972. At that time I accepted, if somewhat tentatively, the widely held (then and now) view that the Parthenon frieze provides a kind of documentary record of the major components of the Panathenaic procession as they appeared in the Classical period. I am now convinced that this was not the case. The imagery of the frieze, I now feel, was designed to evoke a variety of cultural, political, and religious institutions in Periclean Athens. The meaning of the frieze has recently become a very lively topic, and my own revised view is only one of several revisionist theses. References to these are given under 'Supplementary References to the Footnotes'. I am also now convinced, as a result of the extensive restudy of the temple by Frederick A. Cooper and his colleagues, that the temple of Apollo at Bassae had only one Corinthian column in its cella. Footnote 4 on p. 127 should therefore now be amended by the references and comments in my supplementary list.

I am grateful to Cambridge University Press for giving me an opportunity to include this new preface and to add the two lists of additional references. For practical reasons, it has not been possible to modify the text, and I think this is just as well. If I were rewriting this book today, I would probably be tempted to make it seem more prudent and less presumptuously ambitious by hedging and qualifying every other sentence, and I doubt that such scholarly caution would enhance whatever appeal it has.

New Haven 1999 J.J.P.

Prologue

On the meaning of 'classical'

The English words 'classic' and 'classical' and their cognates in other modern European languages have two fundamental areas of meaning – one a *qualitative sense*, the other an *historical sense*.

When we speak of the 'classic example' of something, or of a 'classical phase' within the development of an art or a science, we use these words *qualitatively* to express recognition of a standard of perfection within a particular genre, a standard by which succeeding objects or developments within that genre are to be judged. This sense of the modern words is rooted in the Latin terms from which they are derived. A *classis* was a 'summoning' or 'calling out' of the Roman people for military action. When the Romans assembled in this way, they arranged themselves in groups (*classes*) which were distinguished according to the financial resources and pride of lineage of their members. The adjective *classicus* thus came to mean 'of or pertaining to class' in a general way, but most often it referred to things associated with the upper classes. From this it acquired the general sense of 'first class' or 'of the highest rank'. The second-century grammarian and encyclopaedist Aulus Gellius is careful to distinguish between a writer or poet who is *classicus*, by which he means 'high-class' and 'authoritative', and one who is merely *proletarius* (*Attic Nights* XIX. 8. 15).

In an *historical* sense 'classical' has also come to mean 'of or pertaining to Greek and Roman culture'. The literature of Greece and Rome is referred to collectively as 'the Classics' and the civilization which produced them is called 'Classical Civilization'. This purely historical sense of the terms may have arisen because in the Middle Ages and later the ancient Greek and Roman authors, and by extension the civilization which produced them, were recognized as having an authoritative excellence in both thought and expression. In other words, the qualitative sense of *classicus* in Aulus Gellius may have been applied to the ancient world as a whole. Or possibly, since students were sometimes called *classici* in the Middle Ages (e.g. in the *Dictiones* of Bishop Ennodius, A.D. 475–521) and since study of the Greek

and Latin authors was an essential part of their education, the description of these authors and their civilization as *classical* may simply have meant that they were 'objects of study by students'.

Around the beginning of the nineteenth century the historical and qualitative significances of 'classical' were fused into a new *stylistic* sense. In the world of Goethe and Byron it was recognized that the measured, restrained, balanced, and orderly nature of Greek and Roman poetry contrasted with the more openly enraptured, effusive art of the Romantic era. 'Classical' came to imply a style which was highly formal and ordered as opposed to one which was intensely 'emotional'.

Since the latter part of the nineteenth century historians of Greek art have customarily referred to the art produced in Greece between the time of the Persian Wars (481–479 B.C.) and the death of Alexander the Great (323 B.C.) as 'Classical', and have distinguished this period from the 'Archaic' phase which preceded it and the 'Hellenistic' period which followed it. Those who first used 'Classical' in this way did so because they felt that the art produced in Greece between 480 and 323 B.C. was most worthy of the traditional meanings which attached to the word – it was of the first rank, it seemed to represent a standard by which other developments could be judged, and order, measure, and balance seemed to be quintessentially part of its style. In effect, they limited the *historical* meaning of 'classical' but maintained its *qualitative* and *stylistic* senses.

Today when Archaic art is so widely admired and Hellenistic art is beginning to receive its due, it seems uselessly contentious to insist on the superiority of one stylistic phase over another. In all periods of Greek art great works were produced; facile generalizations about 'primitiveness', 'maturity', and 'decadence' are almost always inadequate. I therefore propose to use 'Classical' in this book, at least at the outset, as an essentially conventional term for a particular stylistic and chrono-logical phase of Greek art, devoid of any *a priori* value judgements, and to let the term define itself by demonstration. By an analysis of what characterizes the 'Classical' style, what forces produced it, and what unifies it in spite of its own considerable inner diversity, we can perhaps arrive at an appreciation of the word's significance which will be inherent in the art itself.

1 Antecedents and first principles

Order and chaos

A deep-seated need to discover an order in, or superimpose an order on, the flux of physical and psychological experience is a continuing feature of all Greek artistic and philosophical expression. While it is true that every conscious creature feels this need to some extent, the intensity with which the quest for order was carried on by the Greeks was exceptional. Whether as a result of some mysterious tendency in the national psyche or as a spontaneous reaction to their turbulent historical experience after the break-up of the Mycenaean world, the Greeks felt that to live with changing, undefined, unmeasured, seemingly random impressions – to live, in short, with what was expressed by the Greek word *chaos* – was to live in a state of constant anxiety.

An awareness of this anxiety which often haunts Greek thought and expression is of crucial importance in understanding and evaluating Greek art. Looking at Greek sculpture out of its original context or at some of the ribald scenes on Greek painted vases, or recollecting in a general way the spirit of Aristophanic comedy, it is easy to be lured into thinking of the Greeks, especially in the Archaic period, as living in an unneurotic, innocent, emotionally uncomplicated world where there were few restraints on natural impulses. Yet even in a casual survey of the extant fragments of the Archaic lyric poets, this picture of the happy springtime of western civilization quickly vanishes. The lyrics are filled with expressions of a profound anxiety provoked by the irrational uncertainty and mutability of life. Archilochos of Paros, for example, experiences an eclipse of the sun and reacts:

> . . . gloom-filled fear has come upon mankind.
> From now on anything may be believed, anything expected
> among men. No longer should anyone marvel at what he sees,
> not even if the beasts of the field make an exchange with dolphins
> for their watery pasture, and the echoing waves of the sea
> become dearer than dry land to those who once found the hillside sweet.

Solon of Athens tries to reconcile the wisdom of Zeus with injustice in the world and is bewildered:

> In every activity there is danger, nor does anyone know,
> at an enterprise's start, where he will end up.
> One man, striving to do what is right, but lacking foresight,
> falls headlong into great folly and great hardship,
> while to another who acts wrongly, God in all things gives
> pure good luck, redemption from his own thoughtlessness.
>
> The immortals bestow rich profits upon men,
> but folly often appears as the result, which when Zeus
> sends it to punish, strikes now this man, now that one.

Semonides of Amorgos despairs at the vanity of human endeavors; Mimnermos of Kolophon shudders at the prospect of old age; and Simonides of Keos beautifully expresses the fundamental anxiety which underlies all these specific fears when he says that reversal (*metastasis*) of the human condition comes more quickly than the overturning of a dragonfly's wing.[1] True, the lyric poets also give us vigorous drinking songs and love poems. The youthful vigor of Archaic Greece is not an illusion, but it finds expression as often under a cloud of worry as in a clear sky of optimism.

If the apparent mutability of the physical world and of the human condition was a source of pain and bewilderment to the Greeks, the discovery of a permanent pattern or an unchanging substratum by which apparently chaotic experience could be measured and explained was a source of satisfaction, even joy, which had something of a religious nature. For the recognition of order and measure in phenomena did more than simply satisfy their intellectual curiosity or gratify a desire for tidiness; it also served as the basis of a spiritual ideal. 'Measure and commensurability are everywhere identified with beauty and excellence' was Plato's way of putting it in a dialogue in which measure is identified as a primary characteristic of the ultimate good (*Philebus* 64E). Rational definability and spirituality were never mutually exclusive categories in Greek thought. If the quest for order and clarity was in essence the search for a kind of spiritual ideal, it was not an ideal to be perceived in rapturous emotional mysticism but rather one to be arrived at by patient analysis. When the Greek saw a mystical light, he was inclined to break it down into its component wavelengths and, to the extent that such things are possible, give it rational definition.

We see this process at work especially in Greek philosophy, which in various

[1] The poems referred to are numbered in Diehl's *Anthologia Lyrica Graeca* as follows: Archilochos, no. 74; Solon, no. 1; Semonides, no. 1; Mimnermos, no. 1; Simonides, no. 6.

ways was aimed at alleviating the anxiety which is inherent in the more spontaneous expression of lyric poetry. The Milesian philosophers of the sixth century were interested above all in discovering a primary substance from which, by an orderly process of derivation, all other phenomena could be explained. Whether it was water, air in various states of condensation, or some other 'element', the Milesians used their primal substance as the basis for a cosmology (*kosmos* = order) in which the world was seen as a perfectly functioning machine. Neat, clear, and sublimely undisturbed by the social world of man, who took shape and dissolved within the natural order of things, it was an austere ideal, an astringent antidote to the apparent senselessness of life; but at least it made some kind of sense. The man who contemplated it deeply could feel that he was part of a great system which was impersonal but predictable, and, like Lucretius, who revived the Milesian attitude in a later age, he could derive a peculiar kind of peace from it. As time passed and Greek philosophy developed, the urge to find order in experience was shifted from physics to the realm of mathematical abstraction by the Pythagoreans, and to the world of human behavior by various thinkers of the later fifth century; and, finally, Plato and Aristotle attempted to weave all these foci of interest into comprehensive pictures of the relationship between human life and the world as a whole. But in all these epochs the basic quest – the search for a *kosmos* – remained the same.

These two fundamental forces in Greek thought and expression – anxiety prompted by the apparent irrationality of experience and the drive to allay this anxiety by finding an order which explains experience – had a profound effect upon Greek art and are at the root of its two most essential aesthetic principles:

(1) *The analysis of forms into their component parts.* This is one aspect of the process, also inherent in physical science, which brings unity to the multiplicity of things by finding common bases for all of them. The bewildering diversity of human figures and of octopuses, trees etc. *ad infinitum* is less bewildering if they are all seen to be combinations of a limited number of geometric forms. Hence in the first mature style of Hellenic art (as opposed to the 'Helladic' art of the Bronze Age), the Geometric style, we see an intense concentration on reducing all natural forms into a series of clearly definable geometric shapes. The Greek artist did not, like his Minoan predecessor, want to be immersed in the ebb and flow of nature, to exult in its subtle changes or to shudder at its suggestion of something ineffable. Rather he chose to stand aside from nature, to analyze what its constituent elements were, and then to reshape it according to his conception of what it should be. Over the centuries, this process became increasingly subtle, but it was

never forgotten, as the great importance which was attached to such concepts as *symmetria* 'commensurability', and *rhythmos* 'pattern', in Classical art and art criticism, indicates. (See pp. 105 ff. and 56 ff.)

(2) *Representation of the specific in the light of the generic.* Greek artists tended to look for the typical and essential forms which expressed the essential nature of classes of phenomena in the same way that Platonic 'forms' or 'ideas' expressed essential realities underlying the multiplicity of sense perception. A geometric statuette of a horse [1] is an attempt to get at the 'horseness' which lies behind all particular horses. This principle helps to explain why the range of building-types in Greek architecture and the range of subjects in Greek sculpture and painting is so deliberately limited. When one is trying to define essence within multiplicity, whimsical innovations, fantasies, and vagrant moods have no place. Consistency and limit are characteristics of order; diversity is more often a characteristic of chaos.

These two aesthetic principles are best understood not as inflexible edicts but rather as statutes of an artistic common law, subject to reinterpretation in every period. According to changing historical circumstances, their application differed. Perhaps the single greatest difference between the Archaic and Classical periods, for example, was a new attitude in the latter toward the 'specific in the light of the generic principle' insofar as it concerned the representation of emotions and changing states of consciousness. Greek artists in general and Archaic artists in particular were normally reluctant to represent the more obvious expressions of emotional variability – howls of laughter, shrieks of anguish, sneers of disdain and the like. Emotions are most often expressions of reaction to the mutability and uncertainty of human circumstances. Archaic art, like contemporary Milesian philosophy, on the whole chose to transcend the overt expression of emotion and changing states of mind and to rely on purely formal qualities of design to express the orderly world which it envisioned. Even in the vase painting of Exekias, whose ability to convey dramatic tension sets him apart from most Archaic artists and links him in spirit to the Early Classical period, we do not so much *see* the emotional experience of the figures represented as *intuit* it from the subtle brilliance of the composition.

The normal approach of Archaic artists to the representation of human consciousness is perhaps best typified in the *kouroi*, which were produced throughout the entire period and are among its most representative products. Most *kouros* figures seem to have been funerary or votive statues commemorating, in fact reembodying, men who had died young and were thought to have a continuing

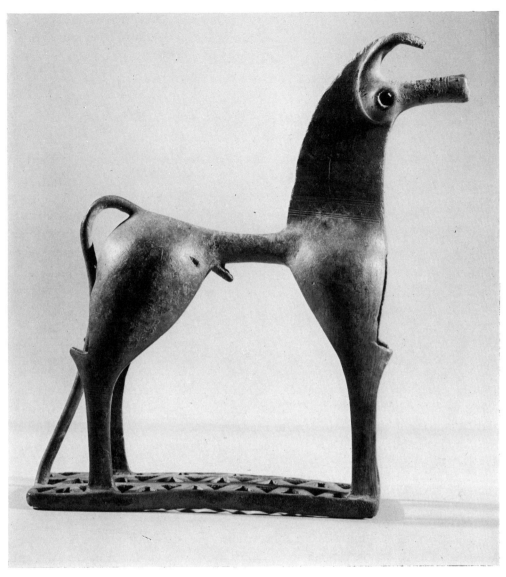

1. Bronze horse, Geometric style, *c.* 750 B.C. Height 6¼″.

existence beyond the grave as *heroes*. The key to their interpretation is provided for us by Herodotus' (I. 31) story of the Argive brothers Kleobis and Biton, who were honored with powerful figures of the *kouros* type at Delphi [2]. When their mother had been eager to attend a festival in honor of the goddess Hera and the oxen which were to have conveyed her wagon to the goddess' sanctuary were late

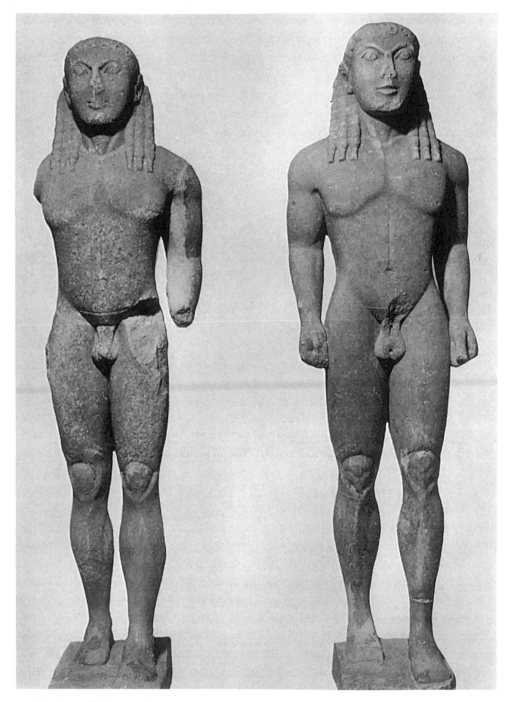

2. Kleobis and Biton, marble, *c.* 580 B.C. Height, with plinth, about 7′.

in returning from the fields, Kleobis and Biton yoked themselves to the wagon and drew it over the hot roads to the sanctuary. This supreme act of strength and piety won them the admiration and respect of everyone present and moved their mother, in a spirit of pride and gratitude, to pray to Hera that her sons be granted the greatest boon that can be bestowed on men. Some time later the brothers lay down to rest in the sanctuary and died in their sleep. Such was the goddess' answer to their mother's prayer. They passed from life at the high point of their power and success. The mutability of life which so haunted the Archaic lyric poets – irrational reversal of fortune, the inscrutability of injustice, natural disaster, the decrepitude of old age – had no further hold on them. Their powerful, ox-like images at Delphi were undoubtedly intended to embody this blissful fate and are, in a way, images of wish-fulfillment, like the cosmologies of the Milesians, which transcend the imperfect world of everyday experience and are unaffected by its travails. The 'archaic smile' which characterizes many of the *kouroi* is not so much an emotion as a symbol, for they are beyond emotion in the ordinary sense of the word.

One of the distinguishing features of the art of the Classical period was that it broke away from this emotional impassivity in Archaic art. To understand why it did so, and in what way it did so, we must examine the changing historical circumstances in which the Greeks found themselves in the late sixth and early fifth centuries B.C.

Greeks and Persians

The chronological limits of the Classical period are bounded by two great confrontations of the Greeks with the Orient, the invasion of Greece by the Persians under King Xerxes in 481/480 B.C. and the invasion of the Persian Empire by Alexander the Great from 333 to 323 B.C. In spite of the fact that every epoch of Greek art, as of later European art, owed much to the periods which preceded it and gave much to that which followed it, these limits are not completely arbitrary. The victory over the Persians in 480 B.C. played a vital role in shaping the state of mind which is inherent in Early and High Classical Greek art. It was the catalyst which transformed the groping humanism of late Archaic art into the Classical style. Alexander's conquest of the Persian Empire, on the other hand, and the consequent spreading of Greek culture over the vastness of the Orient, marked the final step in a process of social and emotional transformation which began in the wake of the Peloponnesian War and which in time nullified the principles on which the Classical style was founded. Since the struggle of the Greeks with the Persians was of such importance in the shaping of Classical Greece, it will be useful to examine exactly what kind of mentality, from the Greek point of view

at least, characterized each culture and what was at stake in their confrontation.

Greek society, as it had developed in the seven centuries which had followed the breakup of the Mycenaean world after 1200 B.C., consisted of relatively small independent communities, or *poleis*[2] as the Greeks themselves called them, in which the sources of power and policy were immediate, familiar, and of personal concern even to those who did not directly wield that power. Because the Orient was also undergoing a period of disruption and readjustment in these centuries and because Greece was on the periphery of the oriental world, the Greek cities were able to evolve their peculiar social forms without the threat of interference from the larger eastern powers. In each of the *poleis* authority, political and moral, ultimately rested in an enfranchised group of citizens. The ways in which the separate cities chose to govern themselves varied. By 500 B.C. Sparta was ruled by two hereditary kings in conjunction with an elected board of advisors, Corinth was governed by a mercantile oligarchy, and Athens by a constitutional democracy, that is, a form of government in which power rested in the hands of the *demos*, the entire male citizenry, which elected its governing officials. (It is customary to remind ourselves that democracy in Ancient Greece applied only to the legal citizens of a community. Most Greek cities had a sizable population of non-voting residents and slaves.) But whatever the form of government, power always rested with a group and served the interests of that group. The occasional usurpation of power by 'tyrants' in the sixth century cannot really be said to form an exception to this rule. The tyrants were always backed by a strong faction within the group, and the most successful of them like Peisistratos of Athens were, moreover, dedicatedly civic-minded.

Perhaps the most overriding characteristic of the Greek cities was the pressure which they exerted upon the individual citizen to merge his life and interests in those of the group. It has sometimes been claimed that the outstanding characteristic of the ancient Greeks was their high esteem for individualism, and it is certainly undeniable that Greece did produce many brilliant, talented, and ambitious individuals, who, if their gifts were used in the service of the *polis*, became prominent men. But if one means by individualism a tolerance of those who reject the group's norms and pursue their own interests in disregard of the dominant values of their society, the *poleis* hardly qualify as hospitable ground. The unconventional individualists of Classical Greece – Themistokles and Socrates, for example – often suffered for their individualism and not infrequently came to a tragic end; and yet even they were essentially what a sociologist would now call

[2] A *polis* (plural *poleis*) was in size like a city but in its political independence like a state, and is hence often translated as 'city-state'.

'group-oriented'. In the *Apology*, for example, Plato's Socrates emphasizes that his persistent and at times annoying quest for truth was in the best interest of his fellow citizens, even if they were unable to realize it.

The pressures which the Greek *polis* put upon the individual to merge his interests in those of his society may account for the great emphasis put on the ideas of moderation, restraint, and avoidance of excess in Greek religious and moral thinking. All Greeks were subject to and respected the maxims of the Delphic oracle: 'know thyself' (i.e. 'know your limitations') and 'nothing in excess'. These pleas for restraint and measure, which were summed up in the virtue of *sophrosyne* ('discretion, temperance, self-control'), were not, it should be emphasized, a purely negative prescription. From Hesiod through Solon to the Classical dramatists and philosophers, such virtues were presented as the key to right living, to a happiness which was in keeping with man's nature and was divinely sanctioned. Men whose desires and ambitions knew no restraint, who defied the accepted measure and order, courted chaos and disaster for themselves and those around them. For the Greeks an irrational overturning of the natural order of things was always fraught with deep anxiety.

The Persian Empire, in contrast to the minuscule cities of Greece, was the most colossal state the East had ever seen, with borders stretching from the Aegean to India and from the Asiatic steppes to the upper Nile. It was the last great political order of the ancient Orient prior to the infusion of Greek and Roman culture in the Hellenistic period, and in many ways summed up three thousand years of oriental culture. The Persians and the Medes were two obscure related tribes in what is now called Iran who, toward the end of the seventh century B.C., had broken up the empire of the Assyrians, taken control of Northern Mesopotamia, and temporarily fragmented the rest of the Near and Middle East into several independent kingdoms. With the rise to power in the sixth century of the dynamic Persian king Cyrus (559–527 B.C.), the Persians moved to re-forge these regional states into a new order. In 546 B.C. Cyrus overthrew the Lydian kingdom in central and western Anatolia and then turned south against the 'Neo-Babylonian' empire which controlled southern Mesopotamia, Syria, and the eastern coast of the Mediterranean. With the fall of Babylon in 539 B.C. these areas, along with Lydia, were incorporated into a new 'Persian empire'. Cyrus' successor Cambyses continued this policy of expansion by attacking and conquering Egypt (525 B.C.), and his successor Darius I (ruled 521–486 B.C.) began to make forays into eastern Europe, perhaps with the intention of establishing a frontier at the Danube.

The state and society thus shaped by the Persians was in every way antithetical to those of Greece. It encompassed disparate cultures and peoples – Persians,

Medes, Egyptians, Indians, Jews, Phoenicians, and even some Greeks – and stood for a social order in which the gap between those who ruled and those who simply subsisted, was immense. The average man was ruled first by local officials, to whom he had some recourse; then by the regional governor, the *satrap*, whom he might occasionally see; and finally by the Great King – remote, grand, and ferocious, a man who could, within the limits of human nature, do anything.

It was natural that the Persians should have wanted to consolidate control over the western shores of their empire by absorbing the Greek cities on the Aegean coast of Asia Minor, and after the defeat of the Lydians they proceeded to do so. This was not the first encounter of the eastern Greeks with a monarchical Asiatic power, since they had already been nominally subject to the Lydian king Croesus. But Croesus was a philhellene who had sent expensive offerings to the sanctuaries of the Greek gods and had allowed his kingdom to become 'Hellenized' in various ways. To the Greeks of the mainland he probably seemed more exotic than frightening, and even in Asia Minor submission to him must have seemed more like a practical *détente* than a defeat.

The spectre of Persian rather than Lydian domination after the fall of Croesus, on the other hand, was a much more fearful prospect and sent waves of anxiety throughout the Greek cities. Persians and Medes came from a land which it took months to reach, were forming an empire which included much of the known world, and were without the philhellenic tolerance of Croesus. When they appeared on the borders of Greece they must have been seen as an unknown and distant giant, an historical embodiment of the Greeks' ancient fear of chaos, which threatened to overturn and even annihilate a familiar, ordered life. Rather than face the prospect of domination by such a force, virtually the entire population of two Greek cities, Phocaea and Teos, migrated from Asia Minor and founded new cities, the former in Italy, the latter in Thrace. Many individual refugees followed their example and the influence of these wanderers, like the poet and philosopher Xenophanes of Kolophon, undoubtedly helped to instill in all Greeks a new sensitivity to the characteristics which bound together their different communities and set them apart as a distinct culture, with distinct patterns of thought and behavior.

But even the Persians, although occasionally brutal, allowed the eastern Greek cities considerable social and political freedom as long as they continued to pay regular tribute and observe their military obligations, and for a time it may have seemed as if a far-reaching cultural crisis could be avoided. The mainland Greeks were probably ready to accept the subjection of the Greeks in Asia Minor as an anxious but tolerable regional situation. In 499 B.C., however, the eastern cities

revolted from Persia, and an attitude of detachment could no longer be maintained. Although this 'Ionian revolt' was touched off by a group of conniving Greek tyrants who were in fact Persian clients, it soon became a genuine popular movement for Greek freedom. Athens and Eretria from the mainland joined the Ionians, and together they marched inland and burned the Persian regional capital at Sardis. When the Persians crushed the revolt in 494 B.C. their punishment of the Ionian cities was fierce and shocked the rest of the Greek world as much as it frightened it. The entire male population of Miletus was put to the sword, and the women and children were sent into Asia as slaves.

The Milesian catastrophe appalled the mainland Greeks as no previous event had, and there was a reluctance to face it. When the poet Phrynichos staged a drama in Athens about the fall of Miletus, he was fined heavily by the Athenians 'for reminding them of afflictions which affected them intimately' (Herodotus VI. 21), and further performance of the play was forbidden.

The Persians' desire to punish the mainland Greeks for their interference in Ionia was raised to a furious pitch by what happened in the years immediately following the revolt. Darius sent an expeditionary force to reassert Persian control in Thrace and Macedonia and to punish Athens and Eretria for their part in the uprising. After some difficulty at sea the force managed to burn Eretria, but when it proceeded to the plain of Marathon on the east coast of Attica the Athenians attacked before the Persians were prepared for action and won a stunning victory. The remnants of the Persian force withdrew, carrying the burden of a disgraceful defeat back to the Persian capital at Susa.

If we may believe Herodotus, the need to avenge this blow to Persian prestige by some minor states on the western border of the empire became an obsession with Darius' son and successor Xerxes, and in 481 B.C. he personally led a massive army into Greece as part of a coordinated land and naval campaign. This time the Persian aim was more than simply to punish a few obstreperous cities. Greece in its entirety was to be made a province of the Persian Empire. The major cities south of Thessaly, led by Sparta, Athens, and Corinth, acted as one for the first time in their history, and with that combination of bravery, daring, and exasperating, unseemly squabbling which always characterized Greek political activity, prepared to meet the invading army. When Xerxes defeated an heroic Spartan contingent at Thermopylae, swept down into Boeotia and Attica, and sacked Athens (previously abandoned by most of its inhabitants), it seemed only a matter of time before the Greeks became part of that oriental world from which, as they now saw, they differed so markedly. The deliverance which the great Greek naval victory at Salamis brought in 480 B.C. must therefore have seemed more miraculous and

epoch-making than most victories. It not only thwarted an enemy but also preserved a culture. When Xerxes returned to Persia and the large land force which he left behind was annihilated at Plataea in the following year, it was the end of a nightmare for the Greeks. They had won their freedom to be Greeks, with all that that implied.

The meaning for Greek culture of the victory over the Persians and its outcome is brought into sharpest focus in the portraits of Xerxes drawn by Aeschylus (a veteran of the war) in the *Persians* and by Herodotus, nearly half a century later, in his history of the war. Xerxes is the anti-Greek, the man of unlimited power who is subject to no restraint, no limit to desire, the man who does whatever he wants, whenever a whim demands it. One day he augments the already large fortune of one of his subjects; the next day he has the same man's son cut in half (Herodotus VII. 29 and 38–9). He flogs and enchains the Hellespont because it dares to be rough when he wants to cross it (Herodotus VII. 35). The greater part of his army, moreover, consists of slaves from all parts of the Orient who go into battle under the lash. By contrast the Greeks, or at least most of them, fight for their freedom, their homes, personal honor, their localistic way of life, and their ideal, however often violated, of *sophrosyne*. Victory in such a conflict was interpreted as something more than a successful, heroic act of self-preservation; it was a triumph of order over irrationality, a divinely sanctioned justification of Greek culture.

2 Consciousness and conscience

The Early Classical period, c. 480–450 B.C.

The new range of expression

The art of the Early Classical period differs from that of the Archaic in its interest in exploring emotions and changing states of mind, particularly in a dramatic context. Archaic statues tend to be iconic, that is, to be unchanging 'presences', in tune with a higher reality and unaffected by the changing conditions of the world. Early Classical statues tend to be dramatic, and to carry with them the impression that they represent one distinct stage in a series of events. They are more often qualified by association with particular times and circumstances. To illustrate this point most simply we can look at two statues which are not far from one another in date and in function but which make totally different impressions. The 'Strangford Apollo' [3], a small (about 3′ 4″ high) *kouros* in Parian marble now in the British Museum, must date from 490 or 485 B.C. and is a good example of the outward humanization which characterizes much late Archaic sculpture. Its scale is strictly human rather than superhuman, and, although the sculptor who made it clearly employed a conventional 'canon' of proportion and composition, the individual elements within that canon more closely approximate a natural mean. Yet although the Strangford *kouros* may impress us as humanized when compared with the 'heroic', greater than life, atmosphere which surrounds many of the earlier *kouroi* [2], it is still fundamentally like them in conception. Its traditional *kouros* stance and impassive face seem to ignore the ordinary human condition. As you look at it, or at any *kouros* in a museum, it will seem to look past you.

By contrast, the 'Kritios Boy' [4] in the Acropolis Museum in Athens seems as if he might turn and ask you a question. This figure was found on the Acropolis in Athens in the nineteenth century but is apparently not part of the debris left by the Persian sack of Athens since it was broken and repaired in Antiquity, whereas the figures smashed by the Persians were not. It therefore probably dates from just after 480 B.C. and stands at the very beginning of the Early Classical period. The

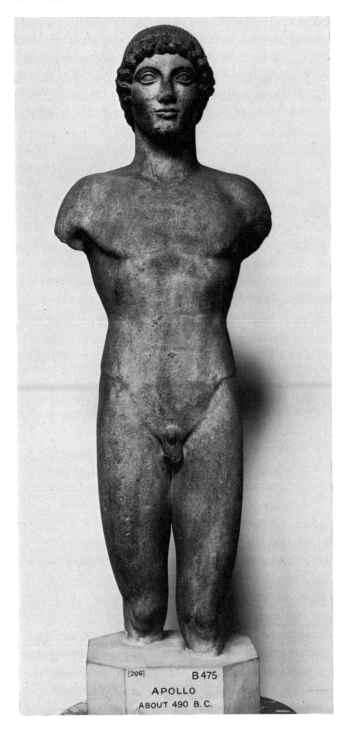

3. Strangford Apollo, marble, perhaps from Lemnos, *c.* 490 B.C. Height approx. 3′ 4″.

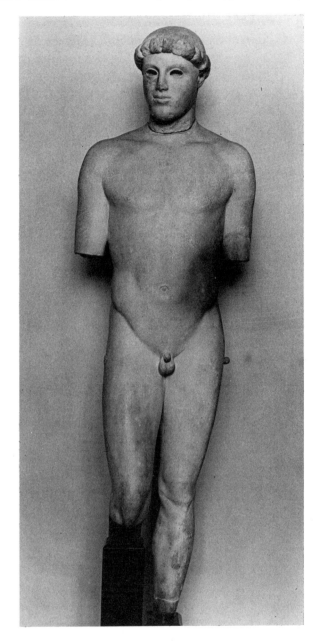

4. Kritios Boy, marble, found on the Athenian Acropolis, *c.* 480–475 B.C. Height approx. 2′ 9″.

sculptor (the ascription to Kritios is based on analogies with the Tyrannicides group, see pp. 51, 58) broke with the 150-year-old *kouros* stance by shifting the seeming stress of the weight to the left leg while leaving the right leg, with the knee slightly bent, free to balance or propel. The displacement of the weight to the left

leg raises the left hip and causes a slight unevenness of the axes of the torso. The head turns to the right, to complete the break with the rigidly frontal *kouroi*. The effect of these technical devices is to create a figure which seems to hesitate and to be uncertain about what it is doing and where it will go. It seems conscious of its surroundings and faced with alternatives which ask for judgement and decision. In short, it seems to live and think.

In the case of the Kritios Boy we intuitively sense a kind of dramatic context for the statue, even though we cannot specify precisely what it is. If we turn to archi-tectural sculptures, which normally represent known mythological episodes and hence have a specific narrative context inherent in them, we none the less still find that a distinct difference in atmosphere separates the products of the Classical period from their Archaic predecessors. One of the most vivid illustrations of the gap in feeling and expression between the two periods occurs in the pedimental sculptures, both apparently depicting combats of Greeks and Trojans, from the temple of Aphaia on the island of Aegina. The west pedimental group of this temple seems to have been completed, along with the temple itself, around 490 B.C. An east pedimental group, also completed at this time, was damaged by an unknown agent and replaced by a new set of sculptures somewhere shortly before or after 480 B.C. [5]. While most of the figures from both the west pediment and the new east pediment are fragmentary, there are extant two largely complete figures of

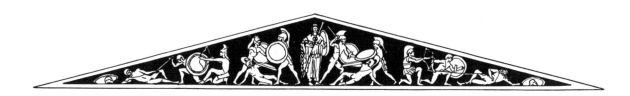

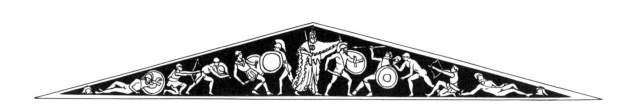

5. Aegina, Temple of Aphaia. Sketch restorations of the west (above) and east (below) pediments.

fallen, wounded warriors, one from each pediment, which had similar narrative functions in their respective scenes and invite comparison.[1] The warrior from the west pediment [6] has been struck in the chest with a spear (of bronze or wood, now missing) which he grasps with his right hand while he props himself up on his left elbow. His expressionless face, sprucely set off by the beaded bonnet of his

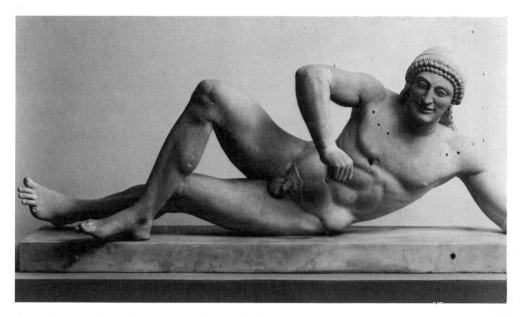

6. Aegina, Temple of Aphaia, west pediment, fallen warrior, marble, *c.* 490 B.C. Length approx. 4′ 2″.

hair, stares out at the viewer. His right leg is arched over the left, giving a clear, almost delicate silhouette, evocative of the crisp figures of early Attic red-figure vase paintings. Rather than suffering from an excruciatingly painful wound, he seems to be posing for a dignified court *tableau*.

The fallen warrior from the east pediment is another matter [7]. As life ebbs away and he sinks toward the earth, he tries futilely, sword (now missing) in hand, to raise himself. His eyes narrow as his consciousness fades; his mouth is slightly

[1] The reconstructions of the pediments which are illustrated here are based, as are the reconstructions in nearly all publications since the early part of this century, on A. Furtwängler's thorough analysis of the fragments in *Aegina, Das Heiligtum der Aphaia* (Munich 1906). Many of the details which enhance the effect of Furtwängler's models and drawings are of necessity hypothetical.

Both pediments have recently been re-established, using only the ancient fragments and omitting the well-known restorations of Thorwaldsen, in the rebuilt Glyptothek in Munich. Without the Thorwaldsen additions they make a much more austere impression, but no fundamental alterations in Furtwängler's pattern of reconstruction appear to have been made.

open as his breathing grows difficult; he stares at the earth. His enfeebled movements contrast poignantly with his massive physical frame in which, for practically the first time, the individual details of the musculature are fused and unified by a softening of the lines of division between them, and by increasingly subtle modulation of the surface from which one senses the presence of a unified physical force

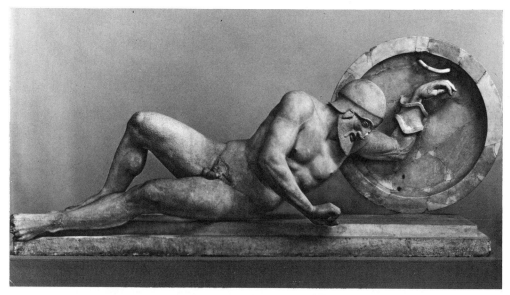

7. Aegina, Temple of Aphaia, east pediment, fallen warrior, marble, *c.* 480 B.C. Length approx. 6′.

emanating from within the body. The sculptor who conceived the figure had obviously thought carefully about exactly what it meant. He must have asked himself what it must really be like when a powerful warrior is wounded and falls. What does he feel? How should we feel? And what meaning is there in our feeling? The warrior from the west pediment seems more like a recumbent *kouros*; his companion from the east pediment is a character in a drama.

In Attic red-figure vase painting too the supplanting of the Archaic emphasis on decorative pattern by an emphasis on emotional expression is apparent, although it must be noted that the vases are far more numerous and varied than the sculptures, that the vase painting medium gives much greater rein to the individual artists' personal whimsicality, and that consequently it is easier to find the occasional work which will contradict broad and essentially valid generalizations. The scene of the death of an Amazon at the hands of a Greek warrior, probably the Amazon queen Penthesileia and the hero Achilles, as depicted by the Berlin Painter in the late Archaic period [8] has much of the crisp, detached clarity of the Aegina west

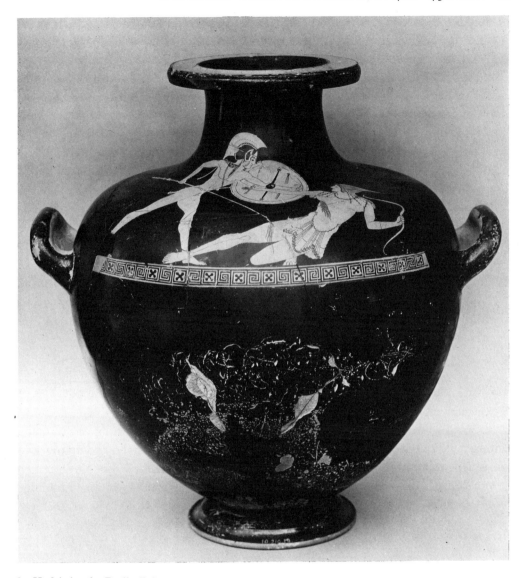

8. *Hydria* by the Berlin Painter, *c.* 490 B.C. Height 14$\frac{3}{8}$".

pediment. The essential theme of this story, variously related in obscure sources, is that Achilles fell in love with Penthesileia at the moment when he slew her. In the Berlin Painter's conception there is little hint of this tragic complication. His beautifully constructed Achillean robot is about to deliver the final blow to Penthesileia who, although wounded and bleeding, falls with what seems like the

calculated gesture of a rhetorician, or, again, a pose struck for a *tableau*. The composition is immaculate, and the implications of the subject are not allowed to interfere. By contrast, in a depiction of what is probably the same scene[2] on a cup in Munich dating from about 460 B.C. by the Penthesileia Painter, these conditions are reversed [9]. The great design, although not awkward, seems to strain against the limits of its small circular field, and the emotional atmosphere of the scene is unmistakable. As Achilles looms over the falling Amazon and begins to deliver the mortal blow, their eyes meet. His thrusting arm seems to freeze as anger, duty, and pride begin to conflict with love and regret. Penthesileia grasps him feebly, partly imploring, partly resisting. In her case fear and pride, and perhaps also love, mix. These complex and conflicting emotional values of the central scene are given dramatic perspective by the two flanking figures. To the left, behind Penthesileia, a Greek warrior with sword drawn is busily caught up in the heat of the battle and seems oblivious of the poignant scene nearby. To the right a dead or dying Amazon sprawls awkwardly, her face indicating that she comprehends nothing. The Penthesileia Painter thus shows us in one scene dramatic consciousness, ordinary consciousness, and unconsciousness. He forces us to enter into the states of mind of the characters involved. Not only do his characters think, but they make us think too – qualities which perhaps constitute the essence of Early Classical art.

Confidence and doubt

What factors were there which might be said to have brought into being this new analysis of consciousness in Early Classical art? It seems something more than a natural evolution from what had gone on in the Archaic period and should perhaps be ascribed to both a *new self-confidence* and a *new uneasiness* which arose among many thoughtful Greeks in the wake of the Persian Wars.

Confidence and optimism arose, of course, simply from the fact that the Greeks

[2] On neither the Berlin Painter's *hydria* nor on the Penthesileia Painter's *kylix*, it must be admitted, are the figures identified by inscriptions, and some have doubted, particularly with regard to the Munich cup, whether it is, in fact, Achilles and Penthesileia who are represented. The Penthesileia Painter's cup, it has been thought, may reflect the influence of the famous painting by Mikon in the *Stoa Poikile* in Athens depicting the battle of Theseus and the Athenians against the Amazons (Pausanias I. 15. 2). Penthesileia was not involved in this battle. On this problem see D. von Bothmer *Amazons in Greek Art* (Oxford 1957) p. 147. The influence of Mikon's painting on the Penthesileia Painter, however, is a purely hypothetical proposition, and several variations on it are possible. The vase painter could have been influenced, for example, by Mikon's general style without necessarily reproducing specific motifs or subjects from Mikon's painting.

On the whole the identification of the subjects on these two vases as the combat of Achilles and Penthesileia seems to me more likely than not. In any case, the basic contrast between the expressive qualities of the Late Archaic and Early Classical styles which the vases illustrate remains valid whatever their subject.

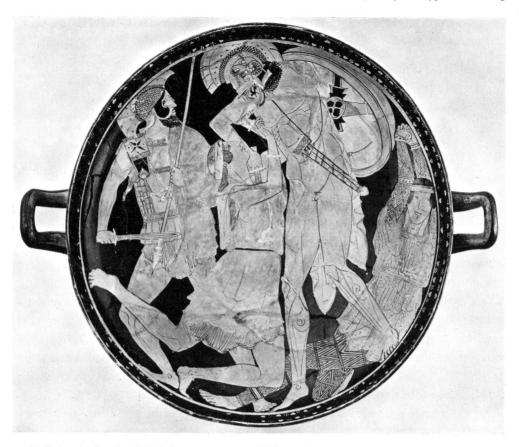

9. *Kylix* by the Penthesileia Painter, *c*. 460 B.C. Width $16\frac{7}{8}''$.

had won. Triumph in the face of such overwhelming odds suggested that perhaps Greek culture, with its restrained, group-conscious, way of life, had received divine sanction and justification. Aeschylus, and following him, Herodotus and others, begin to ponder the question of how *hybris*, 'arrogance, unbridled ambition without restraint', brings in its wake *ate*, 'folly', and finally *nemesis*, 'retribution'. There can be no doubt that in Greek eyes the Persians, embodied by the wild figure of Xerxes flogging the sea, had gone through just such a cycle. In the end 'Zeus' (the name covered a multitude of religious and moral conceptions) had punished them. Speaking through the ghost of Darius, Aeschylus, in the *Persians*, explains why:

> [Disaster awaited the Persians at Plataea]
> as recompense for their arrogance and godless thoughts.

> In coming to the land of Hellas they did not shrink
> from burning temples or pillaging images of the gods.
>
>
>
> And mounds of corpses even in generations to come
> shall be a silent sign to the eyes of living men
> that being mortal, a man ought not to think himself
> surpassingly great; for insolence when it turns mature
> bears ruinous delusion as its special fruit,
> from which it reaps a full harvest of lamentation.
> Beholding the retribution which these men earned as their wage,
> be mindful men of Greece and Athens lest one among you,
> disdaining in his mind the fortune of the present
> and lusting after more, waste the great blessings he has.
> For Zeus, mark you, is the chastiser of boastful ambitions,
> the stern corrector, who sets men straight with a heavy hand.
>
> (lines 807–10, 818–29)

The belief that the Persians had suffered punishment for their *hybris* also made it necessary to believe that there was some kind of order in the immediate world – arrogance was punished, moderation was rewarded. This involved a departure from the thought of the Archaic period, which, unable to discover any rational order in the world of immediate experience (compare Solon's observations on justice, p. 4), had reacted by conceiving of orders which were beyond it. In the Early Classical period, this budding belief that the world as it was might 'make sense' must have provoked a new interest in the nature of its changing conditions. Changing states of consciousness could be understood as aspects of a universal moral order, and it may have been this realization which led the artists of the period to begin exploring them. Perhaps it is not too reckless to say that when the designer of the metopes of the temple of Zeus at Olympia (see p. 50) decided to show Herakles at different stages of his life and in different states of mind, he did so because he intuitively felt that these qualified conditions were stages in a meaningful scheme of things.

But if a new confidence led the Early Classical artists to begin experimenting with the representation of conscious inner life, it was another motive which led them to dwell most often on its sombre, meditative, even haunted aspects. That motive was a new uneasiness of mind produced by the growing belief that men were responsible for their own fortunes, good or bad, and by the implications which this belief had for the course of Greek domestic politics after the Persian Wars.

Greek culture had been preserved from destruction at the hands of the Persians by the decision on the part of many of the individual *poleis* to sacrifice (with all the religious connotations of the word intact) a portion of their traditional self-interest

and independence for the sake of unity and concerted action. The heroism of the Greek soldiers at Plataea was nothing new; but the fact that they were fighting side by side with one another, rather than against one another, was altogether unusual. After the war this unfamiliar unity vanished with astonishing speed. Sparta, inhibited by an unadventurous temperament, by unrest among Greeks who were her subjects in the Peloponnesos, and by a dislike of having her generals too far from home, abrogated any responsibility for freeing the Greek cities of Thrace and Asia Minor which were still controlled by the Persians. Leadership went by default to the Athenians, who had not only the largest navy but also the ambitious spirit and indomitable energy needed for the campaign. In 478/477 B.C. the Athenians formed and took the leadership of a confederacy of Greek cities in the islands, Asia Minor, and Thrace for the purpose of driving the Persians from the northern and eastern fringes of the Greek world. Members of the confederacy, which in time came to number over 200, were obliged to furnish either ships and men or to make a fixed contribution of money to the common treasury of the confederacy on the island of Delos. The confederacy, under the leadership of the conservative Athenian statesman Kimon, scored some notable military successes in the 470s, and by the end of that decade any lingering threat from the Persians had been removed. At this point some of its members felt that its work was done and wanted to withdraw. But Athens, which had become one of the great powers of Greece and a rival to Sparta through her control of this 'Delian League' was reluctant to see it break up. When several of its members revolted, they were brought back to the fold by force and made subjects rather than allies. This pattern repeated itself for a number of years until in 454/453 B.C. the Athenians removed the treasury of the confederacy from Delos to Athens and gave up any real pretense that membership was voluntary. Her allies became her subjects. The power which had undertaken to restore freedom to the eastern cities had ended by becoming a new master.

While Athens' external power grew, her internal history was characterized by ruthless political infighting between a conservative, aristocratic, pro-Spartan faction led by Kimon, and a democratic (in domestic matters) faction which eventually came under the control of Pericles. In 461 B.C. the democrats engineered the ostracism (a form of exile for a fixed period of years without loss of citizenship or property) of Kimon, who had, perhaps foolishly, attempted to provide Athenian aid for Sparta during a slave-revolt and had been, again perhaps foolishly, snubbed and hence disgraced by the Spartans. At about the same time maneuvering by the democratic faction also resulted in the stripping of political power from the court of the Areopagus, an ancient and outmoded body which was one of the principal instruments of conservative power. In the wake of these events, Ephialtes, one of

the democratic leaders, was murdered, presumably by vengeful conservatives. The internal political life of Athens was threatening to become chaos.

Sparta, although unwilling to challenge Athens' leadership of the Delian League, was equally reluctant to accept passively her rival's phenomenal growth in power. As early as 476 B.C. she had made an expedition into Thessaly with the hope of extending her land empire into northern Greece, but the susceptibility to bribery which seems to have overcome Spartan generals whenever they left home guaranteed the failure of the project. Later, after Athens had taken control of Aegina and Megara, the Spartans sent another expedition to the north with the hope of restoring the leadership of Thebes in Boeotia and creating thereby a new force to curb Athenian expansion. On their return from Boeotia the Spartans suddenly resolved to launch an attack directly on Athens itself. They were met by an Athenian force at Tanagra on the border of Attica and Boeotia where a pitched battle was fought (457 B.C.). Although the Spartans were acknowledged as victors in the battle, their losses were so heavy that they gave up their intention of invading Attica and returned to the Peloponnesos. A few months later the Athenians made an expedition of their own to Boeotia and seized control of all its cities except Thebes. Sparta had failed, but Athens, especially after the destruction of a large number of her ships in a brazen and sanguine attempt to interfere in a revolt in Persian-dominated Egypt, had overextended herself. In 452/451 B.C., through the efforts of Kimon, who had been recalled from exile and had reached an accord with Pericles, a five year truce between Athens and Sparta was signed.

A thoughtful observer of these events, like Aeschylus, could not but have felt uneasiness. Were the Greek cities and the factions within them being drawn, through their quest for power even at the expenses of principle, into the cycle of *hybris*, *ate*, and *nemesis* which they themselves had seen in the undoing of the Persians? In a world where Zeus punished *hybris*, where men reaped the fruits of their own actions, were they sowing the seeds of their own downfall?

> ... be mindful men of Greece and Athens lest one among you,
> disdaining in his mind the fortune of the present
> and lusting after more, waste the great blessings he has

the ghost of Darius had said in the *Persians*. These fears, and with them the vivid memory of what destruction actually means (particularly in Athens, which had been sacked and ruined by the Persians) must have been strong motivating forces in the creation of the serious and meditative character of so much Early Classical art. The 'Aspasia' [16], the Charioteer of Delphi [20], and even the very early

'Blond Boy' from the Athenian acropolis [17] all seem to be attempts to embody the ideals of thoughtful restraint and responsibility which the Greeks were so frequently prone to forget.

Art and drama

The confident yet self-questioning atmosphere which developed in the wake of the victory over the Persians also served to bring to maturity the dominant and most characteristic literary form of the fifth century B.C. – Athenian tragic drama. The dramas were public rites, performed at religious festivals by actors who were, in most cases at least, the fellow citizens of those who witnessed them. They were above all reflections of group-experience. The dramatic poet, whether reflecting the mentality of his time or seeking to shape it (or both), spoke to, and often for, society as a whole. It is therefore not surprising that the best dramas bring into focus simultaneously most of the intellectual and emotional preoccupations of the Early Classical period – the willingness to believe that there is a meaningful moral order in the world, the consequent uneasiness over the human tendency to pursue self-interest through violence, the possible implications of such violence within the moral order, the new significance attached to individual human consciousness and thought, and finally a new conception of what constitutes nobility in human character. When the proud and strong characters of Greek drama are pitted against hostile forces, sometimes circumstantial and sometimes within themselves, which threaten to destroy them, one often feels that the fate of Athens and Greece as a whole in the fifth century is being enacted, either historically or speculatively.

We have already seen how a dramatic quality pervaded the earliest works of Early Classical art. Sculptors and painters seem, in fact, actually to have borrowed some of the technical devices which had been developed in dramatic performances to convey character and narrative action – for example, the formal gestures of actors, the masks which were designed to express at once an individual character and a basic human type, and perhaps also a sense of dramatic timing. Nowhere is the attempt to adapt the themes, spirit, expressive power, and technical components of the great dramatic cycles like the *Oresteia* of Aeschylus to the medium of the visual arts more successfully and grandly carried out than in the sculptures of the temple of Zeus at Olympia [10–14]. A comparison of the Aeschylus trilogy with these sculptures is instructive.

The *Oresteia* was produced in 458 B.C., a year or so before the pediments of the temple of Zeus at Olympia were completed, and is our most vivid example of how personal, civic, and cosmic themes were woven into one artistic form in Greek drama. In the first two plays of the cycle, the *Agamemnon* and the *Choēphoroi*, we

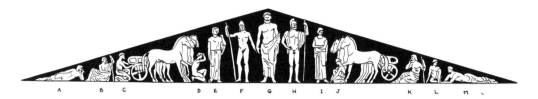

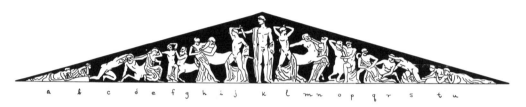

10. Olympia, Temple of Zeus, sketch restorations of the east (above) and west (below) pediments, 462–457 B.C. Original length approx. 87′; original height approx. 10′ 10″.

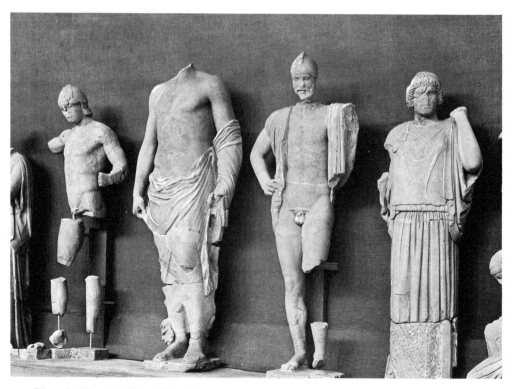

11. Olympia, Temple of Zeus, E. pediment, central group: Pelops, Zeus, Oinomaos, Hippodameia (?) (figures F, G, H, and E in [10]), marble.

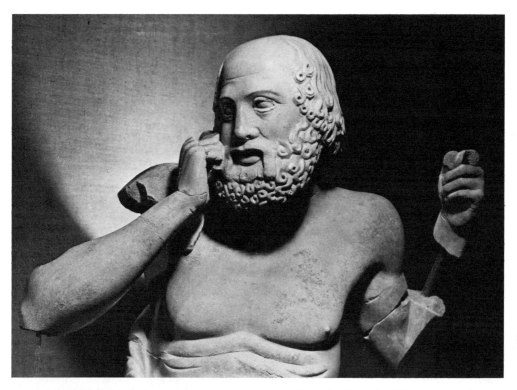

12. Olympia. Temple of Zeus, east pediment,
'Old Seer' (fig. K in [10]), marble.

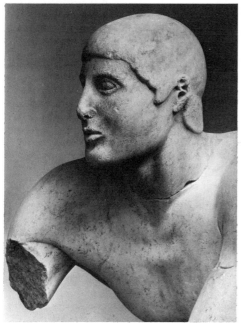

13. Olympia, Temple of Zeus, east pediment,
'Kladeos' (fig. M in [10]), marble.

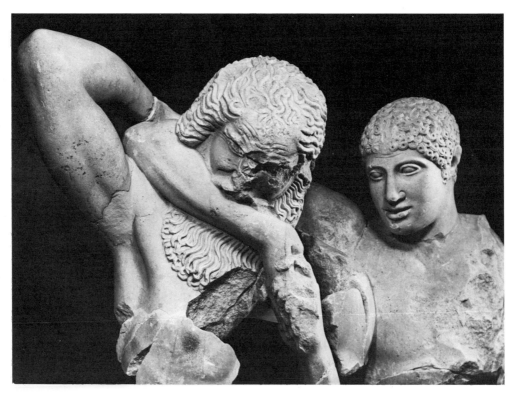

14. Olympia, Temple of Zeus, west pediment, Lapith and Centaur (figures o and p in [10]), marble.

are confronted with a group of strong characters caught in an obscure web of suffering, of mutual and self-destruction, which defies rational explanation. Inheriting the curse of the terrible crimes of his father, Agamemnon commits violence and suffers violence. Divine demands, the pressure of circumstances, and his own arrogant and ambitious nature drive him to sacrifice his own daughter and bring suffering on all who follow him. Clytemnestra, driven by the pain of her daughter's death and by her husband's infidelity, but also by the pressures of her intrigue with Aegisthus and her own will for power, assassinates her husband. Orestes, both protected and spurned by his titanic mother, is then compelled by the dark force of his father's ghost, by a divine command, but also by his own desire to regain his kingdom, to avenge by matricide his father's death, and for this he is pursued by the Furies, the force of an ancient tradition demanding that blood guilt must inevitably be avenged. The forces which sustain and perpetuate this chain of suffering seem to stem both from the characters themselves and from a primeval, chaotic, and brutal world of values which confounds human com-

prehension. Even Zeus, who overthrew his own father, seems to be involved in, rather than in control of, the avenging destructive forces, and the chorus, speaking from both within and without the dramatic action, is forced to invoke him in bewilderment:

> Zeus, whoever he may be, if this name
> please him as an invocation,
> then with it I do call upon him.
> I can think of none other,
> as I weigh all my thoughts,
> save Zeus, if in truth I must cast aside
> this useless burden from my mind.
>
> Zeus, who has guided men toward
> understanding, and whose lordly decree
> it is that wisdom is born in suffering.
> Yet in sleep there flows before my heart
> the memory of pain. Against our will
> we are taught restraint.
> Strangely violent is the grace of gods
> who sit enthroned in holiness.
> (*Agamemnon*, lines 160–6, 176–83)

But in the *Eumenides*, the final drama of the trilogy, Aeschylus brings us out of the earlier dark irrationality into what seems an enlightened world of order and reason. Orestes, defended principally by Athena, the goddess most closely bound up with thought and progress, is tried before a court of Athenian citizens on the Areopagus in Athens, and is acquitted. Athena turns to the Furies, without hostility, urging them:

> not to bring about among my citizens the combative spirit
> of civil strife and hostility against one another;
> Let us unite in furious war, particularly against the man
> Who shall be dangerously enamoured of his own renown.
> (*Eum.* 862–5)

and reason and compromise win them over.

Without suggesting a simplistic allegory it seems possible to draw an analogy between the development of ideas in the *Oresteia* and the development of Early Classical out of Archaic Greek thought. The Archaic period, as I have suggested, was characterized by a search for a universal order and by an anxiety about the inexplicable mutability of human fortune. Its Furies had been, first, class strife, and arising from it repressive oligarchies and aggressive tyrants who tended to

direct the law rather than be directed by it; and second, the oriental monarchies which seemed to have the power to blot out the Greek world without even being aware of its nature. In the two decades following the Persian Wars it was possible, for an Athenian at least, to believe that these demons were being exorcised. An orderly democracy had been making steady progress in Athens since the overthrow of the Peisistratid tyranny in 510 B.C. Rule by restraint and law rather than personal power seemed to be becoming a reality. The defeat of the Persians had seemed a triumph of order and reasoned individual discipline over an irrational darkness which had hung over Greece like the curse over the Atreid line. And after 480 B.C. Greece, like Orestes, perhaps saw itself as escaping from the curse through reason and law. But the *Oresteia* was also produced in the aftermath of the controversy in Athens over the Areopagus court and of the murder of Ephialtes. That Aeschylus deliberately chose the Areopagus as the setting for the climactic scene of the *Eumenides*, in order to remind his audience of Athens' recent troubles, seems beyond doubt. The scene is a plea for an end to irrational violence and for an enlightened respect for the dignity of tradition. Without these, as Athena's final speech makes clear, the Athenians might bring the Furies down on themselves. The serious faces of Early Classical sculpture [4, 12, 17, 20] seem in a way aware that the Furies in Aeschylus' drama are quieted but not destroyed.

The temple of Zeus at Olympia, which was the most important architectural project in Greece proper during the Early Classical period, was completed between 470 and 456 B.C. Although actually financed and built by the people of Elis with the booty which they had won in a war with neighboring towns for control of the Olympic sanctuary, the temple was nevertheless a monument for all Greeks. Not only was it dedicated to their supreme god, but it stood in the most panhellenic of their sanctuaries. Its chief architect was Libon, a local man, but workmen, particularly stone carvers, from many parts of Greece must have been employed on it. The great sculptural groups in the pediments (over eighty feet long and ten feet high in the center) were of Parian marble. A single designer[3] may have been responsible for the plans of both of them, although the actual extant figures reveal the presence of many different hands – an absolute necessity in such a vast project produced in a relatively short period. Since the time when these sculptures were first discovered, beginning in 1876, there have been many suggestions as to their exact original arrangement in the pediments. No restoration has yet won universal

[3] Pausanias, who visited and described the temple in the second century A.D., seems almost certainly to have confused the information presented to him when he ascribed the pediments to the sculptors Alkamenes and Paionios, both of whom were active mainly between 430–410 B.C.

An assessment of some of the ascriptions of various figures from the pediments to different hands is offered by Karl Schefold *The Art of Classical Greece* (New York 1966) pp. 79–88.

acceptance in all its details, but one can still, while allowing for the possibility of small variations in the placement of certain figures, grasp the basic design, meaning, and effect of each pediment.

The east pediment group, which faced into the sanctuary of Olympia and toward the starting line from which the Olympic chariot races began, represented the story of the chariot race between King Oinomaos of Pisa and the young, wandering adventurer Pelops. Oinomaos had a daughter, Hippodameia, whom he coveted, some sources say incestuously, and did not want to lose. Whenever a suitor appeared for her hand, Oinomaos would challenge him to a chariot race from Olympia to the isthmus of Corinth. If the suitor, who took Hippodameia on his chariot and was given a head-start, won the race, he also won the bride, but if he was overtaken by Oinomaos, he was killed. Since Oinomaos had special arms and horses given to him by the god Ares, a number of suitors had met their end in this way. When Pelops arrived in Pisa Hippodameia fell in love with him and persuaded the charioteer Myrtilos, who was also in love with her, to sabotage her father's chariot by replacing its metal linchpins with pins made of wax. In the ensuing race Oinomaos' chariot collapsed and he was killed. Later Myrtilos, either in expectation of a promised reward or urged on by his own inclinations, made amorous advances toward Hippodameia, whereupon he was thrown into the sea by Pelops and drowned; but not, however, before he was able to call down a curse on the line of Pelops.[4]

The designer of the east pediment captures the elements of this story by showing us the moment just prior to the start of the race, when the participants are offering sacrifice, and presumably swearing an oath of fair-play, before the altar of Zeus. The god himself [10G, 11][5] stands in the center and looks towards his right (one can tell by the neck muscles on the extant figure), the propitious side, where the young, beardless warrior Pelops [10F, 11] awaits the beginning of the race along with a female figure who is in all probability Hippodameia [10E, 11]. She is raising her veil from her shoulders, perhaps as a symbol of her role as a bride, or simply in preparation for the journey ahead. To the left of Zeus stands the bearded king Oinomaos [10H, 11] with his mouth slightly open and his brow knit, and next to him another female figure whose arms are crossed and who seems to have been shifting uneasily from foot to foot [10I]. Bernard Ashmole has pointed out that the hair on the fragmentary head of this figure is thin and stringy, symptoms of

[4] A number of the details of the story vary. I follow here the version of Apollodoros *Bibliotheca* II. 4–8.

[5] Pausanias literally says 'an image of Zeus' (v. 10. 6), implying perhaps that we are to interpret the figure as a 'statue of a statue'. The same may also be true for the central figure of the west pediment.

advancing age. She must be Sterope, wife of Oinomaos, mother of Hippodameia. Both of these figures appear uncomfortable, as if aware that circumstances may be turning against them.

These central figures are flanked by chariot groups and by members of the retinues of Oinomaos and Pelops. The teams of horses were perhaps controlled by the figures of two boys, and behind each chariot, along with other figures, are two old men, probably to be interpreted as seers. The old man to the left [10B] is badly damaged, but the seer to the right [10K, 12] is well preserved and is one of the great, original, conceptions of Early Classical sculpture. Not only is the extreme adaptation of the figure's physical characteristics – his sagging body and bald head – to his dramatic role something new, but new also is the clear state of consciousness which he projects, setting him apart from all the other characters in the group. Seated behind the chariot of Oinomaos, he seems to stare at the axle into which the wax linchpins have been inserted. He, unlike the others around him, knows, through his prophetic powers, what has happened and what will happen. As he contemplates the implications of his knowledge he shrinks back in dismay. Like the chorus of the *Agamemnon*, he seems to have 'pondered everything' but is 'unable to find a way'. Just as the actions of Agamemnon, Clytemnestra, and Orestes were ambivalent, products of conflicting forces, and difficult to weigh, so too are those of the characters in this scene. Oinomaos is violent, guilty of bizarre sins, yet a victim of betrayal. Hippodameia, torn between love and duty, has betrayed him. Pelops, an instrument (whether knowingly or unknowingly is a variable point) in the foul-play against Oinomaos, is soon to murder the man who helped him to victory and bring a curse on his descendants. We know little of Sterope's feelings, but her loyalties must of necessity have been divided. And Zeus, standing in the center of it, the god before whom the competitors at Olympia swore an oath of honesty, what is his role? Is he the inciter or the judge, or both, of the action which is taking place? 'Strangely violent is the grace of gods who sit enthroned in holiness.' The old man who contemplates all this has sometimes been identified as Iamos, a seer of Apollo associated with Olympia, but one is instinctively inclined to see in him a visible counterpart of one of the awesome prophets of Greek drama – Calchas, as conjured up by the chorus in the *Agamemnon*, or Teiresias in Sophocles' *Oedipus Tyrannus*.

The two figures in the corners of the pediment are identified by Pausanias as embodiments of the Kladeos and Alpheios, the two rivers which ran by the Olympic sanctuary. The figure identified as the Kladeos [10M, 13] makes an interesting contrast with the seer adjacent to him. His peculiar thin, pointed, expressionless face seems to convey the impassivity of nature, uninvolved in the

problems arising out of human conflict. His also is an Archaic face, present but not reacting. One wonders if the designer of the pediment did not create this figure purely for the sake of contrast, to emphasize the new dimensions which he and his age were exploring in the figure of the old seer.

The taken as a whole the east pediment seems like an episode in a great dramatic cycle. As in drama, the violent action is to take place off-stage. We are confronted with a scene in which the implications of that action are to be pondered. There is a tension in the air. Conflicting motives drive on the characters to their fate. They exist at various states of anxiety and knowledge. There is a moral and religious problem in the scene which they contemplate according to their understanding and which we are forced to contemplate too. The pediment embodies not action, but thought.

The scene in the west pediment [10] of the temple of Zeus formed a marked and, probably, deliberate contrast to the east. It is full of violent action and an almost elemental pitting of right against wrong. The scene represents the battle of the Lapiths (early Thessalian Greeks) and Centaurs, which broke out at the wedding of the hero Peirithoös and his bride Deidameia. The Centaurs were wild creatures, half man and half horse, who lived in the mountains of Thessaly. Wine, to which they had very low resistance, brought out their animal side, and when they had consumed too much of it at Peirithoös' wedding party they attacked his bride and her handmaidens. The party broke up in a wild brawl in which Peirithoös and his comrade Theseus eventually subdued their savage opponents. The designer of the west pediment in all likelihood selected this story to express the triumph of human civilization – with the discipline and adherence to order which it required – over unthinking barbarism. In the center of the pediment stands the towering figure of a young god, who must be Apollo [10K].[6] He can be understood either as a statue within the scene, i.e. a statue representing a statue, or as an invisible spiritual presence. With a gesture of his right arm, without directly participating in the battle, the god who was the guardian of religious law and a patron of civilized institutions, the god who was also present with Athena at the trial in the *Eumenides*, seems to be decreeing order out of chaos. Theseus and Peirithoös, both figures now

[6] Pausanias does not actually identify the figure as Apollo, and a few scholars have challenged this interpretation, preferring to interpret the central figure as Peirithoös or as the young Zeus. But the identification as Apollo is almost certainly correct. There are cuttings in the figure's left hand which seem to have been intended for an archer's bow, one of Apollo's typical attributes. Pausanias, working from notes and attempting to harmonize information given to him by a variety of guides with his own memory, seems occasionally, and understandably, to have been guilty of errors of omission or misinterpretation. A summary, with bibliography, of the various suggestions about the 'Apollo' is given in G. Becatti *Il Maestro di Olimpia* (Florence 1943).

very fragmentary, must have stood on either side of him [10j, l], and next to them tangled groups of Lapith women and youths struggling with the aggressive Centaurs. Throughout these groups there is a deliberate contrast between the snarling, grimacing Centaurs and the self-controlled Lapiths [14 = 100, p], who, even in severe pain, struggle to bring their emotions under control. These faces call to mind the contrasts which must have been produced by masks in a dramatic performance, and one wonders if masks might not, in fact, have been their inspiration.

The west pediment, like the *Eumenides*, celebrates a triumph of rationality. It is another expression of what I have called the 'new confidence' of the Early Classical period and is a meaningful companion piece to the east pediment, which captures the underlying uneasiness of the period.

The new severity

The new spirit of Early Classical sculpture was accompanied, as our illustrations will have made obvious, by new ways of rendering details, by new systems of proportion, and by new patterns of composition – in short, by a new style. Modern critics often apply the term 'severe' to this style, and appropriately so. It is a style with few frills, with few ornaments which could be looked upon as delights 'for their own sake'. As the expressive intention is serious, so is the external form austere.

To make this point we need only compare one of the sprightly and dainty late Archaic *kore* figures, or, less dainty but equally ornamental in its schematic construction, the Athena from the west pediment at Aegina [15], with a standing female figure of the developed 'severe style' like the 'Hippodameia' [10E, 11] from the east pediment at Olympia or the 'Aspasia' type known in a number of Roman copies [16]. The smiling faces of the Archaic figures, their elaborate coiffures, the loving delineation of the contrasting textures of their tunics and cloaks are executed with a jeweler's love of detail and richness. By contrast, the Hippodameia has a massiveness and simplicity which is spiritually 'Spartan'. The proportions of her face, surrounded by a compact bonnet of hair which itself is composed of heavy, simple strands and ringlets, are almost square. She wears the Doric *peplos*, a heavy sleeveless woolen tunic, belted at the waist. Below the waist the garment hangs in heavy tubular folds which are reminiscent of the fluting of a Doric column and give the figure some of the solidity of architecture. The overfold of her *peplos*, from the shoulders to just above the waist, creates a massive and sparsely delineated surface which is almost like a shield. The little extra flourishes, the jewel-like details are gone. The same is true in perhaps an even more extreme

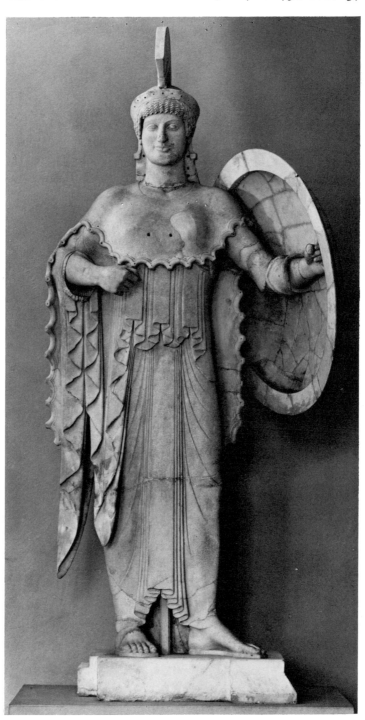

15. Aegina, Temple of
Aphaia, west pediment,
Athena, marble, *c.* 490
B.C. Height approx. 5′ 6″.

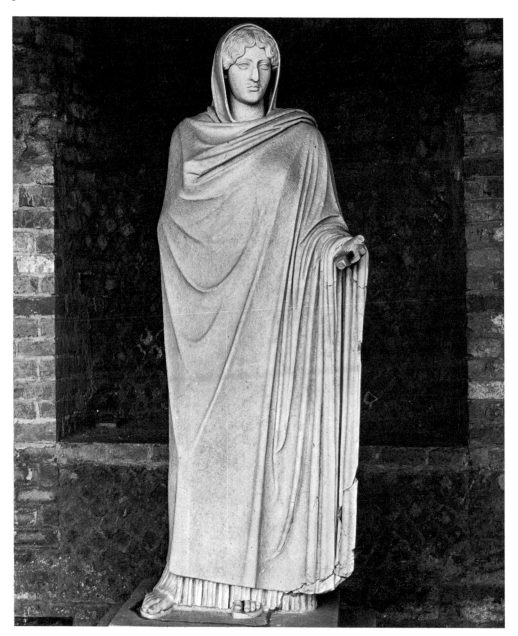

16. 'Aspasia' type, marble, Roman copy of an original of *c.* 460 B.C. Height with base approx. 6′ 1$\frac{3}{5}$″.

degree in the 'Aspasia' type, which provides a still closer comparison with the *korē* type since she wears a *himation* thrown over a lighter tunic. The *himation*, which in this case covers almost the entire body and even frames the face, is rendered in a

flat, wide plane running diagonally and vertically from shoulder to elbow and shoulder to ankle. The effect produced is that of a geometric shape, a polyhedron, resting on a finely fluted base, with only the toes projecting from beneath to give a human dimension. The sombre, hooded face with its hair running to each side in simple strands from a central part, also has a geometric exactitude. The 'Aspasia' type has sometimes been ascribed to the Athenian sculptor Kalamis, whose figure of a woman known as the 'Sosandra', 'saviour of men', was admired by Lucian for its noble simplicity. The Sosandra was perhaps identical with an Aphrodite dedicated on the Athenian Acropolis by Kallias, the wealthy brother-in-law of Kimon, after he had helped the latter to escape imprisonment for debt. It would obviously be satisfying to associate this most 'Spartan' of Early Classical figures with Athens' most pro-Spartan statesman, but the association is a purely speculative one.[7] Whatever its identification, the 'Aspasia' is one of the most successful realizations of the austere, controlled, meditative image which the Greeks wanted to see of themselves in an age when victory and tragedy were thought to be products of their own behaviour.

Perhaps the most consistent element in 'severe style' sculpture and painting, the feature which gives it its definitive stamp, is its characteristically 'moody' facial type which is already well-developed around 480 B.C. in the Blond Boy [17] from the Acropolis. Typical are the heavy jaw, full lips, the heavy lids surrounding the eyes, and the solid mass of hair hanging well down over the forehead. The Blond Boy is of particular interest because the painted pupils of the eyes are still sufficiently visible to give us an idea of its original expression.[8] Like many other Early Classical statues, it seems to have had a rather intense, open-eyed stare which was then muted and given a touch of melancholy by the heavy shadows of the eyelids.

[7] The identification of the figure with Aspasia, the mistress of Pericles, has no serious basis, and the use of the name for the type in question is purely conventional. A statuette of the type in the Metropolitan Museum in New York is inscribed with the name 'Europa', but it is not certain whether the name belongs to the figure represented or to the owner of the statuette. The fact that three of the twenty-three known copies come from Crete, where Europa was an ancient goddess and to which the mythical Europa was conveyed by Zeus in the form of a bull, has suggested to some that the name on the statuette is significant. Martin Robertson has proposed that the identification of the type as Europa is confirmed by the similarity between the New York statuette and a figure on a vase by the Kekrops Painter: cf. 'Europa', *Journal of the Warburg and Courtauld Institutes* 20 (1957) 1–3; for the vase see the *Corpus Vasorum Antiquorum, Deutschland* XI, pl. 46–52.

Still another suggestion is that the statue is to be connected with Demeter *Europē*, whose cult in Boeotia is mentioned by Pausanias (IX. 39. 4).

[8] It should be remembered that the eyes, lips, hair, and, at least at times, the skin of Greek stone statues were painted. The evidence for polychromy in Greek sculpture is analyzed in Gisela Richter 'Polychromy in Greek Sculpture', *American Journal of Archaeology* 48 (1944) 321–33; P. Reuterswärd *Studien zur Polychromie der Plastik: Griechenland und Rom* (Stockholm 1960).

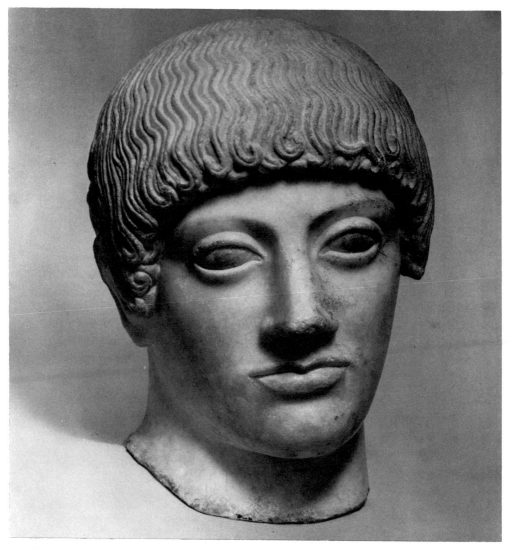

17. 'Blond Boy', marble, *c.* 480 B.C. Height approx. 9⅘″.

Compared to the typical archaic face, all these facial features seem compacted and tightly-knit. In the Blond Boy this effect arises, as Rhys Carpenter has pointed out, from a simple system of proportions in which multiples of basic horizontal and vertical modules (e.g. the width of the nose at the junction of the eyebrows) are applied to all the basic parts of the face. A uniform 3:4 proportion between all the vertical and horizontal dimensions of the face is at the root of its (literal and meta-

physical) measure and order. The new, increasingly squarish (or perhaps we should say 'foursquare') canon of proportions which we see under development in the Blond Boy seems to represent an adaptation of the 'feeling' of the severe style to an increasingly sophisticated tradition devoted to analysis of, and speculation about the significance of the interrelationships of the various parts of a work of art – a tradition which went back to the very beginning of Greek art (see pp. 5–6) and began to move in important new directions in the fifth century (see pp. 105–8).

The tendency toward a reduction in ornamental detail, toward a reduction of elongation in proportions, and toward a general simplicity of surface which we have seen in the sculpture of the Early Classical period can also be seen in the architecture of the time, particularly in the temple of Zeus at Olympia, whose great foundation and massive tumbled-down columns still convey the force and solidity which are so characteristic of its sculptures. We can get some idea of the compact and orderly impression which the temple of Zeus must have made when intact by looking at the remains of two nearly contemporary temples in the western Greek world which were clearly built in imitation of it, Temple E at Selinus in Sicily (recently reconstructed; probably a temple of Hera) and the Temple of Neptune (now generally agreed also to be a temple of Hera) at Paestum in Lucania [18]. Part of the secret of the compactness of Libon's design for the Zeus temple lay in

18. Paestum, Temple of Hera II, from the southeast, *c.* 460 B.C. Height of columns 29′ 1$\frac{5}{8}$″.

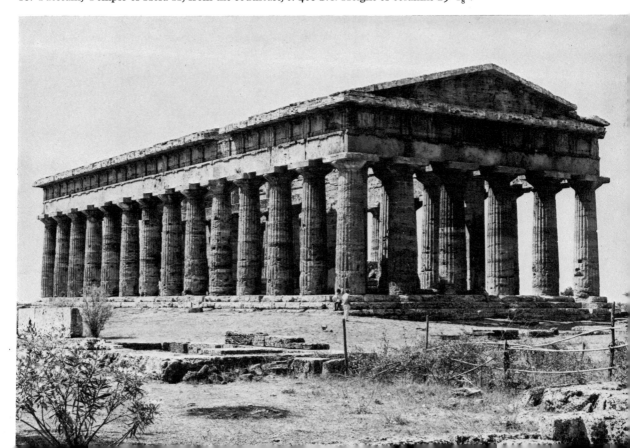

the frequent repetition throughout the structure of a basic module, or commensurate fractions of it, in a 2:1 proportion. This module was calculated in Doric feet, and the starting point from which all measurements were made was perhaps the basic interaxial (the distance from the center of one peripteral column to another measured at their bases) of 16 Doric feet. The columns were about twice this length in height, the triglyphs and metopes about half of it, the mutules and spaces between them about half of that, and so on up to the roof tiles. There were of course small variations and disparities in these measurements in different parts of the temple, but the overall impression of a quite simple *logical equivalence* presented by the structure as a whole must have had a strong psychological effect (probably consciously perceived by architects, subconsciously by others) on all who saw it. Like the Apollo of the west pediment, it connoted simplicity, balance, and measure superimposed on raw matter.

Proportion alone, of course, could not account for the effect of the Zeus temple, or of any Greek temple for that matter. Like Greek sculpture, the meaning of Greek temple architecture was always bound up with and enhanced by the context in which it was seen. The site, with both its topographical and man-made elements, is always, in conception, part of the temple, and Greek architects must have given thought to the question of how each temple, understood as an embodiment of the god whose treasures it housed, could be made to interact with the given environment. Exactly what this interaction connotes is, at Olympia as at other sites, largely a subjective matter. But certainly it would have been impossible to ignore the fact that within sight of the entrance to the temple of Zeus were: to the east, the starting lines of the Olympic stadium and hippodrome; to the south, the Olympic council chamber and an altar of Zeus at which the participating athletes swore a solemn oath of fair play; to the north, another altar of Zeus, dating back to the founding of the site and made from the compacted ashes of ancient sacrifices, an open air sanctuary dedicated to the controversial hero Pelops, and the long, low temple of Hera, the earliest Doric temple on the site and one of the oldest in Greece; and finally, bounding the entire sanctuary on the north, the hill of Cronos, the father of Zeus, with whom, according to Pausanias, Zeus himself was said to have wrestled in order to win control of Olympia. These surroundings undoubtedly called to mind a host of religious and historical complexities surrounding the cult of Zeus – the misty beginnings of Greek religion reflected in the conflicts of Zeus with his father and his consort (conflicts here in abeyance, just as the struggles between the Greek cities were suspended during the Olympic games); the founding of Greek cultural institutions, called to mind by the ash-altar and sanctuary of Pelops, who had contributed to the establishment of the games; and the age-old

struggle between law (sanctified, but ambiguously sustained by, the gods who received holy oaths) and the personal ambitions of men. Perhaps like the trial in the *Eumenides*, the stark geometry of the temple rising amid these ancient sites and structures was also felt to express the emergence of a new order out of a tangled inscrutable past.

If we try to sum up in a general way the motivating forces behind the 'new severity' of Early Classical art, we can point to two factors. One is an anti-traditional feeling, which in this period means to some extent an anti-oriental feeling. Archaic Greek art had never lost touch with the artistic traditions of the ancient Near East from which it had borrowed certain schemes of composition and a good many decorative details (e.g. the *kouros* stance, formal ways of rendering the hair, animal friezes etc.). After 480/479 B.C. the Orient was increasingly viewed as barbarous and contemptible; and Archaic art, which had been fostered in many cases by Greek tyrants who had been on good terms with the oriental monarchs and had set themselves up in power somewhat on the oriental model, was tainted by these associations. In renouncing strict patterns like the *kouros* stance and abandoning the aristocratic love of jewel-like detail in favor of a new repertoire of austerely unornate but flexible forms which could be used to express a sombre thoughtfulness, the Greeks finally achieved an artistic identity which was completely their own.

The other basic motivating force behind the style was the new emphasis on personal and group responsibility which we have already examined. In a world where it suddenly appeared that men had the power to create and preserve or destroy the conditions in which they lived, it was wise to present an appearance which was severe and seemingly undeluded by the external trappings of power.

Ethos and pathos

Up to this point in the present chapter we have studied the persistent interest in emotional expression which characterizes Early Classical art, the conditions which may have given rise to that interest, its relationship to contemporary Attic drama, and the changes in style which accompanied and served it. We should now look at some of the forms which the new expressiveness took outside of strictly dramatic contexts such as those which we encountered in the pediments at Olympia.

Ancient Greek psychology recognized two forces at the root of human emotional expression – *ēthos*, a man's 'character' as formed by inheritance, habit, and self-discipline, and *pathos*, his spontaneous reaction to experiences in the external world. In the fourth century B.C. and later, as we shall see, both writers and artists began to display and articulate an active interest in just what role these two aspects

of human expression should play in the arts. Xenophon in the *Memorabilia* (III. x. 1–5) records a possibly fictional but not thereby any less interesting discussion in which Socrates seeks to convince the painter Parrhasius that art is able to portray the soul, in the sense that it can capture character and emotional reactions in the faces of the figures it depicts. The elder Pliny, probably drawing on an earlier Greek source, praises the painter Aristeides of Thebes (second half of the fourth century B.C.) for having depicted 'characters (*ethe*) and also the emotions' (*perturbationes* – *pathe*) (*Natural History* XXXV. 98). Xenophon and Pliny's source were living in a period when the representation of emotional states was being rediscovered as the forces which had tended to suppress such representations during the High Classical period began to weaken (see pp. 143 ff.). In looking back over the earlier history of Greek art for a period in which they might find parallels for some of their own interests, the aestheticians and historians of this later era hit upon the Early Classical period and especially upon the work of the great painter Polygnotos of Thasos.

Pliny tells us that Polygnotos was the first painter to explore the possibilities of emotional expression by 'opening the mouth, showing the teeth, and giving variety to the face in place of its earlier rigidity' (*N.H.* XXXV. 58), and Aristotle, when he notes in the *Poetics* (1450a 24–8) that the dramas of his own time are weak in character-portrayal but that the dramas of an earlier era emphasized this quality, draws an analogy to painting by noting that the work of his near-contemporary Zeuxis was lacking in the representation of character but that the work of Polygnotos was strong in it. What we know of Polygnotos from other sources suggests that Aristotle's perception was acute. Pausanias has left us a detailed and lengthy description (x. 25. 1 ff.) of a cycle of paintings representing the aftermath of the sack of Troy (*Ilioupersis*) and a view of the Underworld (*Nekyia*), which Polygnotos executed for the people of Knidos in their club-house in Delphi. From Pausanias' description of the individual figures in these scenes it is clear that some were represented with a calm, contemplative mien in which their *ethos* was revealed, while others were representations of *pathos* emanating from suffering. In the former category could be classed scenes like: 'Briseis stands there with Diomede above her and Iphis in front of both of them; they seem to be scrutinizing Helen's beauty'; and in the latter category figures like Helenos who is 'shrouded in a purple cloak and looking extremely downcast' or Antenor and his family of whom Pausanias says, 'the look on the faces of all of them is that of people who have suffered a great disaster'. Polygnotos' work, like almost all ancient Greek mural and panel painting, has not survived, and the loss of it is especially regrettable since he seems to have been one of the fomenting, original forces in Early Classical art.

It has often been suggested that we can catch at least an echo of what his figures were like in scenes on a well-known *krater* by the Niobid Painter in the Louvre [19]. On one side of this vase Athena and Herakles are seen standing at ease on a hilly terrain in the presence of several warriors. The exact subject of this scene, if there is one, cannot be identified with certainty. Perhaps, as some have suggested, it represents a period of respite during the voyage of the Argonauts. In any case, no specific action is seen to be taking place; rather each of the figures is seen in a relaxed, thoughtful, and in the case of Herakles, majestic pose which conveys a 'presence', a thinking being whose *ēthos*[9] is being expressed by his external manner. While the scene as a whole cannot be taken as a copy of any known Polygnotan work, it seems quite possible that the Niobid Painter may have 'cribbed' a few figures from Polygnotos. The seated warrior who clasps his knee, for example, calls to mind Pausanias' description of the figure of Hector in the *Nekyia*: 'Hector is seated, clasping his left knee with both hands and represented in the attitude of one who grieves.'

The other side of the 'Niobid *Krater*' represents the slaughter of the children of Niobe, who are depicted as dead or dying, by Apollo and Artemis. The two sides of the vase taken together thus provide us with that contrast of character-study and *pathos* which was conspicuous in the paintings of Polygnotos, and also, as we have seen, in the two pediments at Olympia.

The expression of *ēthos* which was probably developed by artists like Polygnotos for use in narrative contexts quickly came to be used in free-standing sculpture in figures which were not part of narrative scenes. One of the best-known examples of it is the Charioteer of Delphi [20], whose serious, aristocratic, taut, self-control has called to mind for many critics the ideals celebrated in the Epinician Odes of Pindar, the other great poetic voice, along with Aeschylus, of the period. The charioteer, one of the few original full-scale bronzes surviving from the fifth century, is actually only a fragment of a votive group, which also included a chariot, horses, and a groom. It was dedicated by Polyzalos, tyrant of Gela in Sicily (and brother of one of Pindar's patrons, Hieron of Syracuse), after a victory in the chariot races at the Pythian games of either 478 or 474 B.C. and stood within the sanctuary of Apollo just northwest of the temple of the god himself. The viewer was perhaps

[9] The Greek word *ethos* means simply 'character', good or bad, but because the sort of *ēthos* which is depicted in Early Classical art often impresses us as lofty and meditative, modern critics of Greek art have sometimes used the term to mean specifically 'loftiness or nobility of character' (e.g. Ernst Pfuhl *Masterpieces of Greek Drawing and Painting* (New York 1955) p. 57). Unfortunately this modern interpretation of the term is sometimes read into ancient passages where it does not really apply.

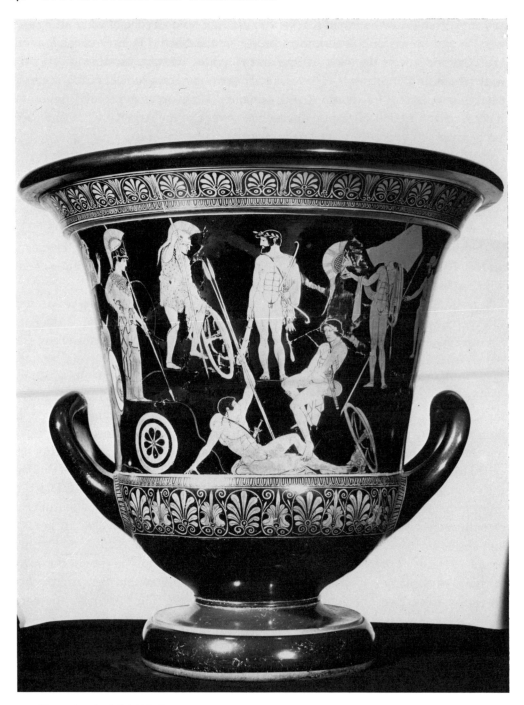

19. *Krater* by the Niobid Painter, *c.* 460–450 B.C. Height 21¼".

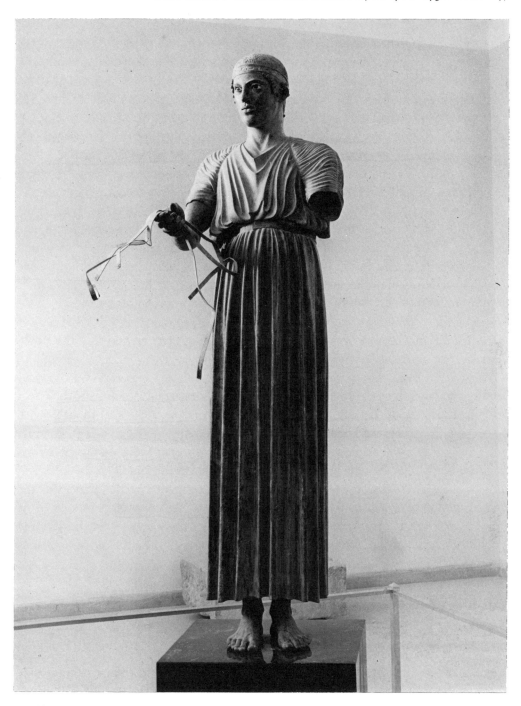

20. Charioteer of Delphi, bronze, c. 478–474 B.C. Height 5′ 11″.

supposed to think of the chariot as proceeding at a slow and dignified pace in a ceremonial victory procession. The charioteer[10] wears the typical costume of his profession, a tunic belted well above the waist and fastened down by a band running over each shoulder and behind his neck (both features being designed to minimize any unnecessary blowing about of the exposed part of his garment while the chariot was in rapid motion). Its essentially simple, but beautifully and subtly varied folds over the shoulders and chest help to remind us that this stately figure's triumph involved a rapidity and excitement which is now being held in check. The lightness in the drapery contrasts with the charioteer's austere face which seems to concentrate, proudly but unassumingly, on the reins by which he controls the victorious team. It is easy to see how the charioteer could be taken as an embodiment, in the visual arts, of one of the odes of Pindar. Not only does it celebrate, like the *Pythian Odes*, a victory won at the festival games at Delphi, but the *ēthos* which it conveys is a manifestation of Pindaric *aretē* (or *areta* in Pindar's dialect), the 'innate excellence' of noble natures which gives them proficiency and pride in their human endeavors but humility before the gods. In the charioteer we are confronted with a definable *ethos* which is neither aloof, as the High Classical period will often be, nor remote and neutral like the Archaic, but rather, like the Early Classical era, simultaneously proud and vulnerable.

The Early Classical sculptors' ability to create a noble 'presence' was used to equally good advantage in their images of deities. Compare, for example, the effect made by the figure of Athena in the Metropolitan Museum in New York [21][11] with the Athena from the west pediment of the Aphaia temple at Aegina [15]. In spite of its fragmentary condition and the scars of repair (apparently ancient) to its face, the New York Athena conveys the exalted yet approachable and communicative nature of the guardian goddess in a way that puts it worlds apart from the smiling goddess of the pediment. This blending of loftiness and awareness is equally apparent in other images of the period, for example the majestic striding 'god of Artemiseion' [22] and, perhaps most engagingly of all, in the representations

[10] The Charioteer is not to be understood as Polyzalos but as a professional driver who, like the jockey of today, was in the service of the owner of the victorious horses. It is possible, although there is no evidence for it, that a statue of Polyzalos also stood in the chariot. In some of the monuments which Pausanias saw at Olympia, the owners had themselves represented in their chariots (see, for example, Pausanias VI. 18. 1).

[11] Opinion is divided as to whether the figure is a Greek original or a Roman copy. The face was broken off and repaired in Antiquity. The oblique, two-level cutting on the top of the head apparently supported and was covered by a Corinthian helmet. The dowel hole on the left shoulder suggests that the goddess held a spear. On the problems associated with this figure see G. M. A. Richter *Catalogue of Greek Sculptures in the Metropolitan Museum of Art* (Cambridge Mass. 1954) pp. 24–5.

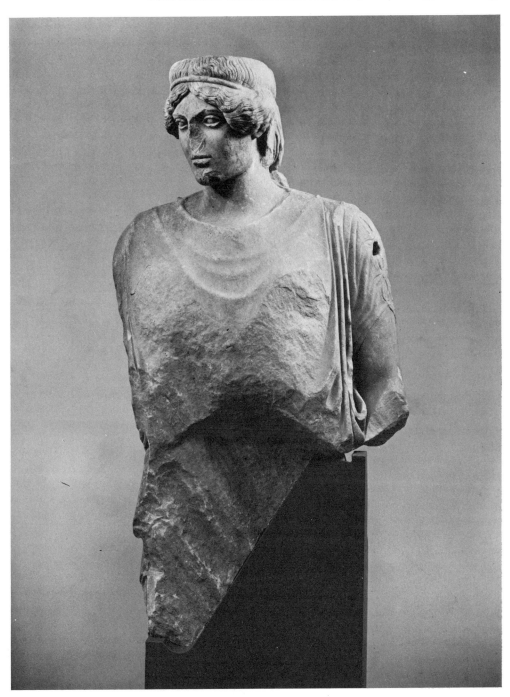

21. Athena, marble, *c.* 460 B.C. Height as preserved 4′ 3¾″.

of Athena as the helpmate of Herakles on the metopes of the temple of Zeus at Olympia.

These twelve metopes, which represent the labors of Herakles, bring together the distinctive features of the art of the period – simplicity of surface (even allowing for painted details), subtlety of expression, the fusion of *ēthos* and *pathos* – in their most highly developed form. In the faces of Herakles, who is seen at the beginning of his labors as young, eager, but uncertain [23a], at the end as mature, weary, but triumphant [23b], and in the course of them as disgusted [23c], wary [23d], or excited, the sculptors seem intent on conveying to us both what kind of man the hero basically is (*ethos*) and also what he has had to endure (*pathos*). Athena, depending on the circumstances, is seen as his stern ally or as the gentle, even sweet, acknowledger of his achievements. The combination of divine majesty and human sympathy on the face of the goddess, as she turns from her duty as guardian of the citadel to receive the Stymphalian birds from Herakles, has no equal in Greek art [24].

We can put the greatness of the Olympia metopes into perspective by taking a brief look at a nearly contemporary group of metopes from Temple E at Selinus in which the external forms of the severe style are competently handled (allowing for the survival of a few archaic features, like the appearance of zig-zag folds in the drapery) but the informing spirit has not really been grasped. In the metope representing the seduction of Zeus by Hera during the Trojan War, the sombre and majestic figures of the deities jar incongruously with the irremediably farcical (thanks to Homer) nature of the subject. In the representation of the death of Actaeon the effect is, if anything, worse [25]. The sculptor here seems to have borrowed from Olympia the idea of having a goddess present at the trial of a hero. But instead of the sublime Athena of Olympia we have a brutish Artemis who seems to take a moronic delight in Actaeon's frantic struggle with the yapping hounds, a scene which, for all its intended seriousness, has a touch of burlesque. The Selinus metopes give us an almost perverse mishandling of the potentialities of the severe style.

As a final point in connection with the representation of character in Early Classical art we must take note of one development which, though its origins are obscure and controversial, probably had its beginning in this period: the rise of realistic portraiture. The Archaic period had produced statues which represented specific individuals (e.g. the Anavysos *kouros*), but it seems doubtful that these bore any real resemblance to the person in question. The Roman literary tradition occasionally makes reference to portraits by Archaic artists (e.g. Theodoros of

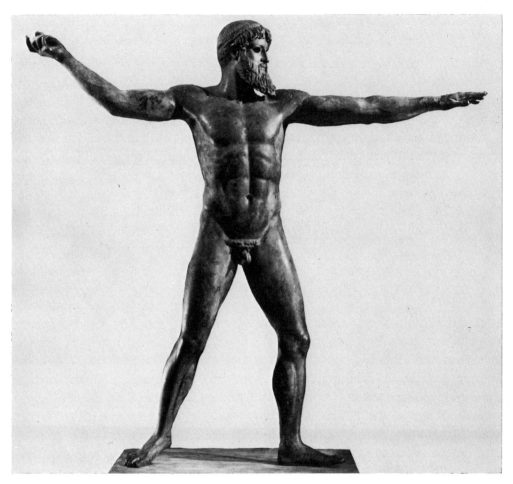

22. Striding God of Artemiseion, bronze, *c.* 460 B.C. Height 6′ 11″.

Samos),[12] but the authority and validity of such claims are dubious. We do know that the Athenian sculptor Antenor made a group representing the tyrannicides Harmodios and Aristogeiton, and that this group was set up in a public place in Athens after 510 B.C., but it was carried off by the Persians in 480 B.C., and we have no record of what it looked like. In the case of the new 'Tyrannicides' group by

[12] The Anavysos *kouros,* as the inscribed epitaph on its base informs us, represented a warrior named Kroisos who fell in battle, perhaps one of the civil struggles connected with the tyranny of Peisistratos, probably in the third quarter of the sixth century B.C. Cf. G. M. A. Richter *Kouroi* (second edition, London 1960) pp. 118–19, figs. 395–8, 400–1.

For Archaic portraiture preserved in the literary tradition cf. J. J. Pollitt *The Art of Greece: 1400–31 B.C. (Sources and Documents in the History of Art)* (Englewood Cliffs, N. J.) pp. 19, 22–3.

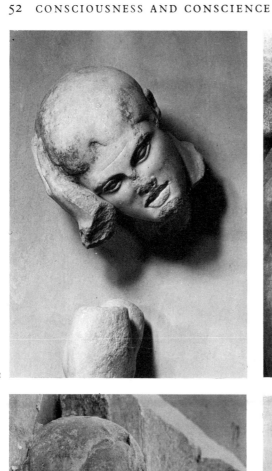

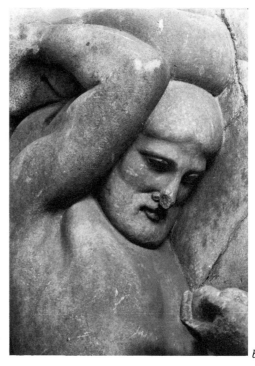

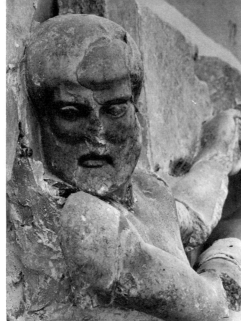

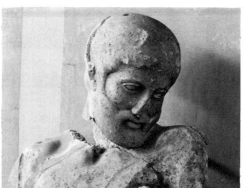

23. Olympia, Temple of Zeus, heads of
Herakles from the metopes: (*a*) Nemean Lion,
(*b*) Atlas and apples of the Hesperides,
(*c*) Augean stables, (*d*) Cerberus; marble,
462–457 B.C.

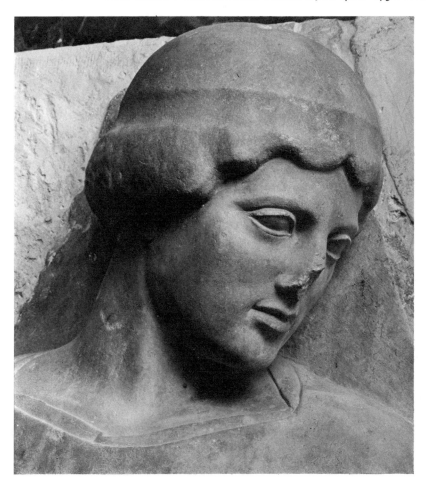

24. Olympia, Temple of Zeus, head of Athena from the Stymphalian Birds metope, marble, 462–457 B.C.

Kritios and Nesiotes, set up after 480, it is impossible to say whether we are dealing with actual likenesses or simply with archetypal figures of a youth and a mature man.

There is, however, a portrait of Themistokles, preserved in a Roman copy[13] at Ostia [26], which, with its simplicity of surface and rather abrupt linear divisions, does seem to derive from the Early Classical period. It also strikes one very much as the face of a specific individual and not simply a type, and is not inappropriate for the patriotic, but ambitious and cunning, leader who outwitted the Persians

[13] The Greek original, like all Greek portraits in the Classical period, would have been full-length (i.e. a body as well as the head). The copyist has abbreviated it into a portrait-bust surmounting a quadrangular shaft, the arrangement which the Greeks used principally for 'herms'.

and both saved and troubled the Athenians. Ancient writers mention several portraits of Themistokles, one of which stood in his own temple of Artemis in Athens and could conceivably have been set up by Themistokles himself (Plutarch *Life of Themistokles* 22). Since we are dealing with a Roman copy, where dating by stylistic details can be treacherous, some have doubted that the original was actually as early as certain features of the copy make it appear,[14] but on the whole the argument for an Early Classical date seems stronger than the argument against it. If realistic portraiture did originate in the fifth century, the Early Classical period, with its interest in showing *this* world with its varying types of character and emotion, would be the logical time.

Movement and pictorial space

Just as the confidence of the Early Classical world, its growing belief that meaning and order could be found in the world of immediate experience, had led to an expanded range of emotional expression, so also it seems to have given rise to an interest in the creation of a broader spatial environment in which figures could be seen to move, as well as to think and react. Along with this quest for a wider 'stage' went a desire to make figures in motion seem more 'real' without sacrificing the rational, definable order which was felt to be essential for a successful artistic composition.

In painting this new focus of interest is reflected in efforts to expand pictorial space and create a setting which was more expansive and varied than the simple base line, with men and objects upon it, of Archaic art. In sculpture it is reflected in the cultivation of an aspect of composition which the Greeks called *rhythmos*.

As was the case in the development of emotional expression, the leader in the movement to develop pictorial space seems to have been Polygnotos. In Pausanias' description of his paintings at Delphi, which we have previously discussed (p. 44), figures are described as being 'above' or 'below' one another, sometimes standing, sometimes seated on rocks, clearly implying that they were distributed over a kind of terrain. And once again the Niobid *Krater* [19], on which we see all the figures distributed over a hilly terrain made up of fine undulating white lines, seems to preserve a record of Polygnotos' work.

It also seems to have been in the Early Classical period that the Greek painters undertook their first experiments in perspective (the apparent diminution of objects in proportion to their greater distance from the viewer). According to

[14] The various arguments are reviewed in G. M. A. Richter *Greek Portraits, A Study of their Development* (*Collection Latomus* xx, 1955) pp. 16–21. A new publication with detailed photographs of the Ostia herm by A. Linfert appears in *Antike Plastik* VII, pp. 87–94.

Vitruvius (VII. praef. 11) the painter Agatharchos of Samos painted a stage setting for one of the dramas of Aeschylus and in doing so made use of the fruits of his observations of the natural laws of vision. The resultant paintings were of such a sort that, in Vitruvius' words, 'although all things represented are really figures on a flat vertical plane, some appear to be in the background, and some in the foreground'. We are also told that Agatharchos wrote a commentary on his work and thereby had an influence on the philosophers Demokritos and Anaxagoras, who were likewise interested in the question of perspective. The truth of this tradition that perspective was first subjected to experimentation in paintings for stage

25. Selinus, metope from Temple E representing the Death of Actaeon, limestone, with the head, arms, and feet of Artemis in marble. Height 5′ 4″.

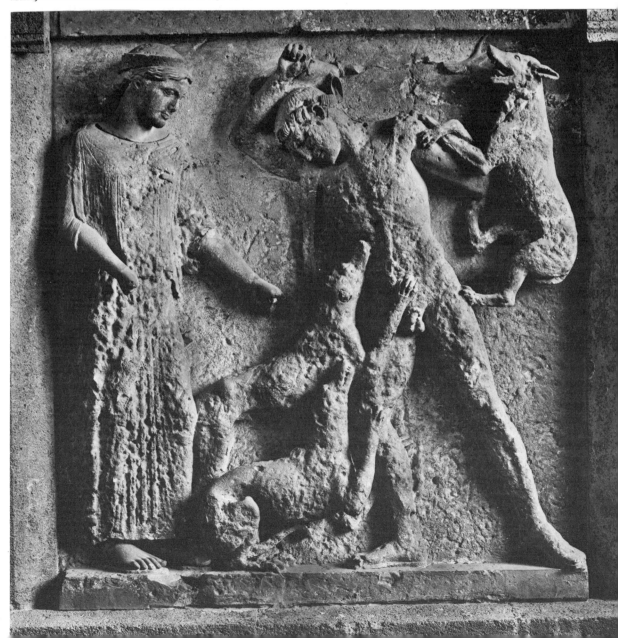

settings seems to be attested by the Greek word for it: *skenographia* (literally 'the painting of stage buildings'; more generally 'scene-painting'). Since there is no evidence of any systematic use of perspective in vase painting until later in the fifth century, we must assume that it took several decades for the effect of these early experiments to be generally felt among Greek painters.[15]

With its resistance to ephemerality and its insistence on a clear definition of parts, the Archaic style in sculpture had not encouraged experiments in the representation of motion. Motion suggests a transition from one condition to another, hence mutability. By the beginning of the sixth century B.C. the sculptors of the Archaic period had isolated a few *schēmata* for depicting motion (like the whirligig pattern for running figures with the upper torso shown frontally and the hip and legs shown in profile), 'designs' which were more in the nature of symbols (one might almost say 'ideas') of motion than depictions of it. Even in the last thirty years or so of the Archaic period, when some of the painters in the new red-figure style became fascinated with depicting foreshortened views of the human figure, the artist's interest was much more in the altered appearance of the body when motion varied its 'pose' rather than in the nature and definition of motion itself.

It was perhaps the new significance attached to human action in the Early Classical period which inspired a reassessment of how motion could be represented. Motion was the concomitant, the physical expression, of action. As with emotion, there seems to have been a feeling that the representation of it should become more vivid and immediate and yet not become so fleeting that it began to defy rational analysis. The concept around which new order for the representation of motion was organized was *rhythmos*. The basic meaning of this word was 'shape' or 'pattern'. It seems to have become associated with music (as has its modern descendant 'rhythm') because of its connection with dancing. A dancer, moving in time with music, performed specific 'steps' in time with the 'beat' of the music. Between each step there were momentary 'stops' (called *erēmiai*) in which the body was

[15] On the development of the rendering of perspective in Greek vase painting see John White *Perspective in Ancient Drawing and Painting* (Society for the Promotion of Hellenic Studies, Supplementary Paper no. 7, London 1956).

The *floruit* of Agatharchos is usually put in the second quarter of the fifth century B.C. because Vitruvius connects him with a performance of one of the dramas of Aeschylus, who died in 456 B.C. It is not impossible, however, that Agatharchos was connected with a posthumous revival of one of the poet's dramas and that his date should be reduced somewhat. Other literary testimonia (Plutarch *Life of Alcibiades* 16; *Life of Pericles* 13) seem to connect him with the last quarter of the fifth century. On the other hand, if he did influence Anaxagoras, as Vitruvius says, he is most likely to have done so around 450 B.C., before the philosopher's expulsion from Athens. The date of Agatharchos, in short, is a problem.

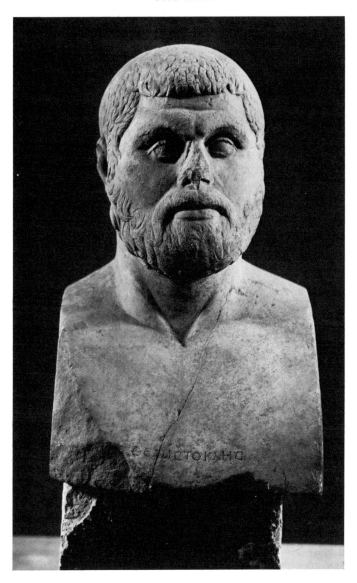

26. Portrait of Themistokles, marble, Roman copy from an original of *c.* 470 B.C. Height approx. $19\frac{7}{10}''$.

held for an instant in characteristic positions. The positions were *rhythmoi*, 'patterns' isolated within continual movement. A single, well-chosen *rhythmos* could, in fact, convey the whole nature of a movement. One might give the analogy of a painting of a pendulum-clock. If the artist depicts the pendulum in a diagonal position, in the process of swinging to either the right or left, the viewer instinctively understands that the pendulum is moving; whereas if it is depicted in a vertical position, he is uncertain as to whether it is moving or not.

According to Diogenes Laertios, the first sculptor to 'aim at' *rhythmos* was Pythagoras of Rhegion (on whom see p. 107), apparently one of the most influential artists of the Early Classical period.[16] The acknowledged master of *rhythmos* among the ancient sculptors, however, seems to have been the sculptor Myron, who was born at Eleutherae on the Attic–Boeotian border but whose artistic home seems to have been Athens. Pliny's assertion that Myron was *numerosior in arte* than Polykleitos is perhaps an attestation of this achievement (*N.H.* xxxiv. 58). *Numerus* was a common Latin translation of *rhythmos*, and we may assume that Pliny's Greek source had referred to Myron as *rhythmikōteros en technēi* or some such phrase, i.e. 'more rhythmic in his art', with all that that implies. Appropriately enough the most vivid example of a particular *rhythmos* used to define an entire movement in Greek sculpture is the *Diskobolos* ('Discus thrower') of Myron. The original *Diskobolos*, a bronze produced around 460 B.C., has not survived, but its appearance can be reconstructed with reasonable accuracy from a literary description (Quintilian II. 13. 8–10) and from a number of Roman copies, mainly in marble, of which the best is the 'Lancellotti *Diskobolos*' [27]. The discus-thrower is represented at the high point of his backswing, the point where, like a pendulum, his motion is arrested for a split second before he lunges forward. The viewer cannot mistake what the motion is; a single *rhythmos* has captured the whole action. Just as *symmetria* (see p. 106) gave rational order to form, *rhythmos* gave rational order to motion.

The principle of *rhythmos* applied in the *Diskobolos* will be found to turn up in many works of the Early Classical period, once one begins to look for it. The 'Tyrannicides' by Kritios and Nesiotes, for example, a bronze group set up in the Agora in Athens in 477 B.C. and now known through Roman copies in various media, strike one almost as diagramatic illustrations from a text-book describing the positions a swordsman should assume in slashing, thrusting, and parrying. Likewise in the east pediment of the temple of Aphaia at Aegina figures like the 'Herakles as an archer' and the lunging figure to the left of him [5] seem to be caught in a characteristic 'stop'. Herakles has pulled the bow taut and steadies himself by exerting a forward pressure with his left leg. In a split second the arrow will be released and both he and the bow will be relaxed. The lunging warrior has landed with all his weight on his right leg and is poised for the moment when the falling warrior to the left will collapse into his arms. This falling warrior and his

[16] For an attempt to explain what the *rhythmos* of Pythagoras may have been, based on the evidence of Roman copies, coins, statuettes, and other material, cf. Ch. Hofkes-Brukker 'Pythagoras von Rhegium: Ein Phantom?' *Vereeniging tot Bevordering der Kennis van de Antieke Beschaving* (1964) 107–14.

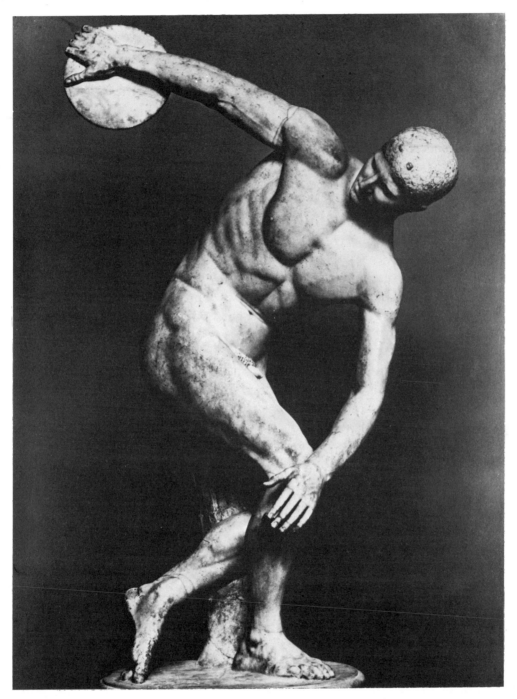

27. *Diskobolos* of Myron, Roman copy in marble of a Greek original of *c.* 460 B.C. Height approx. 5′ ¼″.

twin on the other side of the pediment are preserved only in fragments; assuming that they are correctly restored[17] in our illustration [5], they constitute one of the most vivid examples of the stopping of a characteristic motion.

While we are on the subject of motion in this pediment we might note the overall unity of movement which it exhibits when compared to the older west pediment [5]. Whereas the battle in the west pediment is broken up into separate groups and its central Athena stands out with a smiling unconcern, the east pediment shows a single sweep of composition in which each figure leads naturally to the next, and the combatant groups on each side of Athena are linked by her striding position and by the aegis on her extended left arm. *Rhythmos* seems to have been instilled into the pediment as a whole.

Two decades or more later, in the great bronze 'god of Artemiseion' [22], the quality of *rhythmos* has become more natural and less diagrammatic but is still very much in evidence. With a powerful but seemingly effortless movement, his left arm provides balance and direction while his right arm is poised for a moment before hurling a missile – be it the trident of Poseidon or the thunderbolt of Zeus[18] – into the distance. The *rhythmos* and the *ēthos* of Early Classical sculpture are harmonized.

Archaism and mannerism

'Perspective', since it is an aspect of a varied and shifting environment rather than of an immutable, ideal condition, is one of the key factors in Early Classical art. Dramatic perspective becomes characteristic of many of its products; its painters began to make use of actual spatial perspective. It is therefore perhaps not surprising that this should be the first period in which Greek artists showed signs of being able to see their own style in historical perspective. Such perspective

[17] The restoration of these figures in a falling position was deduced by Furtwängler (see above, p. 19, n. 1) from the holes for the insertion of large metal supports in the back of the torso of 'H' and also from the position of the remaining portions of the legs and feet of both figures.

[18] Both deities were depicted in this pose – Poseidon on the coins of Poseidonia (Paestum), Zeus on the coins of Elis. While it is obviously fatuous to consider the figure a Poseidon simply because it was found in the sea, the dogmatic assertion that it must be a Zeus because the trident of Poseidon would pass in front of the figure's face and spoil its composition is equally unconvincing. We do not know the conditions under which the figure was originally displayed. If it stood on a high base, its face would not have been blocked for the viewer looking up at it. In any case, it is doubtful that there was only one angle, i.e. the side view, from which the figure had to be viewed.

Parallels to the Artemiseion statue in statuettes and in vase painting are collected and analyzed in Christos Karouzos 'The Poseidon of Artemiseion', *Archaiologikon Deltion* 13 (1930–1) 41–104 (in Greek). Karouzos concluded that the figure represents Poseidon because the grip of the right hand is inappropriate for the thunderbolt of Zeus but quite natural for a trident. The case for Zeus is argued by George Mylonas 'The Bronze Statue from Artemiseion', *American Journal of Archaeology* 48 (1944) 143–60.

about artistic styles is often characteristic of very self-conscious ages, like the Early Classical period and like our own.

A frequent symptom of historical perspective and self-consciousness among artists is archaism, the interest in reviving and playing with earlier styles. It is not uncommon today for an artist to work at one time in an abstract style, at another in a neo-classical or neo-medieval style, and at still another in an impressionist style. Archaism in Antiquity was never so varied as it is today, nor was it ever used in quite the same virtuoso-like way, but it does have a long history in Graeco-Roman art. Its principal flowering came in the late Hellenistic period and, especially, in Hadrianic art, but its roots, like so many other innovations in Greek art, are traceable to the period between 480 and 450 B.C., when it is quite apparent in the work of a group of Attic vase painters, of whom the foremost was the Pan Painter.

The Pan Painter could and did paint in a full-blown Early Classical style, but he often chose to use a style which employed many of the mannerisms which had been common in Attic red-figure around 490 B.C., for example the use of neat zig-zag patterns rather than the normal broad tubular forms of the Early Classical period for the folds of the drapery, and the use of highly stylized gestures rather than facial expression to convey dramatic action. All these features can be seen in the depiction of the death of Actaeon on the Pan Painter's 'name piece',[19] a bell-*krater* in Boston [28]: the cloak over Artemis' shoulders is rigidly, if pleasantly, patterned (compared to the more free and natural folds in Actaeon's cloak); her step is that of a graceful dancer; her face, with its small mouth and the simple almond-shaped eye with a black dot for an iris (compared to the eyes of 'Penthesileia' [9] in the cup by the Penthesileia Painter) is highly simplified; Actaeon's agony is all mannered, ornate gesture.

What made the Pan Painter turn back to a style which had been in vogue thirty years before his own time? One suspects that it was partly because he sensed that the new developments in large-scale painting were inimical to vase painting and strained the limits of its technique. Vase painting was basically a matter of decorating the surface of household objects; the illusion of spatial recession clashed with the inescapable feeling of solidity associated with the surface of a vase; and subtle, dramatic expression probably tended to become obscured or to be felt inappropriate in wine cups and water jars. It seems likely that the Pan Painter was attempting to reassert the importance of the purely decorative function of his art. But it is probably also true that he perceived a certain quaint character in the vases

[19] The other side of the vase depicts a rustic, bawdy scene in which Pan is pursuing a shepherd boy. Cf. L. D. Caskey, J. D. Beazley *Attic Vase Paintings in the Museum of Fine Arts, Boston* II (London, Boston 1954) no. 94, pp. 45–51.

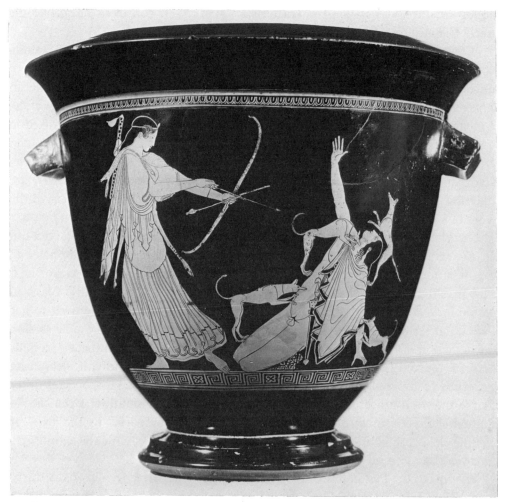

28. *Krater* by the Pan Painter, *c*. 470 B.C. Height approx. 14⅗″.

made by the painters a generation before him and found a certain nostalgic pleasure in recreating it in his own more ambitious age.

Vase painters were much freer than sculptors to indulge their private artistic whims. A statue may take months, even years, to produce and each step in its production requires careful planning. The average vase painter perhaps produced thousands of paintings in the course of a career. There must have been times when boredom and the urge to 'try something a little different' became very strong; from such times, one suspects, arose not only the sophisticated archaism of the Pan Painter but also occasional caricatures, the interest in obscure myth, and the pure

burlesque, which turn up in the Early Classical as well as in practically every other period of Greek vase painting. Sculpture, on the other hand, was too costly a medium to permit the indulgence of whimsicality, and it seems doubtful that we find any true archaism in Early Classical sculpture. The metopes from Temple E at Selinus, it is true, have some Archaic features, but these are probably to be explained by a lag in development between the creative centers on the Greek mainland and the far edges of the Greek world. The Apollo from the west pediment at Olympia has a rather old-fashioned looking arrangement of curls over his forehead and also some rather hard, schematized details in the musculature of his chest. However, whether one interprets these features as true archaism (the creative use of old forms for new expression) or simply as an example of archaeological accuracy depends on how one interprets the significance of the Apollo in the pediment. If the Apollo is understood as a 'statue of a statue' (see p. 33, n. 5), we must conclude that the sculptor was probably simply attempting to reproduce the appearance of a cult image of an earlier era.

Archaism is really a subdivision of the broader phenomenon in art usually called 'mannerism'. A mannerist style is one in which a certain manner of representation or a certain technical characteristic is consistently repeated or exaggerated to the point of affectation. It may be that there are traces of mannerism in the Early Classical period in addition to the clear-cut case of archaism. The expression of 'noble *ēthos*', for example, which is so completely integrated with the content of great works like the Olympia sculptures, seems at times to have become an almost automatic gesture added for its own sake and without any particular concern for the context in which it occurs. This is true, it seems to me, on a good many figures on Early Classical vases, for example the Maenad (supposedly ecstatic and at least, one would think, annoyed) struggling with a satyr on a fragment of a white-ground cup by the Pistoxenos Painter in Taranto. One senses that the noble and serious *ethos* of the Early Classical style might have degenerated into an artificial, bored gentlemanliness, had not the great artists who gathered around Pericles and Pheidias in the 440s revitalized it by making it one of the traits of Periclean humanism.

3 The world under control

The Classical moment, c. 450–430 B.C.

The two opposing poles, confidence and doubt, around which the thought and expression of the Early Classical period gravitated, were by nature in conflict. In Athens during the first two decades after the middle of the fifth century, the scale seems to have tipped in favor of confidence, the belief that men could shape their world in accordance with their own vision of it. It was not so much a matter of man being raised to the level of unchanging divinity, which seems to have been the intent of the Kleobis and Biton, as of unchanging divinity being brought into the world of man and harmonized with it.

A number of forces helped to create this atmosphere of self-belief in the High Classical period: the psychological legacy of the victory over the Persians was still active; there was an anthropocentric drift in Greek philosophy away from concern with the physical world and toward a preoccupation with human society; and the prosperity and power which accrued to Athens from her Aegean confederacy undoubtedly gave some Athenians at least a new sense of well-being. But none of these factors, individually or in concert, can completely explain the new frame of mind. The heady effects of the victory over the Persians were dimming; the anthropocentric drift in philosophy was as much a result as a cause of the new era; and Athens' rise to power was beset with as many set-backs and frustrations as triumphs. What was needed to make all these forces effective and reap their fruit was a will to believe and spokesmen to articulate that will. The Great Believers and also the spokesmen were Pericles the son of Xanthippos and the artists like Pheidias and Sophocles who helped to make the Periclean vision real by giving it witnessable form.

Periclean Athens

Not all Classical art is Athenian nor are all the characteristics of Classical Athens attributable to Pericles, but without Athens Greek art would not have become

what it did and without Pericles Athens would not have been what it was. As the leader of the dominant faction Pericles exerted an influence on the course of Athenian politics from as early as 460 B.C. until his death in 429. The constitutional position which he most often held was that of a *strategos*, one of the ten generals of the Athenian military forces. Working from this relatively modest post he devoted virtually all the energies of his mature lifetime to a single aim: the glorification of Athens as a political power and as a cultural ideal. In order to assure the continuance of the city as a political power, he was committed to the nationalistic imperialism which had driven Athens to adapt the Delian League to her own uses; and to enable the city to fulfill his vision of it as the exemplary cultural center of Greece, he became a patron of philosophy and the arts. By subsidizing and encouraging the visual arts in particular he hoped to create the physical setting which would symbolize and be part of Athens' greatness. The measure of his success is attested by the fame which the monuments of Periclean Athens still enjoy, a fame which was shrewdly predicted by Thucydides (I. x. 2), when he remarked that if Sparta were to be laid waste its remains would give posterity little impression of its power, 'but if the same misfortune were to overtake Athens, the power of the city, from its visible remains, would seem to have been twice as great as it is'.

Perhaps in order to have some respite from the land battles of the 450s and to consolidate Athenian gains, Pericles cooperated in the recall of Kimon from exile (around 455 B.C.) and used the veteran commander's connections with Sparta to work out the five year truce (452/451 B.C.) previously mentioned (see p. 26). Kimon was then dispatched on a naval expedition to Cyprus where the remnants of Persia's Phoenician fleet had been harassing Greek settlements, and in 449 B.C., while the expedition was still in progress, he died. Kimon had stood for accommodation with Sparta and a continuation of aggressive action against the Persians, and whatever pressures he may have exerted on Pericles toward these goals were now removed. The Persians were no longer a serious threat; to continue campaigning against them was wasted effort, but to abandon the force which the Athenians had organized against them meant the abrogation of Athens' new power and prestige. Pericles made a decision, realistic but not altruistic, which committed Athens once and for all to her imperialistic policy. In 449/448 B.C. he arranged a peace treaty with Persia but did not abandon control of the tributary allies.

One of the products of the formal end of hostilities with Persia was the Periclean building program. As a result of an oath sworn by the Greeks before the battle of Plataea not to rebuild the monuments burned by the Persians but rather to leave

them in their ruined state as a reminder of the impiety of the barbarian,[1] there was little building activity in Athens between 479 and 450 B.C. But peace with Persia made this oath seem less binding, and Pericles now decided to rebuild the temples and public buildings of Athens both as monuments to Greece's victory over 'barbarism' but also, and perhaps even more important in Pericles' mind, as visible expressions of Athens' new status in Greece. The program was financed in part by Athens' own resources but also in part by the treasury which legally was to be used only for the coordinated actions of the Delian League. The distribution of this money to what must have been thousands of workmen, traders, and contractors meant prosperity as well as glorification for Athens. Pericles justified it to the allies at first by maintaining that as long as Athens gave them protection and security there was no need for them to worry about how their money was spent. Later in life, he seems to have inclined to the more idealistic (if no more satisfying, from the allies' point of view) idea that Athens had created an exemplary society and that the allies were privileged to be associated with it. The practical and idealistic aim of the program and the nature of its achievement are vividly described in these excerpts from Plutarch's detailed description of it in the *Life of Pericles* 12–13:

Now that the city was sufficiently supplied with the necessities for war [Pericles maintained that] they ought to devote the surplus of the treasury to the construction of these monuments, from which, in the future, would come everlasting fame, and which, while under construction, would supply a ready source of welfare by requiring every sort of workmanship and producing a wide variety of needs; these in turn would call into service every art, make every hand busy, and in this way provide paid employment for virtually the entire city, thereby ornamenting it and sustaining it at the same time ... As the works rose, shining with grandeur and possessing an inimitable grace of form, and as the artisans strove to surpass one another in the beauty of their workmanship, the rapidity with which the structures were executed was marvellous ... There is a certain bloom of newness in each work and an appearance of being untouched by the wear of time. It is as if some ever-flowering life and unaging spirit had been infused into the creation of them ... Pheidias directed all the projects and was the overseer of everything for him [Pericles], although there were also great architects and other artists employed on the works.

As the usurpation of the treasury of the Delian League might suggest, the political events of the period between the signing of the peace with Persia and the outbreak of the Peloponnesian War in 431 B.C. contrast in an almost dismal way

[1] This clause of the oath is preserved by Diodorus XI. 29. 3 and Lycurgus *Against Leocrates* 81. As a matter of conscience it should be pointed out that the authenticity of the oath, as well as the Peace with Persia, was questioned by the ancient historian Theopompos, and modern historians, after years of controversy, are still divided on the point.

with Pericles' vision of Athens and the great buildings which were created to express it. The 'unseen war' between oligarchic (and usually anti-Athenian) and democratic factions which ran throughout the fifth century and often had a more decisive effect on the history of the various Greek cities (including, eventually, Athens itself) than did actual military confrontations, soon began to disrupt Athens' recently acquired holdings on the Greek mainland. Pericles' failure to quell oligarchic *coups d'état* resulted in the loss in 448–446 B.C. of Boeotia, Phocis, and Megara, and the near loss of the rich island of Euboea. The pressure of these events constrained Athens to seek a new peace with the Peloponnesian alliance led by Sparta. In 446/445 B.C. a thirty years' peace treaty was signed, but to obtain it Athens had to cede the ports on the Corinthian Gulf in the Megarid and Achaea which she had won in the 450s B.C. The prospects for an Athenian land empire had vanished.

As a result of these reversals Pericles seems to have decided that Athens should confine her energies to consolidating her maritime empire and should not compete actively with the Spartan alliance for territorial control on the mainland. The power which the Athenian fleet exercised in the Aegean islands and the coast of Asia Minor, Thrace, and parts of the Black Sea was now supplemented by a series of colonial outposts settled by Athenian citizens, and at the same time a basis for colonial and commercial operations in South Italy and Sicily was established. The decision to concentrate all efforts on maintaining their 'overseas' holdings turned out to be, from the Athenians' point of view, both opportune and effective. In 440/439 B.C. they were able to put down dangerous revolts against their confederacy in Samos and Byzantium. But the policy also led them into a series of conflicts with Corinth, the only Peloponnesian city which had extensive commercial interests overseas. When Corcyra, an early colony of Corinth, became embroiled in a quarrel with its parent city, Athenian ships, allied with the Corcyraeans, actually met the Corinthians in a naval battle off the south coast of Corcyra. In the same year Potidaea, a city in the Chalcidice which was a Corinthian colony but had been made a tributary ally of Athens, revolted from Athenian control and was besieged by an Athenian force. In the wake of these and other events the 'Thirty Years Truce' deteriorated. A council of the Peloponnesian allies at Sparta decided upon war and in the spring of 431 B.C. they invaded Attica and ravaged the land, rendering it henceforth useless as a source of food supply. The Athenians who had lived on the farms and in the villages of the country-side withdrew behind the walls of Athens and Peiraeus for safety. Following Pericles' strategy the Athenians decided not to oppose the Spartan land army but countered instead with a series of naval operations against the coast of the Peloponnesos and

the islands adjacent to it. The complex and wasting Peloponnesian War, which, with periodic truces, was to last a generation and alter drastically the Greek cultural psyche, was under weigh.

At the end of the first year of the war Pericles was selected to make a public funeral oration in honor of the Athenian soldiers who had fallen in the first campaigns. This famous speech, as Thucydides (II. 34–46) presents it, captures better than any other document the ideals of Periclean Athens and the spirit which pervades its art. Athens is depicted as the one society where justice applies equally to all and where social restrictions do not prevent a man from becoming as great in public life as his natural capacity permits; submission to law and authority and acceptance of the dangers of war are maintained voluntarily, without force and without complaint; power and discipline are balanced by a free intellectual life and a buoyant spirit; the functioning of the society is open for all to see; neither secretiveness nor suspicion exist. Such a society was a paradigm, Pericles felt, for all societies, the 'school of Hellas'. If it controlled others, it did so by virtue of innate merit, and its subjects therefore could have no cause for complaint.

The Funeral Oration is the high water mark in that tide of humanistic optimism which had been growing in Greece since the Persian War. Implied in it is the belief that man can shape the world to his own vision of it; that an ideal pattern can be made manifest in this world by human action; that the irrational and the chaotic can be overcome by conscious effort. The year 430/429 B.C. was the last time that an intelligent Athenian was able to adhere fervently to this doctrine. In 429, a plague, both physical and mental, struck Athens.

Man and the measure of all things

The confident belief in the value of human thought and action which is expressed in Pericles' Funeral Oration was part of a broad intellectual current in the second half of the fifth century B.C. and extends beyond the confines of Athens. In Greek philosophy it is most clearly articulated in the Sophist movement. The Sophists were a diverse group of itinerant teachers, scholars, and eccentrics who differed widely from one another in the details of their doctrines and activity, but were unified as a group by a common emphasis on the importance of *human perception* and *human institutions* in interpreting experience and establishing values. The tendency of Greek philosophy in the Archaic period, as we have said, was to search for a rational order, a *kosmos*, which was beyond the fallibility of human perception and the mutability of the human condition. The willingness of the thinkers of the Classical period to reverse this trend and bring the *kosmos* 'down

to earth' seems to be a reflection of the humanistic confidence of the age.

The most influential of the Sophists was Protagoras of Abdera (*c.* 480–410 B.C.) whose well-known dictum 'man is the measure of all things' has sometimes been expanded beyond its original context to serve as the motto of the Classical period as a whole. What Protagoras actually seems to have meant by this phrase was that all knowledge is subjective, that is, dependent upon the mind and sense organs of the individual, and that objective knowledge which discounted the perceiver is impossible. Each man's personal subjective experience became the standard by which judgements about the nature of existence, knowledge, and ethics were to be made. From this point of view a 'thing' was what it 'seemed' to be; the 'real' nature of an 'object' became a matter for subjective determination; man, and not an absolute standard outside of him, was the measure of it. This attitude, though it might at first seem to be a purely technical point of epistemology, has broad implications which can be extended not only into politics and morality (cf. Plato's critique of the idea in *Theaetetus* 151e–179b) but also into the history of art. Whether by direct influence or by a more general association 'in spirit', Greek sculpture in the Classical period, and the Parthenon sculptures in particular, show a tendency toward subjectivism in the design of sculptural form, that is, a tendency to think of sculptures not only as hard, 'real' objects known by touch and by measurement but also as impressions, as something which is in the process of change, a part of the flux of experience, bounded not by solidity and 'hard edges' but by flickering shadows and almost undiscernable transitions [34, 41, 42]. We shall return to this point below.

The doctrine of man as the measure of all things, however, can be, and was, also taken to imply a kind of general anthropocentrism, somewhat similar to that of Italy in the fifteenth and sixteenth centuries, in which human institutions, human endeavor, and human achievements are of more consuming interest than cosmological abstractions. One of the fruits of the anthropocentric attitude was the rise of a belief in human progress and the consequent belief in the possibility of a 'golden age'. A doctrine of cultural evolution which saw mankind as progressing, with the help of *technē* (usually translated as 'art' but meaning, more precisely, the orderly application of knowledge for the purpose of producing a specific, predetermined product), from the state of primitive food-gathering to the civilized condition represented by the Classical Greek *poleis*, was perhaps principally developed by Protagoras and other Sophists (cf. Plato *Protagoras* 322a–c) but passed beyond purely philosophical circles and became one of the general topics of discussion among thoughtful men in the fifth century. It occurs in poetic form in the *Prometheus Bound* of Aeschylus (lines 476–506), but its most

impressive rendering is in the first *stasimon* of Sophocles' *Antigone*, where the idea of cultural evolution is incorporated into a hymn to man:

> There are many wonders, but none more wondrous than man.
> Across the white-capped sea in the storms of winter
> this creature makes his way
> on through the billowing waves.
> And earth, the oldest of the gods,
> the undecaying and unwearied one, he wears away
> with constant ploughing, back and forth, year after year,
> turning the soil with horses he has bred.
>
> Carefree flocks of birds he brings under his control,
> herds of wild beasts, and creatures of the sea,
> caught in the coils of his woven nets,
> this resourceful, skilful man.
> He masters with his inventions the free-roaming
> beast of the mountains, and the shaggy-maned
> horse, broken for the bit, harnessed about the neck,
> and the untiring mountain bull.
> Language, thought swift as the wind, and the patterns
> of city life he has taught himself, and escape from
> the shafts of storms, and the shelter-piercing frosts of clear days.
> He can cope with everything, never unprepared whatever
> the future brings. Only from death does he fail to contrive escape.
> Even for diseases thought hopeless he has figured out cures.
>
> Clever, with ingenuity and skill beyond imagining,
> He veers now toward evil, now toward good . . .
>
> (lines 332–68)

Leaving aside the ominous implications of the last lines of this passage (implications which were to become more meaningful to Sophocles and others as time went on), the hymn reflects the spirit of Periclean Athens in its hey-day, when man's ability to create the society he wanted to live in must have seemed unquestionable. The *Antigone* was produced in 442 B.C. Protagoras must have been in Athens lecturing about the nature of society and progress in and around that year, since he is said to have been commissioned by Pericles to draw up the constitution of the panhellenic colony of Thurii, settled in 443 B.C. And the Periclean building program, giving physical embodiment to Athens' belief in itself, was in full swing. In this year, in fact, a team of sculptors under Pheidias' supervision may have begun to carve the Parthenon frieze, which in many ways occupies the place in the visual arts which Sophocles' choral ode holds in literature.

The Parthenon

Among the buildings which the Persians destroyed when they sacked the acropolis of Athens in 480 B.C. were two temples of Athena: one, located closer to the north slope on what was perhaps at an earlier time the site of a Mycenaean palace, dedicated to Athena *Polias*, and dating from about 520–510 B.C.; the other a marble temple which had been begun after 490 B.C. and was still in an early stage of construction at the time of the sack, situated toward the south slope, and dedicated to Athena in her aspect of *Parthenos*, the warrior maiden [29, 30].[2] The administrators of the Periclean building program intended to replace both of these buildings and turned their attention first to the temple of Athena *Parthenos* because the foundations of the temple which had been under construction in the 480s were still sound and some of the marble column drums and blocks, which had already been quarried on Mt Pentelikon in Attica and transported to Athens, were still fit to be carved and used.

Among many great creations of the Periclean building program the Parthenon [31], as this new Doric temple came to be called at least as early as the fourth century B.C., was the monument which most vividly embodied the experience and aspirations of its age. It was constructed between 447 and 432 B.C. when Athens' power was at its peak and the Peloponnesian War had not yet taken its spiritual and economic toll. The chief architect of the temple was Iktinos, who was assisted by Kallikrates, perhaps an Ionian and a specialist in the Ionic order, and perhaps by others. Pheidias, the general overseer, as we have seen, of the Periclean building program, undertook to do the colossal gold and ivory cult statue of Athena and probably designed the architectural sculptures.[3]

[2] In referring to 'Athena *Polias*' and 'Athena *Parthenos*' and also to the temples on the Acropolis as 'the Parthenon', 'the temple of Athena *Polias*', and the 'Erechtheion', I am following the conventional usage of modern archaeology and not necessarily the ancient nomenclature, for which the evidence is quite complicated. The relevant information is collected and analyzed in a lucid monograph by C. J. Herington *Athena Parthenos and Athena Polias* (Manchester 1955). Herington suggests that two goddesses, an agrarian mother goddess (=Athena *Polias*) and a warrior maiden (=Athena *Parthenos*) may originally have been worshipped on the Acropolis but that by the fifth century their identities had been fused into a single 'Athena'. The state religion of the Classical period recognized the existence of only one goddess on the Acropolis. The cult ceremonies associated with her seem to have focused almost exclusively on the northern sanctuaries (i.e. the temple of Athena *Polias* and its successor, the Erechtheion). The Parthenon, with its great cult image and elaborate sculptures, seems to have been deliberately designed, as Herington has suggested, as a vehicle for the expression of peculiarly Periclean ideals.

[3] The question of whether Pheidias was the designer of the architectural sculptures of the Parthenon and, if so, of how thorough his designs were, is a debated one among modern critics. Some feel that the artists sometimes had no more than general verbal instructions, others suggest that rough sketches on papyrus or parchment may have existed, while others hypothesize plastic models of some sort. On the whole, the frieze and pediments of the Parthenon seem to suggest a master

In the design of the building itself it is often difficult to draw a line between practical necessity and deliberate intention, since Iktinos seems subtly to have exploited the former in the latter. Practical necessity dictated a fairly wide temple in order not to cramp Pheidias' great cult image, and the foundations of the pre-Persian Parthenon had thus to be extended to the north. Practical considerations also compelled Iktinos to make use of several hundred unfinished column drums from the old Parthenon and thus to be restricted to the proportions of those drums. On the other hand, the preferred standards of proportion of the Classical period, which Iktinos himself must have helped to formulate, would have in any case demanded a temple which was wider in proportion to its length than the late Archaic Parthenon had been. The temple of Aphaia at Aegina, for example, which is perhaps an earlier product of the architectural workshop to which Iktinos belonged,[4] had had a peristyle arrangement of 6×12 (six columns at the ends of the temple and twelve on its longer flanks) and a stylobate with a proportion just slightly more than $2:1$. The temple of Zeus at Olympia (see pp. 32 ff.) was 6×13 and had a stylobate of approximately 91 by 210 feet, the underlying principle seeming to be that, if length and width are divided into even units, the length should be twice the number of units of width plus one. Starting with the dimensions of the older column drums, Iktinos worked out a plan for the new Parthenon in which the '2:1 plus 1' principle of commensurability runs throughout the temple. Its colonnade is 8×17, and a $4:9$ proportion characterized its basic dimensions: e.g. the stylobate (approximately 101×228 feet), the proportion of the height of the order (up to the horizontal cornice) to the width of the temple, the diameter of the columns to the interaxial, and the proportion of the width of the cella to its length (excluding the *antae*). Practical necessity, in other words, seems to have been accepted as a challenge by Iktinos, and from what was potentially a limitation he created positive virtues. This pervasive proportionality in the Parthenon, it should be emphasized, was not simply the result of a kind of metrician's game, worked out as an intellectual exercise; the *symmetria* principle, the principle of 'commensurability' (see pp. 106–7), was seen, by some Greeks at least, as a potential source of philosophical illumination because it made manifest the abstract ideas which formed the substratum of immediate existence.

design more obviously than the metopes. For an excellent analysis of the 'design problem' applied specifically to the metopes but also applicable to the other sculptures, cf. F. Brommer *Die Metopen des Parthenons* (Mainz 1967) pp. 178–81.

[4] The Aphaia temple, situated very near Athens, is the earliest structure in which there are substantial traces of the refinements (e.g. inclination of the peristyle; thickening of the corner columns) which are used with such astonishing subtlety in the Parthenon. The slenderness of its columns also perhaps connects it with the 'Ionicizing' trend in Athenian Doric visible in the Athenian treasury at Delphi as well as the Parthenon.

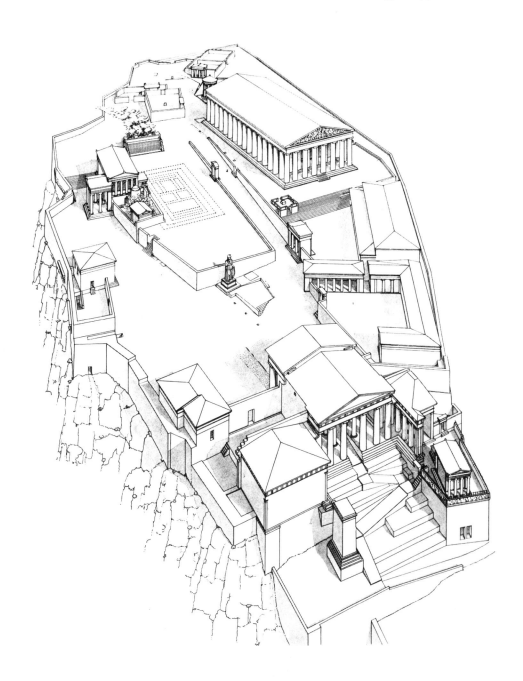

29. Acropolis of Athens as seen from the northwest. Restoration by Gorham P. Stevens.

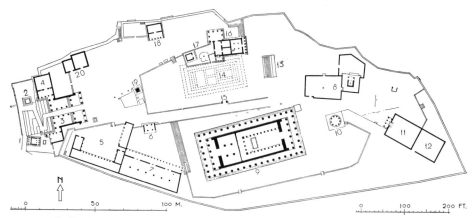

1. Nike Temple. 2. So called Monument of Agrippa. 3. Propylaea. 4. Picture Gallery. 5. Sanctuary of the Brauronia Artemis. 6. Propylon. 7. Chalkotheki. 8. Precinct of Zeus Polieus and Boukoleion. 9. Parthenon. 10 Temple of Roma. 11. Heroon of Pandion. 12. Service. 13. Great Altar of Athena. 14. Old Temple of Athena. 15. Propylon. 16. Erechtheum. 17. Pandroseum, Temple of Pandrosus, Sacred Olive Tree, Cecropium. 18. Dwelling of the Arrephori. 19. Promachos. 20. Service Building (?).

30. Acropolis of Athens, plan by Gorham P. Stevens.

But the Classical period was not an age in which pure abstraction, divorced from the real world of human life and action, was of all-consuming interest. Man was the measurer, and things had to be measured in the light of his experience. It is perhaps this basic intellectual predisposition more than anything else which accounts for the subtle and intentional variations from mathematical regularity which run throughout the Parthenon. These are evident in the curvature of supposedly straight lines, the inclining of vertical members away from true verticality, and variations in the 'normal' dimensions of individual parts of the temple. The stylobate, for example, curves upward so that at the center on the flanks it is more than 4 inches higher than at the corners, and on the ends more than 2 inches higher than the corners. The whole stylobate thus forms a subtle dome. This curvature, moreover, is carried up into the entablature [32]. The columns of the peristyle have an inward inclination of more than 2 inches, including the corner columns which incline diagonally. This inclination is also carried up to the entablature, where a few elements, however, counteract it by inclining outward, e.g. the abacus of the column, antefixes, *akroteria*, and horizontal cornice. The columns at the corner of the temple are thickened by nearly 2 inches and the

intercolumniations adjacent to them are contracted more than 2 feet. These delicate variations meant that virtually every architectural member of the Parthenon had to be carved, like a jewel, to separate, minute specifications. The uniformity which systematic mensuration normally makes possible was obviated.

What motive was thought to justify the incredibly painstaking and time-consuming carving which these variations made necessary? The answers which have been proposed to this question in Antiquity and later fall into three essential theories which might be called the compensation theory, the exaggeration theory, and the tension theory.[5]

The first of these suggestions goes back to the Roman architect Vitruvius who maintains, for example, that 'if a stylobate is laid out on a level, it will appear to the eye to be hollowed out' (III. 4. 5), that corner columns should be thicker 'because they are completely set off against the open air and [without compensatory thickening] appear to be more slender than they are' (III. 3. 12); and who adheres to the general principle that *quod oculos fallit*, 'with regard to that in which the eye deceives us' (III. 3. 11), e.g. an apparent 'sag' of the stylobate or other horizontal lines, *temperatione adaugeatur*, 'addition should be made by calculated modulation' (III. 3. 13). Vitruvius holds, in other words, that the subtleties of the Parthenon are what the Greek writers on optics called *alexemata*, 'compensations' or 'betterments', to counteract optical illusion. Even if one finds Vitruvius' explanation of Greek architectural refinements less than completely satisfying, there is at least one strong reason for not ignoring him altogether. He claims to have had at his disposal a treatise written about the Parthenon by Iktinos and a certain Karpion (error for Kallikrates?). From what we know of ancient treatises on architecture (see Vitruvius' list, VII. praef. 12), they dealt principally with questions of engineering and proportion. It seems likely that Iktinos' treatise would have been of this sort and that in it he would have explained in detail the basis for both his system of *symmetria* and its variations. The assumption upon which the Vitruvian view is built, of course, is that the Greek architects wanted all the elements of their buildings to look 'regular' and 'correct' – e.g. horizontals should look horizontal, verticals vertical, columns should appear to be the same size – and that the function of the refinements was to make the appearance of the temple fit their mental conception of it.

It is possible, however, to take a completely anti-Vitruvian view of the nature of the refinements and hold that the architects' purpose was to make the temple look quite different from what it actually was. If one looks at a horizontal line from

[5] On the sources, ancient and modern, for the theories described here cf. W. H. Goodyear *Greek Refinements* (New Haven, London, Oxford 1912).

below, for example, as one would have with most of the horizontals of the Parthenon, it is normal optical experience that the line appears not to sag but rather to bow upward. And the longer the line the greater this upward curve seems to be. It is possible, therefore, that the curvature of the stylobate of the Parthenon, for example, was intended to amplify normal optical distortion so that the temple appeared to be more immense than it actually was. A similar explanation could be used to explain the entasis of the columns and a diminution in width of the metopes in proportion to their nearness to the corners of the building (the latter not carried out, however, with complete consistency). One objection to this approach is that it implies a kind of obvious and theatrical aspiration toward bigness, a feeling that bigness is itself desirable, which while it had some adherents among the tyrants of Greek Sicily, does not seem to fit what we know of the artistic taste of Periclean Athens.

Still a third interpretation of the refinements is that they are intentional deviations from 'regularity' for the purpose of creating a tension in the mind of the viewer between what he expects to see and what he actually does see. The mind looks for a regular geometric paradigm of a temple with true horizontals, right angles etc., but the eye sees a complex aggregate of curves and variant dimensions. As a result, the mind struggles to reconcile what it knows with what the eye sees, and from this struggle arises a tension and fascination which make the structure seem vibrant, alive, and continually interesting.

31. The Parthenon, from the northwest, 447–432 B.C. Height of columns 34' 2¾".

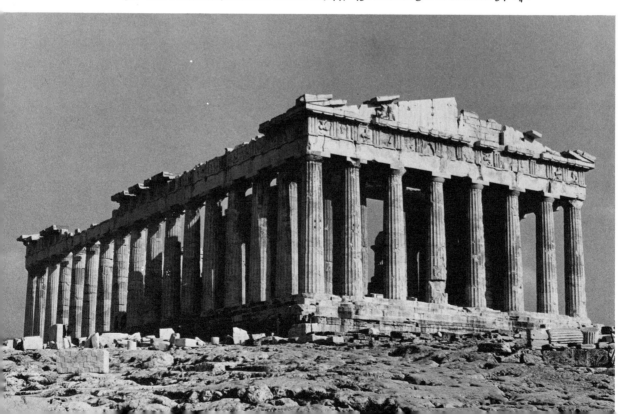

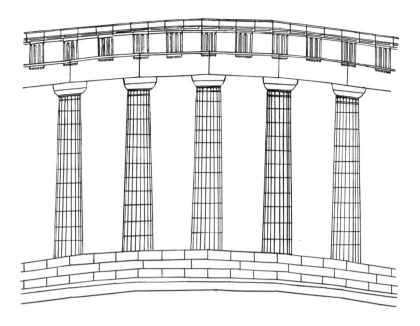

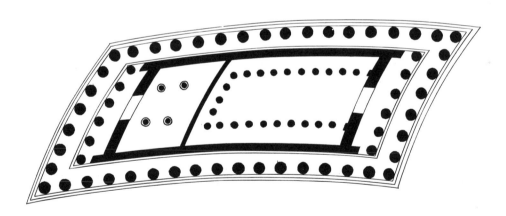

32. Diagram in exaggerated proportion of the horizontal curvature of the Parthenon. The upper diagram is based on N. Balanos, *Les Monuments de l'Acropole*, pl. 2, fig. 2.

It is not impossible that all three of these interpretations of the Parthenon's refinements have some validity and played a role in creating the temple's total effect – the thickening of its corner columns, for example, is almost certainly a compensation for optical distortion, and the curvature of horizontals may help to give the building an extra dimension of grandeur – but it is clearly the third which seems to reflect most naturally the intellectual experience of the age. It suggests that in the Parthenon things as they *appear* are harmonized with things as they are *known*. *Alētheia*, 'reality' as known by abstraction (e.g. mathematical proportions), is presented as the basis of *phantasia*, experience of things through the medium of our senses and brain. The new world of Protagoras is brought into balance with the older world of Pythagoras – the foremost of several fusions of opposites which make the Parthenon the most vivid and comprehensive embodiment in the visual arts of Classical Greek thought and experience.

The subtlety and originality of the exterior of the Parthenon is also carried into its interior [plan 30]. Its *pteroma* (the ambulatory between the cella and the exterior colonnade) was very narrow and within it at either end one was brought up against the front and rear porches (*pronaos* and *opisthodomos*) whose six sizable (almost 33-feet-high) Doric columns must have seemed to stretch across the entire width of the temple creating the impression of a closely-packed grove of columns similar to those in the great Ionic temples of Asia Minor. This Ionic impression would have been reinforced by the continuous sculptured frieze, an Ionian architectural form, which ran above the columns and their purely Doric architrave around the entire exterior of the cella. Passing through the *pronaos* into the *naos*, the main room of the cella facing east, one again confronted an enveloping colonnade, this time consisting of superimposed Doric columns which not only framed Pheidias' great cult image along its sides (as the interior colonnade at Olympia would have done with his Zeus) but also ran behind the image (a device not required for the practical job of supporting the ceiling) forming a kind of columnar exedra around the image. This interest in exploring the effects which could be produced by the manipulation of architectural elements in interior space had not been a characteristic of most earlier Greek architecture; after the Parthenon, as we shall see, it became increasingly common, and Iktinos continued to be its most brilliant exponent (see pp. 126–9). Behind the *naos* was another large room (entered from the west through the *opisthodomos*) which served cult purposes and was the *Parthenōn* proper. Its ceiling was supported by four large columns which, judging by their lower diameter in proportion to the height of the ceiling, must have been Ionic.

If we keep these Ionic details in the interior of the temple in mind and look

again at its exterior, we can perhaps sense there too an Ionic feeling. The slender columns of the peristyle (the height being 5·48 times the diameter of the column at its base, compared to 4·7 at Olympia) seem to instill some of the elongated Ionic grace into the Doric order; and the octastyle façade calls to mind the wide fronts of the temples of the Ionian world in contrast to the compact hexastyle arrangement of most Doric temples.

This fusion of Doric and Ionic forms in the Parthenon was undoubtedly intended to express one of the qualities of Periclean Athens. On a mundane level, it called to mind the fact that although situated on the essentially Dorian mainland, Athens claimed kinship with the Ionians of the Cyclades and Asia Minor, and the basis of its newly-won political power resided to a great degree in these areas. And on an idealistic level it was Pericles' conviction, enunciated in the Funeral Oration, that Athens had managed to 'cultivate refinement without extravagance and knowledge without softness' (Thucydides II. 40). The Ionic order called to mind the luxury, refinement, and intellectualism of Ionia; the Doric was associated with the sombre, stolid simplicity of the descendants of Herakles in the Peloponnesos.[6] In a temple which embodied Athens, it was natural that Pericles should want the two to be harmonized.

The sculptures of the Parthenon were integrally bound up with the building's form and meaning and are inseparable, in form and execution, from its architecture. From epigraphical evidence it can be determined that the external metopes were executed during the period from 447 to about 442 B.C., that the internal frieze was worked on mainly between 442 and 438 B.C. (when Pheidias' cult image was dedicated), and that the pedimental groups were essentially finished by 432 B.C. During this fifteen-year period we must visualize what must have been a small army of sculptors, assembled from different parts of Greece and having different technical backgrounds, moving from project to project under Pheidias' supervision, watching one another at work, absorbing and exchanging ideas, competing with one another in displays of skill, and eventually developing a common spirit and a

[6] Aside from a perhaps natural tendency among non-intellectuals to classify intellectuals as 'soft', the traditional Ionian reputation for unmanliness seems to have arisen from the fact that the Ionians in Asia Minor were conquered first by the Lydians and then by the Persians in the sixth century B.C. An early example of the attitude is Xenophanes' elegiac poem denouncing the Colophonians for submissiveness and love of luxury (Diehl, frag. 3). By the second half of the fifth century the weakness of Ionians (and hence Athenians) seems to have become nearly proverbial, and the Spartans clearly used it as one of the themes of their political propaganda (cf. Thucydides V. 9; VI. 77). Herodotus implies that many Athenians were somewhat ashamed of their Ionian ancestry (I. 143 and V. 69), and it may be that in emphasizing Ionic elements in the architecture of his building program, Pericles was attempting to counteract Spartan propaganda by developing a new sense of pride in Ionic traditions at Athens.

homogeneous style. The end product of this intense period of activity and inter-association (the atmosphere of which, in artistic matters at least, must have been similar to that of Renaissance Florence) was the High Classical style of Greek art, a style which, once it had developed in the Parthenon, became a standard by which not only later Greek and Roman art but most later European art, either in a spirit of emulation or rebellion, measured itself.

The metopes of the Parthenon, numbering ninety-two in all, were by far the most extensive cycle of metopes ever put together in Doric architecture and employed a series of archetypal myths and legends to celebrate, in a manner characteristic of most Greek architectural sculpture, the triumph of the forces of order and civilization over those of chaos and barbarism. Those on the east depicted the battle of the gods against the earth-born giants who attempted to seize Mt Olympus; those on the west appear to have presented a conflict (or conflicts) of Greeks and Amazons, the oriental warrioresses who once, according to legend, had attacked Athens itself. Because of extensive destruction it is now difficult to reconstruct the themes of the metopes on the longer north and south sides in their entirety. Some, and possibly all, of those on the north represented scenes from the Sack of Troy (again a theme in which Greeks face Orientals). On the south scenes of Lapiths struggling with Centaurs [33, 34] flanked a central group, now known only through seventeenth-century drawings, which may have dealt with the early history of Athens.[7]

With the exception of the Lapith–Centaur metopes from the south side, all of these sculptures are so badly damaged that it is impossible to base many iconographic or stylistic generalizations upon them. It is possible, however, to speculate on what the metopes of the Parthenon as a whole might have been thought to be allusions to by the Greeks who first saw the temple taking shape. As we have

[7] In its later history the Parthenon served first as a Byzantine church and subsequently as a mosque. During the Christian period some of the metopes appear to have been interpreted as presenting Christian subjects (the westernmost north metope was perhaps taken as an Annunciation and the Lapiths and Centaurs on the south were perhaps seen as illustrations of the Byzantine moral fable, the *Physiologus*); those which did not, i.e. most of the east, west and north sides, suffered from vandalism.

The temple as a whole remained largely intact until 1687, when a Venetian shell struck a Turkish powder magazine installed within the building and blew it up. Although this explosion did not completely demolish the building, it did deprive most of the surviving sculptures of their protective covering, and they began to deteriorate rapidly from the effects of weathering and further vandalism. During the years 1799–1812 Lord Elgin, the British ambassador to Turkey (at that time in control of Greece), obtained permission from the Turkish authorities to remove from the Acropolis most of the surviving south metopes, substantial portions of the frieze, and some battered pedimental figures. These pieces, forming the major part of the 'Elgin Marbles', were transferred to England, later sold to the British government, and are now in the British Museum.

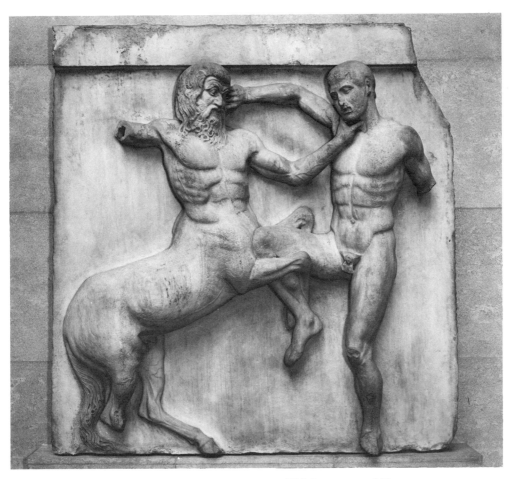

33. Parthenon, south metope no. XXXI, *c.* 447–442 B.C. Height approx. 4′ 8″.

already suggested the Greeks had a tendency to see the specific in the light of the generic – for example, Classical portrait statues tend to embody a category as much as an individual, Greek buildings adhere to pre-established 'orders', and statues embody numerically conceived patterns. This habit of thought helps to explain the persistent use of a relatively small number of themes in Greek architectural sculpture – the battle of the gods and giants, for example, and the exploits of Herakles – over several centuries. These themes became general archetypes, generic expressions, of specific events. In the scenes depicting the triumph of their ancestors and their gods against barbaric (i.e. both 'savage' and 'foreign') adversaries few Greeks would have missed an allusion to the triumph over the

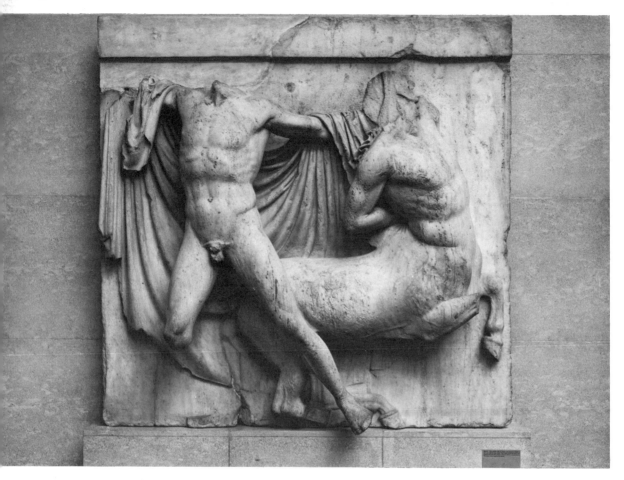

34. Parthenon, south metope no. XXVII, *c.* 447–442 B.C. Height approx. 4′ 8″.

Persians. The Athenians would probably also have sensed an allusion to Pericles' exaltation of Athens as the most profoundly civilized of the Greek cities. Some might also have recognized another example of the Greeks' deep-seated will to define the emergence of order out of chaos. It might have seemed that man's harnessing of the wild forces of nature, embodied by the earth which had given birth to the giants and been the source of the actual stone from which the Parthenon had been constructed, had been made manifest in the measured, refined brilliance of the temple and its ornaments.

The stylistic development of the Parthenon metopes can best be measured by comparing south metopes no. XXXI, an early (or at least conservative) example [33], which harks back in style to Olympia and perhaps the school of Myron, and no. XXVII, a later (or at least progressive) metope [34], in which the essential

elements of the Parthenon style have taken shape. The hard, linear musculature of the earlier work, its simple paratactic composition, and the tentative, unconvincing interaction of the two figures (e.g. the awkwardness of the Lapith's 'right hook') seems to place this sculpture in a state of suspension between the schematic, purely ornamental tradition of Archaic relief and the organically pictorial nature of sculpture which was developing in the Classical period. (Of course judgements of artistic virtues and faults are relative to the standards one employs. By average standards this metope is a fine piece of sculpture; only by standards set by the Parthenon itself can we fault it.) One wonders if an older sculptor, confronted with the 'new vision' of Pheidias' design, found himself hard-pressed to translate that design into stone. In metope XXVII [34] a revolution has taken place. Its motion-filled and graceful composition unifies the counteracting forces of the Lapith and Centaur. The Centaur appears as a compressed coil of energy pulled back into a circle by the taut Lapith whose left leg and arm anchor the composition above and below. The muscles of his lean torso are formed not by lines but by a subtle undulation of the surface which is defined by shadows. This exploitation of the play of light across a surface is even more apparent in his great mantle which unfurls in a series of balanced but not schematized ridges behind both figures. This metope seems to hover on a borderline between pictorial illusion and the hard 'reality' of carved stone. Like the Parthenon itself, it must be simultaneously understood as something known and measurable and also as a sense-impression, something which the individual consciousness must sort out for itself in the unending fluctuation of light and dark. It demands that we employ the complete range of our powers of perception to understand it.

Along with this fusion of *alētheia* and *phantasia* we also sense an emotional disengagement. The battle is real but the Lapith has become 'Olympian'. He seems to partake of the awesome aloofness which must have characterized Pheidias' great cult image of Athena – the *maiestas* and *pondus* of Pheidias, as Quintilian expressed it, which eclipsed and suppressed the study of character and emotion of the Early Classical period. In the developed metopes, it has often been noted, even the faces of the Centaurs seem to absorb some of this calm dignity and lose the mask-like, caricatured quality (inherited from the west pediment at Olympia) of their less progressive brethren.

The frieze of the Parthenon, which formed a band 3 feet 5 inches high and about 524 feet long running around the upper edge of the outer wall of the cella, presented only one subject. Precisely what that subject is has become a controversial question, although most critics would agree that in a general way it represents a religious procession in honor of Athena which begins on the west side of the temple, from

there runs eastward in parallel streams along the north and south sides of the temple, and culminates over the entrance to the *naos* on the east side, where the parallel streams merge upon a religious ceremony witnessed by a group of deities. A visitor to the Acropolis would have followed essentially the same path: he would have approached the temple from the west through the Propylaea and then have moved along one of its sides, most commonly the north (hence the west frieze is more closely connected in composition to the north frieze than to the south), toward the main entrance to the temple on its east side [2), 30]. He would have seen the frieze at a very steep angle and in reflected light. To compensate for this, the upper part of the relief was made slightly deeper than the lower, and all the figures were, as usual, vividly painted; but one still is inclined to wonder whether the Classical Greeks were in as good a position as we are to appreciate the frieze's purely sculptural beauty.

On the west frieze a group of horsemen are seen marshalling and mounting up at the beginning of the procession [35]. There is a general drift toward the north corner, but this drift is, at times, controverted by anecdotal figures and static details (one horse seems to chase away flies while his riders converse) and is stabilized by a magnificent rearing horse at the center. As the procession turns the corner at the north and south it gets fully under weigh. The massed riders, now projecting a reserved seriousness appropriate to the religious awe of the occasion, exert calm control over the vivid clattering energy of horses [36, 37]. As a group they provide an especially good example of the genius in composition of the frieze's designer. No two figures are alike; each relates significantly to the others and yet is interesting in itself; the scene has narrative coherence and yet arrests our attention as a purely abstract design [37]. Ahead of the riders come the chariots surmounted by drivers and men in armor; then a group of older men, musicians, and, at the head of the procession on the sides of the temple, figures who are to be participants in the sacrificial rites: pitcher bearers, tray bearers, and the caretakers of the sacrificial victims [38]. As the corner is turned on either side of the temple and the east section of the frieze begins, the procession comes to a slow halt in the presence of a sacred rite which takes place in the center. Here a man and a young assistant appear to be receiving and folding a large piece of cloth while a woman prepares to receive two folding-chairs brought forward by her assistants. This scene is framed by twelve seated deities (or thirteen if one counts the small child on the right of the group who may be Aphrodite's child Eros), who are in turn framed by standing groups of bearded men, and, on the outer edge, a group of maidens holding offering bowls and jugs who are supervised by marshalls. The seated deities seem certainly to be the twelve Olympian gods, with Zeus and Hera

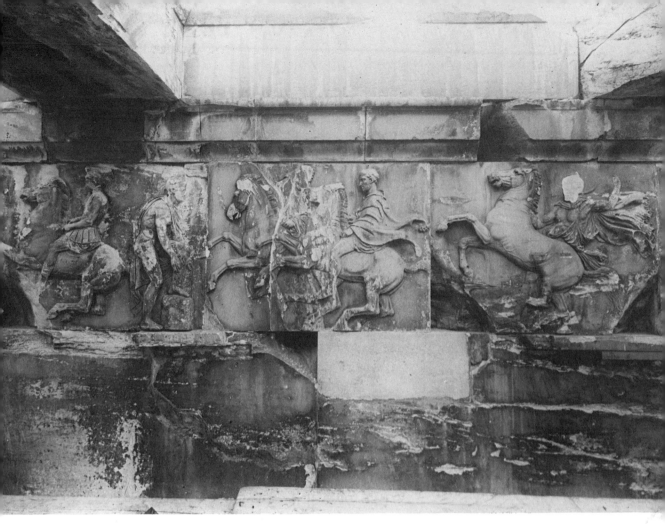

35. Parthenon, west frieze, *in situ*, *c.* 442–438 B.C. Height approx. 3′ 5″.

seated nearest the center on the left and Athena and Hephaestus, the two who were most particularly associated with Athens, on the right.

It has long been felt that the frieze as a whole must represent the great procession which formed part of the Panathenaea, the Athenian festival in honor of Athena. Although this festival was annual, it was celebrated with increased elaboration every fourth year. At that time a new and elaborately woven cloak (*peplos*) was borne to the Acropolis in accordance with what seems to have been a very ancient religious tradition and presented for the adornment of the old image of Athena (not Pheidias' gold and ivory image). It must be this act which is taking place in the center of the east frieze: the man receiving the *peplos* is perhaps an Athenian magistrate or priest, and the woman with him must be a priestess of Athena, supervising the disposition of chairs which either symbolize the priesthood or help

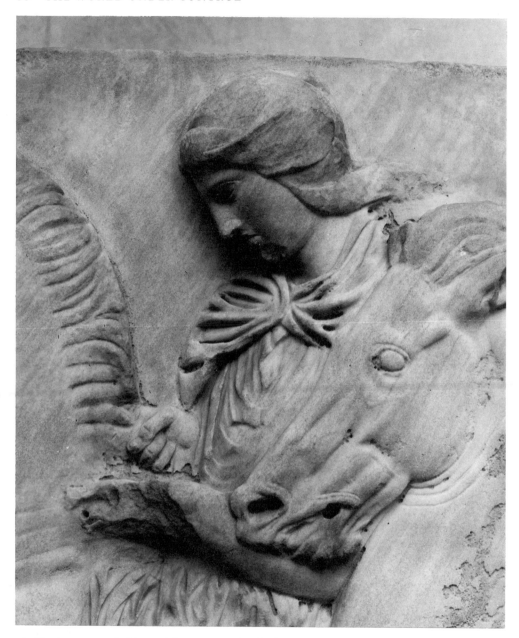

36. Parthenon, north frieze, slab no. XXXIX, detail of a rider.

to invoke particular deities. From literary sources we know that the Panathenaic procession began near the Dipylon gate by which one entered Athens from the northwest and that it ran along a prescribed route through the Agora and up to the

Acropolis. The west frieze is perhaps to be interpreted as the organization of the procession near the Dipylon gate, the north and south friezes the procession toward the Acropolis (with its rocky ascent possibly being conveyed by painted details), and the east the final stages of the celebration in the precincts of the gods. The riders, the warriors on chariots, and the musicians seem to be participants from the equestrian and musical contests which formed part of the Panathenaic festival.

Greek architectural sculpture had always in the past represented the archetypal actions of gods and legendary heroes. If in the Parthenon frieze the Athenians have in fact inserted a picture of themselves into a context normally reserved for gods and demi-gods, the innovation is only explicable in the light of the humanistic idealism and confidence of Periclean Athens. We have seen that in the Classical period in general and in Periclean Athens in particular, there was a tendency to fuse the real and the ideal, to see an ideal pattern as immanent in immediate experience rather than as transcendent. Pericles' Funeral Oration depicted Athenian society with god-like qualities, and perhaps the Parthenon frieze, where the visible and spiritual gap between men and gods vanishes, was intended to convey the same vision. Perhaps we see the citizens of Periclean Athens apotheosized.

A number of scholars have noted, however, that the frieze curiously omits

37. Parthenon, north frieze, slab no. XXXVII, detail.

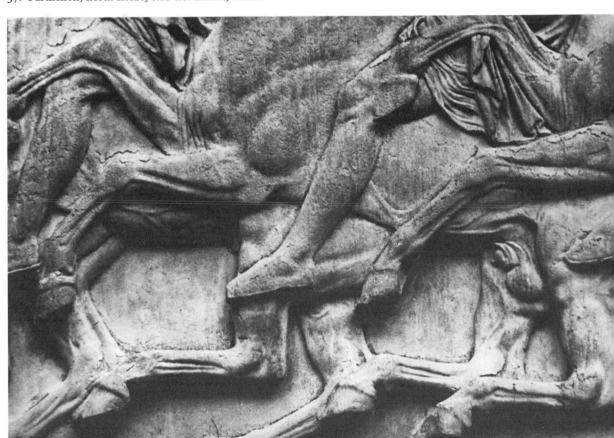

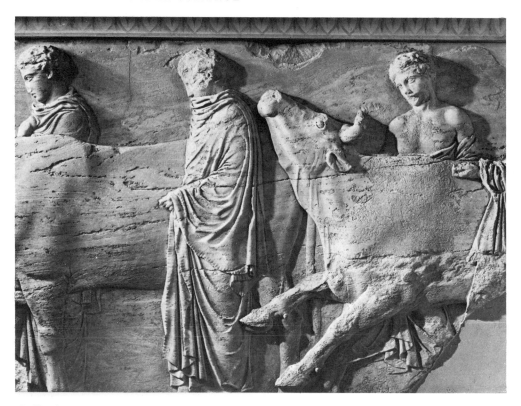

38. Parthenon, north frieze, slab no. 11.

certain features of the Panathenaic procession which are known to have formed an important part of it in the Classical period, most notably armed infantrymen (*hoplites*) and the maidens who bore baskets containing sacred objects (*kanephoroi*). These omissions may be attributable to an episodic technique of narration in which the effect of the whole procession is captured by a linked series of excerpts from it. But there is also the possibility that the frieze shows us not the Panathenaea of the Periclean period but the Panathenaea of an earlier time, perhaps the legendary festival which took place at the founding of Athens itself,[8] when the infantrymen and basket bearers did not form part of the ceremony. By this interpretation the figures on the frieze would consist of deities and divinized humans of an heroic

[8] This view has been advocated in particular by Chrysoula Kardara 'Glaukopis, the Ancient *Naos*, and the Subject of the Parthenon Frieze', *Ephemeris Archaiologike* (1961) 61–158, esp. 115–58 (in Greek). For a summary in English of Kardara's proposals and another approach to the problems which they raise cf. R. Ross Holloway 'The Archaic Acropolis and the Parthenon Frieze', *The Art Bulletin* (1966) 223–6.

past, and would not, as subject-matter, be nearly so remarkable a departure from the norms of Greek architectural sculpture.

To answer the question of what the Parthenon frieze really meant, we would have to know, first, the designer's intention, and secondly, what his contemporaries would have understood. Did the designer, for example, intend a specific Panathenaic procession in all its details, or was he trying to invoke in a more general way the spirit of all Athenian religious processions, including the one which must have taken place at the time of the dedication of the Parthenon? And how much did he expect his contemporaries to comprehend? The identifications of individual figures on the frieze proposed by those who see it as a primeval Panathenaea – e.g. some of the virtually attributeless figures on the west frieze as Erichthonios, Hermes, Theseus, and Poseidon – are not convincing.[9] The Athenians who first observed the completed frieze in the 430s B.C. would perhaps have noticed details which seemed heroic or traditional rather than contemporary – the 'heroic' nudity of some of the male figures, for example – but would they have concluded that they were looking at the Panathenaic procession in the time of King Kekrops? It seems more likely that they would have seen an exalted picture of themselves.

The style of the Parthenon frieze is much more even than that of the metopes. One feels that the common idiom of the Pheidian school has solidified, although the presence of different hands, and even different ways of thinking within the general medium, are identifiable. Perhaps its most apparent feature is the Olympian emotional disengagement which we could detect emerging in the metopes. A sense of aloof, divinized youthfulness runs throughout all the figures, even those who are supposedly old. This Olympianism is emphasized by deliberate contrast with the wild energy of the animal figures – the impetuous rush of the horses and the nervous bolting of the sacrificial bulls. Contending forces are once again controlled and harmonized. Although as a rule in the frieze we may say that the indisputable knowability of things is more strongly felt than their sensuous mutability, the same fusion of the ideal and the apparent which we detected in the metopes is also present. Perhaps the most spectacular exploitation of the new appreciation of optical impression is the depiction of an onrushing chariot and armed

[9] The whole question of just how much the designers of Greek architectural sculpture expected their contemporary audience to understand is an obscure one. In the inscriptions recording the expenses incurred during the building of the Erechtheion, payments to the sculptors who worked on the frieze of that building are noted (*I.G.* I² 374). From these we learn that the sculptors were paid for each figure carved and that the figures were recorded by such general descriptions as 'the man holding the spear, the horse and the man striking it, the woman and the small girl pressed against her'. Such descriptions perhaps suggest that the accountants, and possibly even the sculptors, did not know what the specific subjects of the carvings were.

warrior which forms slab xxx of the south frieze [39]. It is as if an explosion had taken place just in front of the chariot and shock waves were enveloping the group. The lines composing the horses' heads and manes seem like sudden flames and are carried across the panel by the crest of the warrior's helmet and by his cloak as it ripples violently in the wind. The wind-blown, fleeting impression which the group makes serves as a reminder of the transiency of sense-perception even in a setting where men are approximating divinity. It seems again to emphasize man's role as the measurer of things, and, in contradistinction to the Kleobis and Biton, for example, to anchor even the most Olympian subject to the human dimension. Perhaps this is why the impressionistic element of the Parthenon style becomes especially apparent in the pediments of the temple, where the divine forces which brought Athens into being and sustained it in days of greatness are extolled.

The pedimental sculptures of the Parthenon suffered grievously in the explosion of 1687, and it is easier today to appreciate the splendor of individual surviving figures than of the pedimental compositions as a whole. We know from a brief statement by Pausanias that the east pedimental group represented the birth of Athena and the west the struggle between Athena and Poseidon for the over-lordship of Athens. Only one original element from either group is still in place on the building (the 'Kekrops and Pandrossos figures' in the west pediment), but we can form some idea of the original appearance of the entire west pediment and the flanks of the east pediment from drawings made in 1674 by an artist whose identity is not completely certain but who seems to have been Jacques Carrey, a painter attached to the suite of the French ambassador to Turkey [40].

In the center of the west pediment we must assume that Athena has just performed the decisive miracle which won her the right to be the protectress of Athens – she has made an olive tree miraculously spring up on the Acropolis – and she and Poseidon draw back excitedly at its appearance. On either side of them are chariot groups accompanied by attendant messenger deities, Hermes on the side of Athena, and Iris on the side of Poseidon. Flanking the chariot groups are smaller figures who seem to have represented members of the legendary founding families of Athens. All of these figures, beginning with the explosive V-shape formed by Athena and Poseidon, give the impression of being agitated by shock waves radiating from the miraculous center of the pediment. In the windblown rushing figure of Iris [41] we are confronted with a figure whose effect is created almost exclusively by the vibrant play of irregular patterns of light and shade over its surface. The Parthenon sculptors' concentration on the optical, subjective dimension of sculptural experience is now fully developed. Light and shade have become the tools of a new expressionism.

39. Parthenon, south frieze, slab no. xxx.

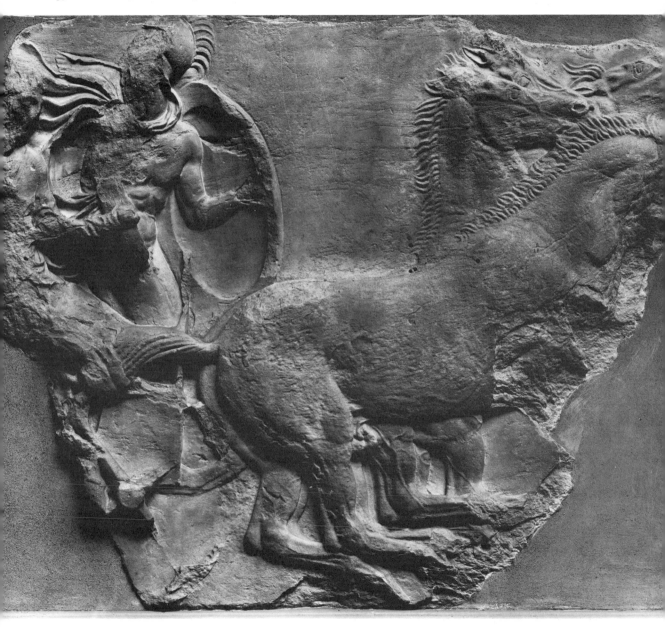

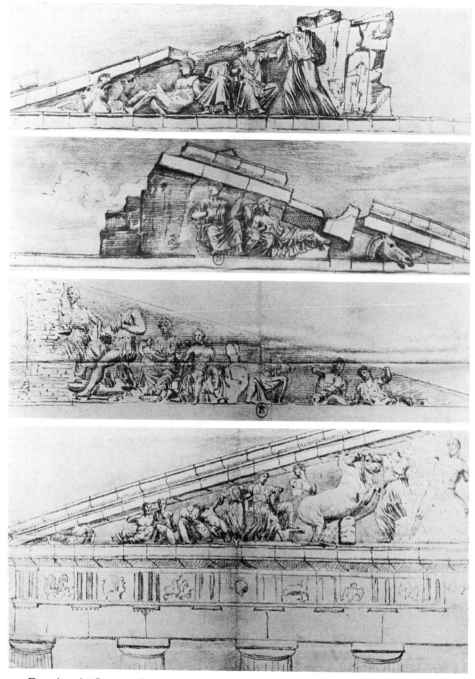

40. Drawings by Jacques Carrey (?) of the east (above) and west (below) pediments of the Parthenon as they appeared in 1674.

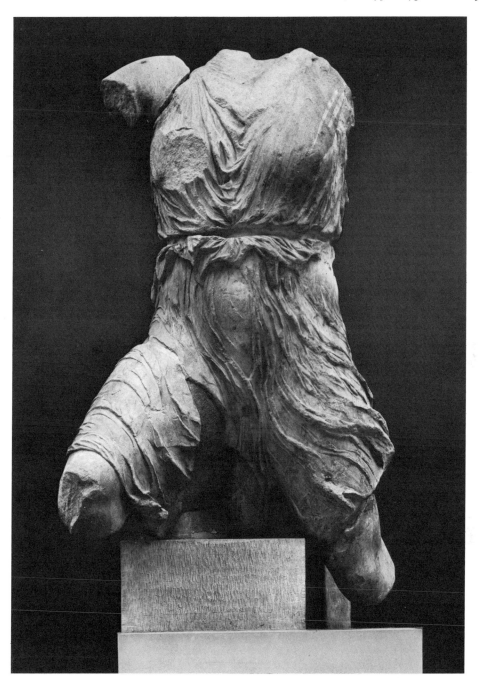

41. Parthenon, west pediment, Iris, *c.* 438–432 B.C. Height as preserved, approx. 4′ 5″.

The central figures of the east pediment are totally lost. From what appear to be copies of parts of the central group in later Greek and Roman sculpture and vase painting, modern scholarship has been able to produce reasonable restorations of what its general appearance might have been, but the identification, position, and format of the individual figures are highly controversial, and it would require a separate book even to summarize them. For our purposes it suffices to say that the center must have been occupied by a seated figure of Zeus, and by Athena herself, fully grown and fully armed, already embodying the new Athens. These figures probably created an explosive center, as in the west pediment, the effect of which was carried out in progressive stages through the now missing attendant deities immediately flanking it to the preserved figures on the far edges of each side. At the ultimate boundary, in the narrow corners of the gable, the scene is framed by the rising of Helios (the sun) and his horses on the left (south) and the sinking of Selene (goddess of the moon) or Nyx (night) on the right. These figures, marking the horizon and the procession of the heavens, seem intended to emphasize that the pediment depicts an orderly cosmos of which Athens, in the form of Athena, forms the center along with Zeus, the source of divine power, and with Hephaistos, the god of *technē* and hence of human achievement. It has been suggested by Evelyn Harrison that the other deities in the pediment were perhaps disposed on the north and south sides of this central group in accordance with the geographical location of their cult centers or shrines in ancient Athens, and that they symbolized, through their own mythological characters, through their relationship to one another, and through their relationship to Athena, different aspects of the Athenian *polis*.[10] This close association which seems to have been felt between the gods of the pediment and the life and land of Athens may also be expressed in a purely abstract way by the style of some of the figures, which seems to connote earth forms and natural forces. The drapery of the famous group of three goddesses on the north side of the pediment [42], for example, often conventionally called the 'Three Fates' but probably representing Hestia, Dione, and Aphrodite, is carved in bold, whirling, heavily shadowed folds which suggest the cascading of a waterfall over a mountainside. The same effect is felt with slight differences on the opposite side where a goddess with her cape billowing out behind her, probably Artemis, rushes like the wind across the sky to bring the news of Athena's birth to two seated goddesses whose heavy forms convey an earth-bound solidity and who are, in fact, probably Demeter and Kore, the deities *par excellence* of earth [43]. Next to them a relaxed but massive and powerful male figure reclining on an

[10] Cf. Evelyn B. Harrison 'Athena and Athens in the East Pediment of the Parthenon', *American Journal of Archaeology* 71 (1967) 27–58.

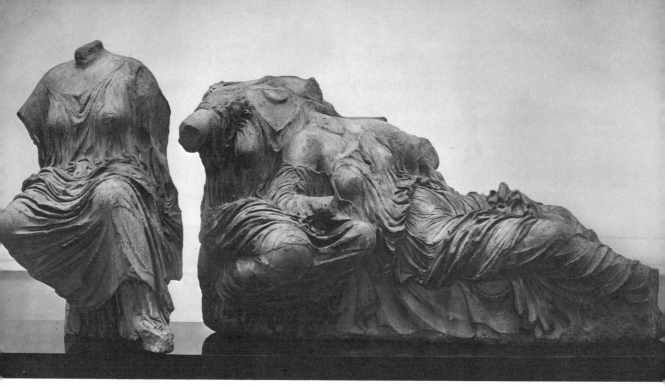

42. Parthenon, east pediment, figures 'κ', 'ʟ', and 'м', perhaps Hestia, Dione, and Aphrodite. Length of 'ʟ', 'м' approx. 7′ 8″.

animal skin, confronts the rising sun. The undulating, gradual transitions between the details of the musculature of his torso call to mind a sun-lit hillside which balances the 'watery shape' suggested by the 'Three Fates' group. He has been identified as Dionysos or, perhaps even more plausibly as Herakles,[11] the man who through his achievements became a divinity and thus symbolized that bridging of the gap between the human and the divine which is so characteristic of the thinking of the Parthenon's designers.

The Parthenon and the Classic moment

The difficulties involved in defining the words 'classic' and 'classical' were pointed out at the beginning of this book. Now that some of the products of the

[11] It can be objected that the birth of Athena preceded the admission of Herakles to Olympos in 'mythological time', and that Herakles should logically not be present at the goddess' birth. It may be, however, that symbolic values outweighed the demands of literal narrative in the mind of the pediment's designer.

The different interpretations of this figure, known simply as 'D' in the scholarly literature, are summarized by F. Brommer in *Die Skulpturen der Parthenon-Giebel* (Mainz 1963) pp. 148–50, to which add: Harrison's observations in the article cited in the previous note and Rhys Carpenter 'On Restoring the East Pediment of the Parthenon', *American Journal of Archaeology* 66 (1962) 265–8 (Carpenter identifies the figure as Ares).

High Classical style have been examined, we can appropriately return to this question, not to frame general definitions but rather to isolate what might seem to be characteristic of the works to which the terms are applied. In Archaic Greek art the genre of particular things had outweighed their specific, individual qualities in artistic representation. Hence abstraction, expressed through the geometricization of natural forms, dominated Archaic art. In the fourth century, as we shall see, it is possible to detect the first indications of a taste, which would mature in the Hellenistic period, for the representation of specifics without any emphatic suggestion of the genre or form (in the Platonic sense) from which they were derived. Realism, in short, began to undermine the long-standing role of abstraction in Greek art. In the art of the High Classical period, and particularly in the art of the Parthenon, these two poles of artistic thinking – the absolute and the relative – seem to have been magically balanced. The relativity of sense experience (e.g. optical refinements) co-exists, as we have seen, with absolute concepts like 'number'. The mutability of nature, unformed and unreflective, represented by the mountains and the sea which ring the Acropolis are pitted against the formal perfection, seemingly symbolic of the human mind's capacity for abstract thought, of architectural order. The mortal natures of the processionists of the frieze are

43. Parthenon, east pediment, figures 'A' through 'G', perhaps Helios and his horses, Herakles, Demeter and Kore, and Artemis. Height of 'G' approx. 5′ 8″.

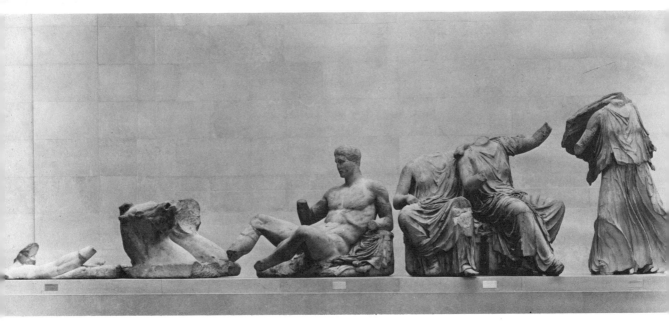

infused with the traits of undying divinity. Historical time in the west pediment was given equal weight with what seems to have been a symbol of timeless cosmic order in the east.

Besides being an outgrowth of a new anthropocentric drift in Greek philosophy, which we have already discussed, the Classical moment also seems to reflect, in fact to be a projection of, the sense of group solidarity which Pericles' eloquence, combined with prosperity and a degree of luck, had forged in Athens. A Greek *polis*, when understood as a particular pattern of life and not just a geographical grouping of people and their belongings, was essentially an abstract conception just as a 'nation' is today. Personal life, on the other hand, is basically a succession of particular, concrete interests and experiences. In Periclean Athens, if we may believe the picture presented to us in the Funeral Oration, the latter, for many citizens at least, came to be merged without friction into the former. What an individual wanted for himself and what he owed to the ideal were in harmony.

In the same persons there is at once a concern for private and for civic affairs; and even among those whose attention is usually turned to their private occupation, there is no lack of understanding of civic matters. For we alone regard the man who takes no part in civic affairs not as unconcerned, but as useless ...

Belief in the group, in society raised to the level of an abstraction and revered as a quasi-deity, seems to have been an essential ingredient in the atmosphere of the High Classical period and its art. When the belief was shaken, as we shall see, the artistic style which it sustained lost its cohesion.

The Pheidian style and spirit

In spite of the frequency with which his name enters into discussions of High Classical Greek art, Pheidias remains a shadowy figure. How well he knew Pericles, to what extent he had absorbed the thought of Protagoras or Anaxagoras, to what extent he himself really shared or helped to formulate the convictions which Thucydides ascribes to Pericles – these are unanswerable questions. We know Pheidias and his feelings only through the art which is ascribed to him.

Ancient writers give us a confused and troubling picture of his later years. He was accused of embezzling some of the precious materials used on the Athena *Parthenos* and left Athens in disgrace, either as a fugitive or as an exile. While there is some evidence that the condemnation of Pericles' artistic overseer was an indirect attack by political opponents on Pericles himself, it is not impossible that Pheidias was actually guilty as charged. In the years following his departure from Athens he worked on the great image of Zeus at Olympia, after which he either died in exile or returned to Athens where he was imprisoned and executed.

Either way, it was a strange fate for an artist who must be considered one of the great and influential intellectuals of the fifth century. Thucydides' history seems not to have been written, and certainly not generally known, until well after the hey-day of Periclean Athens. Sophocles and Euripides were as often critics as apologists of their home city. It was really Pheidias who, by forging a style which gave external, symbolic form to the Periclean vision and by carrying it abroad to the panhellenic sanctuaries, particularly through the Olympian Zeus, made it possible for the rest of the Greeks to appreciate and to an extent participate in the Athenian experience.

Today, even when we may doubt that the master's hand is anywhere in evidence on them, we look first of all at the sculptures of the Parthenon in order to understand the spirit of Pheidias' work. In Antiquity it is clear, however, that one thought of Pheidias above all as the creator of two great chryselephantine cult images – the Athena *Parthenos* and the Zeus at Olympia. The appearance of these images can be reconstructed to an extent from literary descriptions, diminutive and partial copies, and representations on coins and other small media, but their real force and grandeur is lost to us. Each image, as the ancient sources make clear, was adorned with a series of decorative details which brought together a variety of significant themes, just like the temples in which they were placed.

The Athena *Parthenos*, for example, held an image of Victory in her right hand. Her left hand rested on a large shield which bore an Amazonomachy in relief on its exterior and Gigantomachy (possibly painted) on its concave interior. On her sandals were reliefs representing a Centauromachy, and the base which supported the statue was decorated with a relief showing the birth of Pandora in the presence of a group of deities. Thus the goddess who was the embodiment of Athenian intellectual and cultural attainments was adorned with familiar symbols of the triumph of order and civilization over chaos and barbarism on all levels. But she rested on a base in which Pandora, 'The All Endowing One', fashioned by Hephaistos and given life by Athena, was shown making her first appearance in the world. The choice of this last myth is puzzling and provocative. Every Classical Greek knew from Hesiod that Pandora was sent by Zeus to punish mankind for having received fire, perhaps symbolic of technology and self-assertion, from Prometheus. She brought to mankind grace and beauty, but also desire; the arts, but also toil; intellect, but also guile and deceit. Before Prometheus and the coming of Pandora men had lived, as Hesiod tells us, 'free from ills, and without harsh toil' like Adam and Eve before the Fall. Afterwards, there would be struggle and triumph but also peril. Perhaps in choosing the Pandora myth Pheidias was hinting that since the Athenians had received the real blessings of Pandora they must

also be prepared to accept her curses. Athens had reached her cultural pre-eminence through risks and struggle, and there was now no going back to a world without cares. This too, if we look again at the Funeral Oration, was one of Pericles' themes:

> But none of these [the fallen Athenian soldiers] allowed either wealth with its prospect of future enjoyment to unnerve his spirit, or poverty with its hope of a day of freedom and riches to tempt him to shrink from danger ... For it is not the miserable that would most justly be unsparing of their lives; these have nothing to hope for: it is rather they to whom continued life may bring reverses as yet unknown, and to whom a fall, if it came, would be most tremendous in its consequences.

Pheidias, like his Early Classical predecessors, perhaps at times knew the old doubt as well as confidence, and should perhaps be understood as a prophet as well as a propagandist.

The Zeus at Olympia, executed after the *Parthenos* (hence after 438 B.C.) and probably Pheidias' last great work, can be shown to have had similar thematic complexities when all the details in Pausanias' description of it are analyzed. But too close an analysis might tend to obscure the fact that the principal effect of this image, and apparently of all Pheidian art, was what one might call an 'Olympian' feeling, that is, the feeling of an atmosphere associated with the Olympian gods, who were thought of as emotionally disengaged from, but at the same time conscious of, the human condition. An ancient anecdote recounted that when Pheidias was asked what model he used in making his Zeus, he cited not a human model but some lines from Homer:

> Thus spoke the son of Kronos and nodded his dark brow and the ambrosial locks flowed down from the lord's immortal head, and he made great Olympos quake. (*Iliad* I. 527–30)

Pheidian sculpture stood somewhere between the complete aloofness of most Archaic art and the deep involvement in specific characters and emotions of most Early Classical art. Like the Parthenon figures, all Pheidian sculpture seems to have projected a state of mind which was detached but not remote, aware but not involved.

It is the literary descriptions of the effect of the Zeus, rather than Pausanias' factual description, which bring us closest to it. Quintilian felt that it 'added something to traditional religion'. And Dio Chrysostom gives us a hint as to what Quintilian's remark meant: '... whoever might be burdened with pain of the soul, having borne many misfortunes and pains in his life and never being able to attain sweet sleep, even that man, I believe, standing before this image, would forget all the terrible and harsh things which one must suffer in human life'.

It is probably fair to say that no cult image after the time of Pheidias was ever

without his stamp. The Zeus and Athena became prototypical standards for the representation of divinity, standards which in the opinion of the later Hellenistic and Roman critics, were the products of the spiritual intuition of a great sage. 'When he was in the process of making the form of his Zeus and Athena', says Cicero (*Orator* 9), 'Pheidias did not contemplate any human model from whom he took a likeness, but rather some extraordinary vision of beauty was present in his mind, and, fixing his attention on it and intuiting its nature, he directed his hand and his art toward making a likeness from it.' 'To such a degree', adds Quintilian, 'did the majesty of the work do justice to the deity.' Among extant monuments it is, if anything, in later works influenced by the Pheidian types, rather than in rough copies, that we can participate in the spirit of Pheidias' masterpieces. The head of Zeus from Mylasa in Caria, now in Boston [44], and the bronze Athena recently discovered in Peiraeus, both probably products of the second half of the fourth century B.C., and more generally the Serapis type [74] by the fourth-century sculptor Bryaxis, all seem imbued with a Pheidian spirit and are perhaps later variations on sculptural types which Pheidias created.

Using this 'Olympian feeling' as an emotional index and the sculptures of the Parthenon as a stylistic index, a number of works known in Roman copies – e.g. the presumed 'Athena Lemnia', and the Tiber Apollo – have with some justice been attributed to Pheidias and still others to his renowned pupils, like Alkamenes and Agorakritos. Perhaps one of the more significant and sound of these attributions is the identification of a portrait of Pericles known from good copies in the British Museum and the Vatican with the 'Olympian Pericles' of the sculptor Kresilas [45] mentioned by Pliny. Kresilas was a native of Kydonia in Crete, but judging by the number of dedicatory statue bases with his signature found in Athens, he must have been part of Pheidias' circle. The aloof but aware feeling in this portrait, the original of which was most probably a full-length bronze, must have contrasted strikingly with the seemingly 'involved' portrait of Themistokles created a generation earlier [26].

Identification of the lost works of Pheidias and his followers must, however, always be surrounded by controversy. For a more immediate and less speculative example of the spread of Pheidian Olympianism and how it penetrated to a popular level of consciousness in Athens, we can turn once again to Attic red-figure vase painting. As I have indicated previously the gap between the painters who worked in larger media and the vase painters tended to widen as the fifth century progressed, and vase painting tended to become increasingly a minor art. But even so, there always seem to have been one or two artists who managed to overcome the seeming limitations of the medium and achieve that harmony of form and meaning,

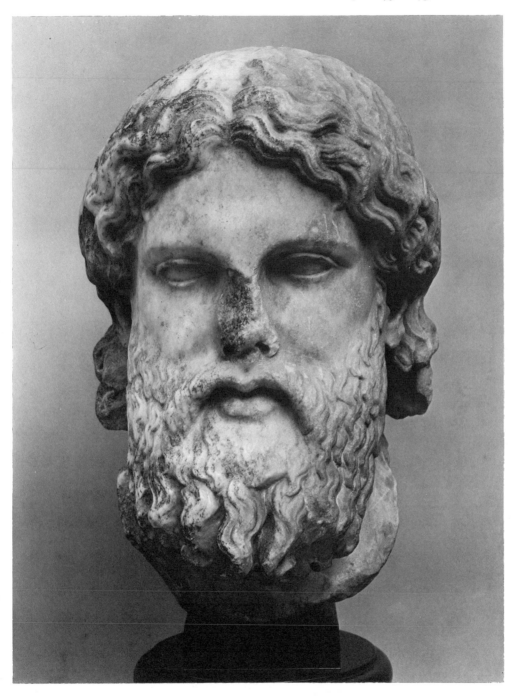

44. Head of Zeus from Mylasa in Caria, marble, *c.* 350 B.C. Height 18½″.

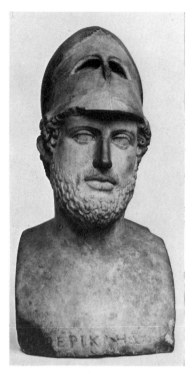

45. Portrait of Pericles, Roman copy in marble of a bronze original, *c.* 440–430 B.C. Height approx. 23¼″.

of intention and technique, which had characterized the finest Greek vase painting of the earlier eras. Such an artist was the Achilles Painter, who was probably about the same age as Pheidias (i.e. active between 460 and 430 B.C.) and seems to have grown into the Pheidian style. In one of the earliest works attributed to him, a bell-*krater* [46] probably executed around the time of the Olympia temple sculptures (see pp. 32 ff.), the vivid face of the bearded old warrior who is conversing with a younger man (the latter's face now broken) – his knitted eyebrows, wrinkled face, and intense gaze – belong to the Early Classical tradition of character drawing. As on several of the Olympia metopes the figures are at rest, and yet one feels that their confrontation may be part of a dramatic narrative. Even if we do not know precisely what the subject of the scene is, it is clear that a dialogue is going on, and emotions appropriate to a particular narrative situation are being expressed. By contrast, in the works executed by the Achilles Painter twenty years or so later, this narrative style is submerged in favor of a Pheidian Olympianism. The figure of Achilles on the amphora in the Vatican [47] which gave the painter his name seems to have stepped out of the Parthenon frieze. Specific emotion yields to a serene, unruffled presence. The face, particularly the eyes, which are now drawn with

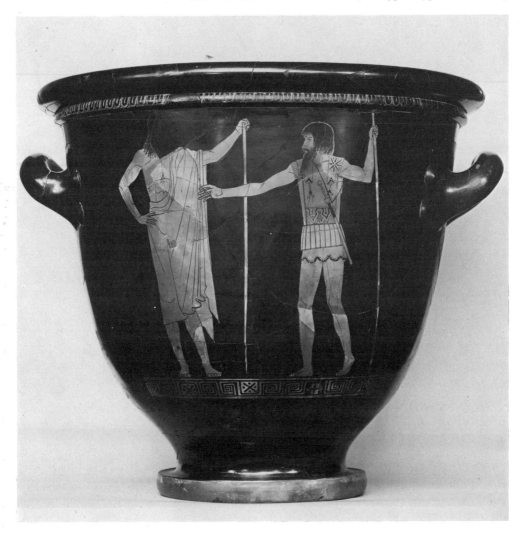

46. *Krater* by the Achilles Painter, *c.* 460–450 B.C. Height 14½".

long eyelashes and the pupil and iris clearly contrasted, is full of potential expression, but that expression does not seem to be qualified by any specific situation.

The same is true of the many white-ground *lekythoi* executed by the Achilles Painter and his followers. In the hands of lesser artists the Olympianism of the Achilles Painter sometimes became mere vapidity, but these white-ground vases, perhaps because most of them were used as funeral offerings or for funeral ceremonies, have a quiet poignancy which calls to mind the unflinching, unregretting, but not unfeeling acceptance of death of the Funeral Oration.

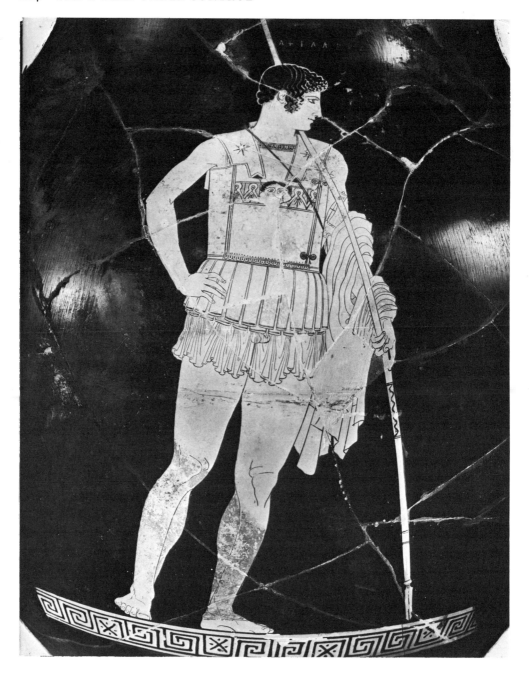

47. *Amphora* by the Achilles Painter, *c.* 440 B.C. Height 23⅝″.

There were other very gifted vase painters in this era like the Kleophon Painter [48], who also absorbed the spirit and even the motifs of the Parthenon style [compare with 38] but used a more free (at times even casual), expansive style of drawing which at times has a monumentality scarcely containable in vase painting. The viewer often finds himself thinking what the artist might have done if he had been working in a grander medium. The self-sufficiency of earlier red-figure, its crisp linearity and untroubled subordination of content to design, had already begun to show signs of strain in the Early Classical period, and its breakup is now carried one gentle step further. But while the vases produced in the 440s and 430s may not have their predecessors' appeal purely as *objets d'art*, the best of them capture the assertive freedom and dignity which were part of their era.

Polykleitos: new versions of old formulae

The one non-Athenian sculptor of the High Classical period whose merit was not eclipsed by the brilliance of Periclean Athens was Polykleitos. In the Hellenistic and Roman periods his work stood second only to that of Pheidias in the admiration of connoisseurs. Polykleitos' native city, Argos, had been neutral during the

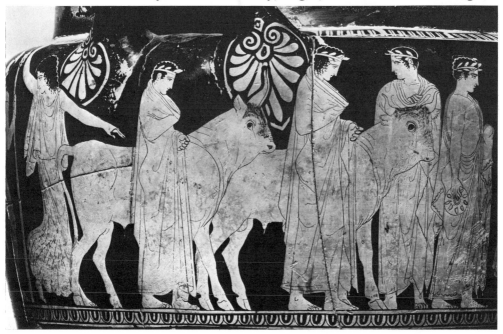

48. *Krater* by the Kleophon Painter, *c.* 430 B.C. Height of vase approx. 26″.

Persian Wars, and later, while usually favoring Athens over Sparta in the great power struggle which occupied the remainder of the fifth century, the Argives for the most part managed to avoid being swept up in the more debilitating phases of that conflict. Argos was spared the emotional shocks and revolutions which seized Athens. It was a good place for older traditions to survive.

Polykleitos was remembered in Antiquity as the chief master and foremost exponent of the principle of *symmetria*, 'commensurability of parts', in art. Around the middle of the fifth century, or shortly thereafter, he wrote a treatise, known as the *Canon*, in which he delineated and apparently sought to justify the system of *symmetria* which he had developed for representing the human body in sculpture. The *Canon* seems to have been well-known and influential, in its intent at least, in later times. During the fourth century a number of important artists – for example, the sculptor Lysippos (see pp. 174 ff.), the painter-sculptor Euphranor, and the painter Parrhasius – also propounded systems of *symmetria*, apparently emulating (although not duplicating) Polykleitos' work.

The basic idea behind the *symmetria* principle, that an artistic composition should consist of clearly definable parts, was a venerable one in Greek art. It existed, as we have seen, in the Geometric period and continued in force throughout the Archaic period. Greek sculpture in particular in the Archaic period saw the development of workshop formulae of *symmetria* which seem to have been inspired by Egyptian prototypes, but underwent considerable local development.

What distinguished Polykleitos' system of *symmetria* from what had gone on before, however, was that it seems to have had philosophical content as well as a practical function. Its aim was to express what Polykleitos himself called *to eu*, 'the perfect' or 'the good', and what others seem to have called *to kallos*, 'the beautiful'. There is some evidence that the philosophical tradition which gave rise to and helped to shape this philosophical conception of *symmetria* was Pythagoreanism.

Although there are no extant writings by Pythagoras of Samos (active in the late sixth century B.C.) or by his immediate successors in the philosophical brotherhood which he founded at Croton in South Italy, many of their basic ideas are preserved by Aristotle in a summary of the views of the 'Pythagoreans' given in the *Metaphysics*. Like other pre-Socratic schools of philosophy the Pythagoreans were concerned with finding a substratum of some sort from which all visible phenomena could be explained. The substratum which they hit upon as fulfilling these functions was *number*, or more precisely, numbers. Numbers were seen as the basic constituents not only of physical bodies but of abstract qualities, like justice, as well. It was perhaps Pythagoras' own observation that the intervals needed to pro-

duce harmonic chords on the string of a lyre were expressible in a limited group of integers (2:1, 3:2 etc.) which led him to suggest that all distinct phenomena resulted from the imposition of numerical limit on an infinite continuum. If musical sounds could be reduced to a series of consonant proportions, so too, perhaps, could the stars, planets, and the diverse objects on earth. In Aristotle's words, 'The qualities of numbers exist in a musical scale (*harmonia*), in the heavens, and in many other things' (*Met.* 1090 a 23). To some Pythagoreans, at least, the contemplation of numerical harmony in diverse phenomena had a spiritual end; contemplation of 'divine' patterns was seen as a means of purifying the soul and preparing it for a higher state of being.

How much of this doctrine was known to Polykleitos and appealed to him is a matter of guesswork, but his term *to eu*, 'the perfect', does have Pythagorean overtones,[12] and it may be that in expressing this quality through a harmony of parts in sculptural form, he was attempting to give expression to an ideal conception of human nature, a divine pattern which expressed the essential nature of man in Pythagorean terms.

It is interesting to note, as a parenthesis, that the gap between the Archaic workshop formulae of *symmetria* and Polykleitos' philosophical elaboration upon it, is spanned by the Early Classical period and that one of the sculptors who was most influential during this period was named Pythagoras. One interpretation of the literary evidence suggests that this Pythagoras migrated, like his namesake the philosopher, from Samos to South Italy. Moreover, according to Diogenes Laertios, 'he was the first to have aimed at *rhythmos* [see p. 58] and *symmetria*'. One cannot help but wonder whether the sculptor Pythagoras might not have been, philosophically speaking, a Pythagorean, and hence been the first to attribute philosophical significance to sculptural proportions. Unfortunately no work by the sculptor Pythagoras, even in Roman copies, can be identified with reasonable certainty, and we have little evidence as to how his work compared in form and intent with that of Polykleitos.[13]

In turning from the literary tradition to the monuments we find that it is probably impossible to reconstruct Polykleitos' famed *Canon* of *symmetria* in detail but that one can quite easily 'feel' the presence of a harmonious system in the works which are ascribed to him in Roman copies. In the *Doryphoros* ('Spearbearer') [49], for example, however its arithmetical or geometrical proportions

[12] Cf. Aristotle *Metaphysics* 1092 b 26, where, by implication it appears that the Pythagoreans used the phrase to express the ethical and spiritual good which was derived from the contemplation of numerical proportion; also Plato *Timaeus* 68E where it refers to the 'good' in all generated phenomena fashioned by the cosmic Demiurge, a passage which may reflect Pythagorean influence.

[13] See, however, p. 58, n. 16.

may have been measured, there is a visible harmony of counterbalancing forces achieved by arranging the parts of the body in a chiastic scheme: the straight, weight-bearing right leg is balanced by the bent, weight-bearing (the spear) left arm; the free but flexed left leg is balanced by the free but straight right arm; the raised right knee opposes the lowered left hip and *vice versa*; the head turns to the right while the torso and hips are twisted slightly to the left. There is also a balance between motion and stability: he is taking a step, yet he is statically balanced. In the *Diadoumenos* ('Youth binding a fillet on his hair') the same features, plus an additional contrast of the axis of the hips against that of the shoulders, are apparent. In fact, this system of balances can be found to a degree in every work which can reasonably be associated with Polykleitos for other than purely stylistic reasons.

In spite of his strongly traditional interests, a number of features clearly link Polykleitos' work in spirit with the art of Periclean Athens. The goal of his system of *symmetria* was to describe an ideal nature in man, as in the sculptures of the Parthenon. He also concentrated on harmonizing opposing forces. What the Parthenon artists did with light and shade, with substance and impression, with the knowable and the apparent, Polykleitos did with theoretical proportions and the eye's perception of them: he developed a form in which the commensurability which one *knew* to exist was also *felt* or sensed to exist.

The literary sources give no indication, however, that Pheidias and his pupils and contemporaries at Athens shared Polykleitos' preoccupation with the theory of *symmetria*. In itself this preoccupation marks Polykleitos as an Argive traditionalist. The same may be said about the types of statues which he produced. The original *Diadoumenos*, for example, must have been a votive statue in bronze set up to commemorate an athletic victory in one of the panhellenic sanctuaries. The *Doryphoros* is recorded to have been a kind of display piece made as an illustration of Polykleitos' *Canon*; but it too probably stood in some public place as part of a votive or sepulchral monument. The greater part of Polykleitos' effort, in fact, was probably devoted to making athlete figures upon specific commission, and this simple fact of his professional life links him with earlier traditions of Greek sculpture rather than with contemporary developments at Athens.

It is fair to ask, then, whether Polykleitos was influenced at all in any direct way by Athens and Pheidias, and whether there is an historical, as well as a thematic unity, between the two greatest sculptors of the High Classical period. It would appear that there was. Polykleitos seems to have been increasingly influenced by the Pheidian style as his own career progressed. Athens and Argos were on good terms, and it is not improbable that he visited Athens on occasion and saw the Parthenon and other projects take shape. And of course almost every Greek must

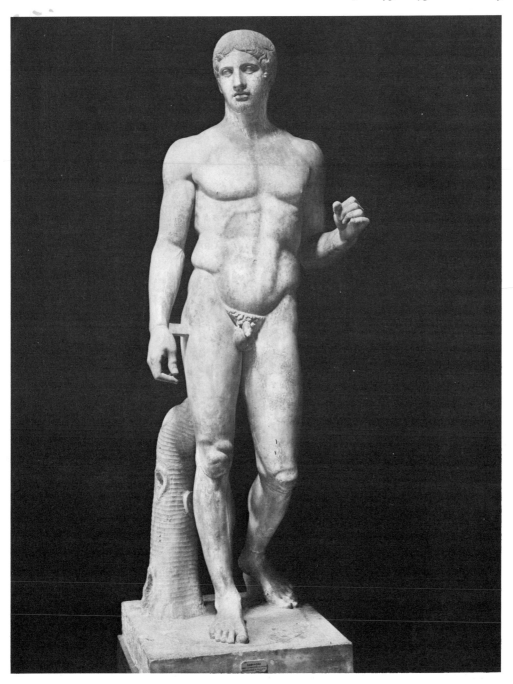

49. *Doryphoros* of Polykleitos, Roman copy in marble of a bronze original, *c*. 450–440 B.C. Height approx. 6′ 11½″.

have seen Pheidias' image of Zeus at Olympia at one time or another. If dating by the stylistic details (particularly the rendering of the hair) of Roman copies has any validity, the *Doryphoros* would seem to date from about 450 B.C. and the *Diadoumenos*, with its richer, more plastic hair, from about 430. In the interim between these two works a certain 'Pheidianization' seems to have taken place. While both, as so many critics have pointed out, represent an idealized vision of youth, the *Doryphoros* has a rather neutral and strictly theoretical feeling, while the *Diadoumenos*, perhaps because of the meditative cast of the head and the fact that it represents a specific action within the format of a completely relaxed pose, seems to have taken on some of the Olympianism of the Parthenon frieze. Like the riders of the Parthenon frieze, it suggests conscious reflection even when devoid of emotion. If this comparison seems too subjective, it can also be noted that around 420 B.C. Polykleitos undertook to do a colossal gold and ivory statue of Hera for a new temple at the Argive Heraion, thus becoming, either under pressure or by predilection, both a rival and successor to Pheidias in the genre of sculpture for which the Athenian master was best known.

4 The world beyond control

The later fifth century, c. 430–400 B.C.

The resurgence of the irrational

In the summer of 430 B.C., following the winter in which Pericles had delivered his Funeral Oration, a devastating plague struck the crowded city of Athens. The plague was an unforseeable, rationally incalculable blow whose profound symbolic implications, as Thucydides recognized when he placed his famous description of it immediately after the Funeral Oration, were as momentous as the actual loss of life at Athens. In the wake of the physical suffering caused by the disease, the symptoms and course of which Thucydides describes with clinical interest, came the beginnings of a moral and social revolution.

Thucydides' description of the plague is so effective that it defies paraphrase. 'There was the awful spectacle of men dying like sheep through having caught the infection in nursing one another.' The infectious nature of the disease meant that the more honorable and compassionate a man was, the more certain he was of destruction. Dejection swept the city 'where even the members of the family were at last worn out by the moans of the dying, and succumbed to the force of the disaster'.

... The bodies of dying men lay one upon the other, and half-dead creatures reeled about the streets and gathered round all the fountains in their longing for water. The sacred places also in which they had quartered themselves were full of corpses of persons that had died there, just as they were; for as the disaster passed all bounds, men, not knowing what was to become of them, became utterly careless of everything, whether sacred or profane.

It came to the point where some would usurp funeral pyres prepared by others or casually throw the corpse which they bore on a pyre already burning.

Nor was this the only form of lawless extravagance which owed its origin to the plague. Men now cooly ventured on what they had formerly done in a corner and not just as they pleased, seeing the rapid transitions produced by persons in prosperity suddenly dying and those who before had nothing succeeding to their property. So they resolved

to spend quickly and enjoy themselves; regarding their lives and riches alike as things of a day. Perseverance in what men called honor was popular with none, it was so uncertain whether they would be spared to attain the object; but it was settled that present enjoyment, and all that contributed to it, was both honorable and useful. Fear of gods or law of man there was none to restrain them. As for the first, they judged it to be just the same whether they worshipped them or not, as they saw all alike perishing; and for the last, no-one expected to live to be brought to trial for his offences, but each felt that a far severer sentence had been already passed upon them all and hung ever over their heads, and before this fell it was only reasonable to enjoy life a little. (Thucydides II. 52–4)

What the plague was to Athens for a few years, the Peloponnesian War was to Greece as a whole for a generation. Thucydides, who was a first-hand witness of the war, describes it, in fact, as rather like a disease, worsening by stages and ending in the collapse of the cultural ideals which he ascribes to Pericles. Nowhere does he make this view clearer than when he describes the incredibly bloody internal struggle which took place between democratic and oligarchic factions on the island of Corcyra beginning in 427 B.C.:

So bloody was the march of the revolution, and the impression which it made was the greater as it was the first to occur. Later on, one may say, the whole Hellenic world was convulsed ... The sufferings which the revolution entailed upon the cities were many and terrible, such as have occurred and always will occur as long as the nature of man remains the same; though in a severer or milder form, and varying in their symptoms according to the variety of the particular cases. In peace and prosperity states and individuals have better sentiments, because they do not find themselves suddenly confronted with imperious necessities; but war takes away the easy supply of daily wants, and so proves a rough master, that brings most men's characters to a level with their fortunes ... The cause of all these evils was the lust for power arising from greed and ambition; and from these passions proceeded the violence of parties once engaged in contention ... Thus every form of iniquity took root in the Hellenic countries by reason of the troubles. The ancient simplicity into which honor so largely entered was laughed down and disappeared; and society became divided into camps in which no man trusted his fellow ... all parties dwelling rather in their calculation upon the hopelessness of a permanent state of things, were more intent upon self-defense than capable of confidence. (III. 82–3)

The final sentence of the preceding passage is especially revealing. The old Greek recognition of the unpredictable and irrational nature of human affairs and of the impossibility of a permanent state of things in the human world was re-asserting itself. The 'confidence' which had sustained a belief in order during the half-century following the Persian Wars was yielding to Archaic anxiety in an even more extreme form.

The decay of idealism and the growth of a conscienceless, tough-minded callousness which Thucydides saw as characteristic of all Greece, but particularly of

Athens, became increasingly apparent in the major successive phases of the war. During the first ten years (431 to 421 B.C.), Athens weathered the plague, contended with its restive allies, and launched moderate-sized expeditions in Thrace, western Greece, and even on the coast of the Peloponnesos. The Peloponnesians on their part invaded and ravaged Attica annually and opposed Athenian naval incursions when it was feasible. This phase of the war was on the whole inconclusive. Each side had managed to put enough pressure on the other so that in 421 B.C. they were willing to enter into a peace treaty which was designed to last fifty years (the 'Peace of Nikias').

But the basic causes of the conflict were not resolved, and by 418 B.C. the aggressive, opportunistic faction at Athens, led by Alcibiades, had formed an alliance with Argos which Sparta reasonably saw as a threat to its security. A second phase of the war began in earnest when the Athenians and Argives met the Peloponnesians in a large battle near Mantineia. The result was a decisive Spartan victory which broke up the Athenians' new alliance but failed to discourage them in a new series of acquisitive schemes such as the expedition against the island of Melos (416 B.C.) and the great Sicilian expedition of 415–413 B.C. Thucydides, without saying it in so many words, seems to have seen a process of *hybris*, *atē*, and *nemesis* at work in these expeditions. The Athenians justified their seizure of Melos, which had tried to maintain a position of neutrality in the Peloponnesian War, and their subsequent execution or enslavement of the entire Melian population, as Thucydides tells it, by a callous, pragmatic 'might is right' philosophy. This 'insolence' was followed by the deluded frenzy with which, overruling all voices of prudence and realism, they equipped the fleet which was to sail to Sicily, seize Syracuse, and found a grandiose western Athenian empire. And with such a background, the almost total annihilation of the Athenian army after protracted suffering and humiliation two years later, the drastic damage to its fleet, the crippling of its economy, inevitably seems, in retrospect, like *nemesis*.

In the final phase of the war (412–404 B.C.) the Peloponnesians concentrated on using their newly developing naval power to break up the Athenians' maritime alliance. With incredible resiliency, the Athenians, now torn by internal dissension and unstable leadership, their fleet weakened, their food supply impaired, fought back and even won a few victories, but a final great naval disaster at Aegospotami on the shores of the Dardanelles forced them to capitulate. Xenophon, Thucydides' successor as chronicler of the war, describes the lamentation which swept through Athens as many contemplated their impending doom after Aegospotami. Actually the end could have been much worse, as it had been for the Melians. The Spartans set up a tyranny of Athenian oligarchs ('The Thirty') in the city, but otherwise left

the populace unmolested. Athens still existed and would continue to exist. With a background of music provided by female flautists, many citizens eagerly went about the task of dismantling the city's fortifications and looked forward to peace. It could have been worse, true, but the energy which had created High Classical Greece was spent.

The psychological upheaval in Greece during the Peloponnesian War which is implicit in Thucydides becomes explicit in the greatest of the Athenian dramas of the time. Sophocles' *Oedipus Tyrannus*, produced in 429 B.C., almost at the beginning of the war, portrays a masterful ruler who enters the scene as a great riddle-solver, ferociously intellectual, flushed with confidence from previous success, optimistic, seemingly in firm control of his world but, significantly enough, faced with an inscrutable plague in his city. At the end of the play he is blinded and powerless, comprehending too late the nature of great forces of which he was not the master. Sophocles, religiously inclined and a traditionalist by nature, seems bothered in the *Oedipus* not by the blindness or irrationality of fate but by the blindness and inherent arrogance of the 'man is the measure' philosophy. The pride of the 'hymn to man' in the *Antigone*, written in the 440s (see p. 70), had turned to anxiety by the early 420s.

What appears as anxiety in Sophocles seems to become in the later dramas of Euripides a despairing recognition of the triumph of the irrational, which breaks through the orderly façade of the human intellect like an animal shattering a flimsy cage. Euripides had already sensed this at the beginning of the war when he contrasted the speciously logical and civilized figure of Jason against his demonic and unpredictable wife in the *Medea* (431 B.C.). In *The Trojan Women*, produced in 415 B.C. after the massacre at Melos, he voiced a shocked cry of despair at the conscienceless brutality which was infecting all Greeks; and finally, in the *Bacchae*, written toward the end of his life while in self-imposed exile in Macedonia (408–406 B.C.), he created a frightening picture of the total dominance of savage forces in man and nature. Pentheus, the hero of this last play, is superficially intellectual, skeptical, and confident; his adversary is Dionysos, the god *par excellence* of frenzy and self-abandonment. It is no contest. In the end Pentheus' severed head is carried onto the scene by his mother, who along with the other women of Thebes has torn him apart in a fit of madness inspired by the god.

Drama seems to relive in myth, as we have observed earlier, what Greece itself lived in fact. If the Greeks entered the Peloponnesian War with the confidence and power of Oedipus, they extricated themselves from it with only the sundered head of Pentheus.

Refuge in gesture

What kind of art would one expect to see produced during such an era? By analogy with other troubled periods, the late Roman Empire, for example, or Italy after the sack of Rome in 1527, one might naturally predict that there would be at least some traces of an agonized, tortured, insecure art, expressing the anxieties of the age. But the late fifth century confounds one's expectations. What actually appeared was a style which increasingly stressed grace, softness, the elegant flourish, the mastery of manner. In the period from 430–400 B.C. sculptors in particular devoted a great part of their attention to exploiting the decorative potentialities of the 'wind-blown' style of rendering drapery which had been developed by the sculptors of the Parthenon pediments.

The most conspicuous example of the new style is found in the reliefs of the parapet which surrounded the graceful little Ionic temple of Athena *Nikē* on the Acropolis [29, 30]. These reliefs, which ran around three sides (north, west, and south) of the bastion on which the temple stood, depicted *Nikai* (Victories) erecting trophies and bringing forward sacrificial bulls in the presence of Athena, whose seated figure occurs three times on the frieze (one on each side). The expressive effect on the Nikai was created almost wholly by the carving of their drapery. Smooth surfaces where the drapery is pressed against the body, revealing the anatomy beneath it, are contrasted with deep swirling furrows created by the use of a running drill. The relief medium enabled the sculptors to carry these furrows beyond the surface of the body itself, creating patterns of line and of light and shade which were totally independent of anatomical structure and could be elaborated for their own sake. The impression the Nikai give of being calligraphic designs quite as much as sculptural figures is further reinforced by their often arbitrary and only vaguely functional actions. The pose of the 'Nike adjusting her sandal' [50], for example, strikes one as a formal device designed to provide a semi-circular pattern in which the sculptor could give a virtuoso's display of his ability to vary the texture of the drapery in a series of parallel ridges; and the animated Nike from the north side of the parapet who is enwrapped in a beautiful flourish of waving furrows [51] seems to lay her hand on the head of the adjacent bull only as a token to duty. In these sculptures ornamental beauty has become an end in itself and to a great degree has usurped the role of meaning or 'content' in the specific narrative sense. It is true that they do have a general overall theme – victory, and that the Nikai may be thought of as engaged in a very casual processional movement toward Athena, but compared to the Parthenon frieze where each group of figures was planned so as to contribute through both its form and meaning to a single great design and subject, the parapet seems almost aimless. The

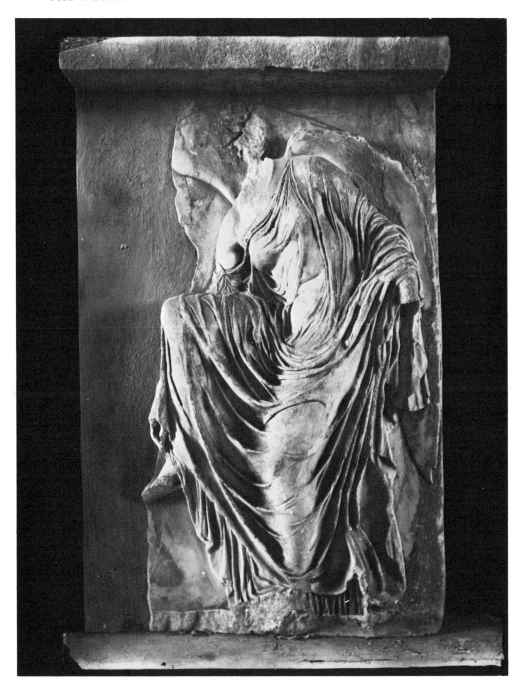

50. Nike adjusting her sandal, from the south side of the parapet of the temple of Athena *Nikē*, marble, *c.* 420 B.C. Height approx. 3′ 6″.

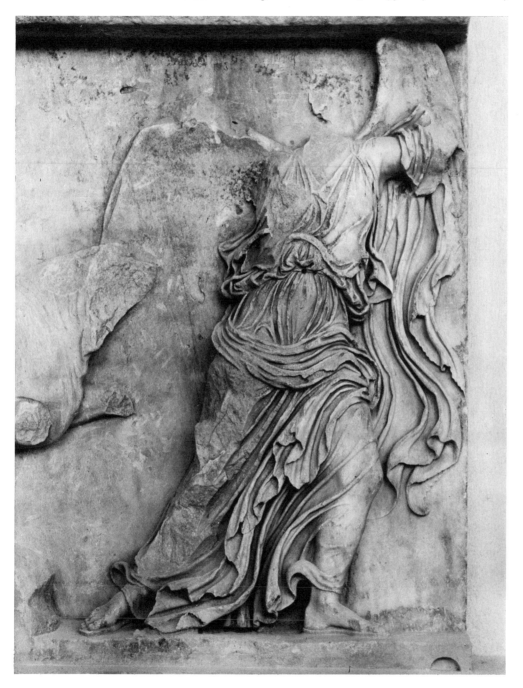

51. Nike, from the north side of the parapet of the temple of Athena *Nikē*, marble, *c.* 420 B.C.
Height approx. 3′ 5″.

very fact that Athena appears thrice, like an ornamental motif, seems to say that the subject is just for show and that it is the ornamental function which counts. The Nikai perform a beautiful ballet, but the choreography seems designed to divert one from giving too much thought to the question of just what the dance is about.

Not all the relief sculpture of the later fifth century is as purely ornate in character as the Nike parapet. Battle scenes, for example, which were a venerable form of decoration in Greek architectural sculpture, continued to be produced in temples and in the renascent form of grave monuments. The specific battles represented could be historical, as on the great rider relief in the Villa Albani which probably dates from the early 420s and may have formed part of a public funeral monument in Athens, or mythological, as on the curious frieze from the interior of the cella of the temple of Apollo at Bassae which represents a Centauromachy and an Amazonomachy [52] (see pp. 126 ff.).[1] But even when there is a specific narrative content to these reliefs, their purely decorative character is very marked. The combatants are strung out in neatly designed groups, and the actions of the individual figures become poses set off against a background of billowing capes and fluttering tunics. A kind of theatrical excitement is generated, not by the pathos of battle, but by the carefully staged flourishes of the actors' costumes. Decorative manner, not subject matter, is still what really engages the artist's attention.

While good examples of it are fewer, the florid, flying drapery style was also apparently widely applied in free-standing sculpture. One of the most striking examples is a female figure, perhaps an Aphrodite, which has been pieced together from fragments excavated in the Athenian Agora in 1959 [53]. The busy play of lines everywhere over the surface of the figure, particularly the explosive motion with which the *himation* rises over the left hip and arm, seems to be reaching beyond calligraphic elegance toward an expressionistic rendering of nervous excitement. An even greater display of technical virtuosity, although not necessarily of expressive power, is the Flying Nike by Paionios of Mende [54]. This

[1] The Ionic frieze from the temple of Athena *Nike*, probably finished a few years before the parapet, poses an iconographical problem. There can be little doubt that its battle scenes, in which Greeks appear to be fighting a combination of Orientals and other Greeks, represent a specific subject or subjects, but whether the subject is historical or mythological is not clear. It may represent one or more episodes of the Persian Wars (Greeks fighting Persians and also the Greek allies of the Persians), in which case it should perhaps be classified along with the Parthenon frieze as one of those instances in which the Athenians showed themselves in a context usually reserved for gods and heroes. The frieze could, however, represent the Trojan War – i.e. Greeks fighting Trojans and their oriental allies, who are given a 'modernized' form of oriental dress. Or, even if it does represent the Persian Wars, one might argue that by the 420s B.C. that war was beginning to be thought of as part of the heroic past and to seem increasingly remote from present realities.

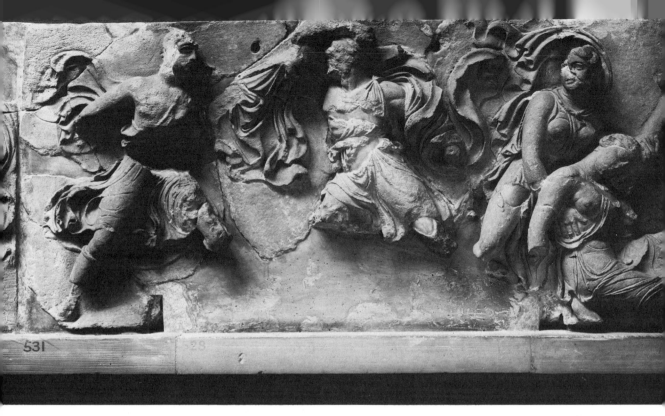

531

52. Amazonomachy, from the frieze of the temple of Apollo *Epikourios* at Bassae, marble, *c.* 420 B.C. Height $25\frac{1}{4}''$.

image was set up on top of a tall pillar in the sanctuary at Olympia to commemorate a victory of the Messenians and the Naupaktians over an adversary which is unnamed in the dedicatory inscription but seems to have been the Spartans.[2] When seen by the viewers below, the Nike would have seemed to be alighting on the pillar amid a violent swirling rush of air which both pressed her *chiton* tightly up against her body and at the same time churned it into great deep folds behind her. Her *himation*, now largely broken away, seems to have billowed out into a great canopy which framed the entire figure. Elegant refinement strikes a balance with action and excitement. A similarity in spirit to her sisters on the Nike parapet is evident, and reinforced as it is by detailed similarities in the handling of the drapery, has suggested to Rhys Carpenter and others that one of the

[2] The Messenians and the Naupaktians fought alongside the Athenians against the Spartans in an engagement at Sphacteria and Pylos in 425 B.C. It seems likely that the Nike was set up several years after this date, perhaps during the Peace of Nikias. When Pausanias visited Olympia in the second century A.D. his informants told him that this was in fact the battle which the Nike commemorated, but since it seemed unlikely to him that the Messenians and the Naupaktians would have been so bold as to taunt the still powerful Spartans in this way, he suggested that the figure might rather commemorate an obscure expedition against Oiniadai in 452 B.C. The style of the statue, however, makes it almost certain that the information which Pausanias' informants gave him was accurate.

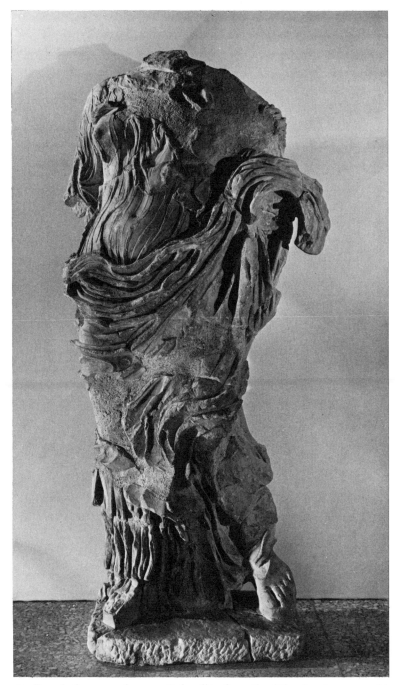

53. Female figure, perhaps an Aphrodite, from the Athenian Agora, marble, *c.* 420 B.C. Height as preserved, approx. 6′.

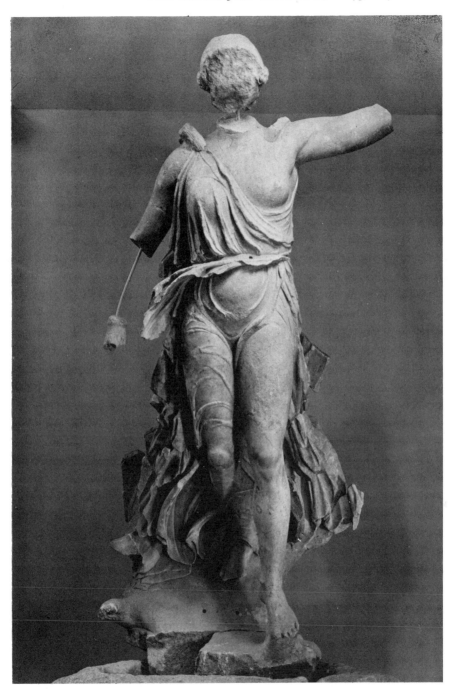

54. Nike, by Paionios of Mende, marble, *c.* 420 B.C. Height 7′ 1″.

hands detectable on the parapet ('Master B' [51]) is, in fact, that of Paionios.[3]

The development of this flying drapery style has sometimes been seen as part of an inevitable evolution in sculptural technique, an evolution directed toward solving the problem of how to sculpture a draped figure in movement so that its drapery gives the impression of plasticity and yet does not obscure the integrity of the body beneath it. Technical problems of this sort were no doubt continually of concern to Greek sculptors, but this technical challenge alone cannot explain the prevalence of the florid style in the last three decades of the fifth century. It clearly represents a taste of the age and must have answered an emotional need, both for its users and its viewers. Artistic styles are products of conscious choice, and one may well doubt that there was any irresistible evolutionary force which could have compelled the Greek sculptors, robot-like, to create the flying drapery style if they had not wanted to. Cultural conditions must have made it desirable, rather than technical evolution inevitable.

A sufficient indication of this is the popularity of the style in vase painting, where the technical problems which might seem to make its use in sculpture inevitable do not apply. (The effect of transparency can be achieved in painting regardless of the patterns of folds which are employed for the drapery.) In vase painting too there is a movement toward an elegance, prettiness, and essentially feminine refinement both in the rendering of subjects and, increasingly, in the choice of them. The animal vigor of much Archaic painting and the ambitious attempts to express character and idealism in Classical painting succumb to a style which is undemandingly pleasant. Satyrs no longer seem a threat; maenads are fundamentally well-behaved; warriors no longer give the impression of really wanting to hurt one another. Vase painting adapts itself to what seems to be a world of cosmetics and subdued conversation.

Representative of the best typical work produced early in this period is a *lekythos* in Berlin by the Eretria Painter (active mainly 430–420 B.C.) showing Dionysos seated among Satyrs and Maenads. The transparent, gently fluttering drapery of the Maenad who gracefully dances to the left of Dionysos, and the relaxed, casual, anecdotal poses of most of the figures on the vase relate it both in style and spirit to the Nike parapet. Later in the century the work of the Meidias Painter and his school uses the flying drapery style with a theatrical flourish which is akin to the frieze from the temple at Bassae. The large *hydriai* which are the Meidias Painter's masterpieces cannot be comprehended in single photographs, but the details illustrated here can be taken as typical of the range of his style. In the scene on the

[3] Cf. *The Sculpture of the Nike Temple Parapet* (Cambridge Mass. 1929) pp. 35, 78.

shoulder of a *hydria* in the British Museum depicting the abduction of the daughters of Leukippos by the Dioskouroi [55] there is a stagey excitement created by the billowing cloaks of the abductors and of the fleeing females below (Peitho and Agave), but it is an excitement of manner only. Nothing is allowed to interfere with the display of fine costumes and elegant poses. The daughters of Leukippos put up a token of resistance but not enough to dishevel their delicate transparent gowns and neat coiffures. The Dioskouroi have more of the lover's dash than the abductor's ferocity. Aphrodite, seated at her altar in front of a quaint archaic cult image, and Zeus seated to the far left, are calm, as befits their status; the ladies below exhibit a certain distress, *pro forma*. But no one really misbehaves badly, and there is really nothing to fear. One feels that ultimately the result of the abduction will be a scene like that on a *hydria* by the Meidias painter in Florence on which Adonis, seated on the lap of Aphrodite, is advised by Himeros, the winged child god of 'Yearning', while Pannychia ('All-Night Revel') beats a tambourine and the nymphs Hygieia ('Health') and Paidia ('Childish Amusement') gossip together with the intimacy of schoolgirls.

When compared with the Parthenon, which gave expression to a wide range of cultural tensions, achievements, and aspirations, the art of the late fifth century often seems, as we have said, devoid of serious content. It shows a fascination with technique and exalts ornamental elaboration above subject matter. At the same time it seems clear that the florid style was consciously selected and developed by the artists of the period to express a particular state of mind. These two viewpoints – that the florid style was relatively devoid of content and yet was consciously chosen for its expressive power – are not necessarily paradoxical. The individual works in question may often seem purely ornamental, but the style, taken as a whole, can be said to have an intrinsic meaning. An art which dwells on surface manner can be quite as significant in its own way as an art which overtly strives to embody soaring ideals.

What, then, is the significance of the style which we have been analyzing? We noted earlier that, in view of the political conditions of the age, one might expect to find a parallel for the despair and dramatic pathos of Euripides in the visual arts of the time, but such expectations are not really fulfilled. It is true that the Euripidean dramas have certain ornamental qualities, particularly in their choral odes, which might be said to reflect the attitude inherent in the flying drapery style. But on a profounder level works like the reliefs of the Nike Parapet are distinctly un-Euripidean; they offer us a kind of excitement but are not genuinely dramatic. Perhaps in looking to Euripides for parallels to the development of the visual arts we are setting our sights too high and should turn instead to the other great literary

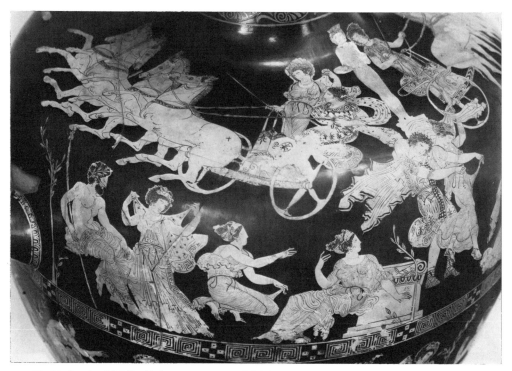

55. *Hydria* by the Meidias Painter, *c.* 410 B.C. Height of complete vase 20½″.

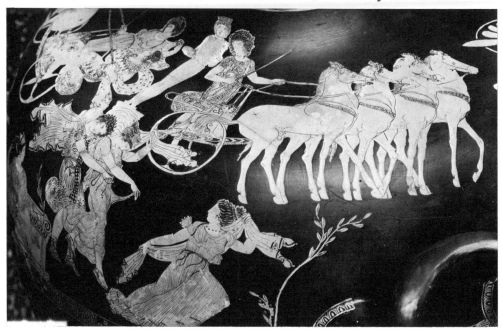

phenomenon of the later fifth century – the development of stylistic analysis in rhetoric. The rhetoric 'boom' of the late fifth century may also, like developments in drama, have been a reaction to the disillusionment of the age, but the direction in which the reaction moved was different. The most influential rhetorician of the age, Gorgias of Leontini (*c.* 483–376 B.C.) expressed doubt, in a philosophical treatise, that men could ever attain real knowledge and therefore turned his attention instead to the means by which one's opinion could be made persuasive. These means were the devices of rhetorical style – antithesis, assonance, rhymes etc. – which had an appeal that was independent of the ideas they might be used to express. We know that some of Gorgias' rhetorical display pieces, like the *Encomium on Helen*, were completely frivolous in content, their technique being everything and their subject matter accessory. Many of those who were influenced by Gorgias were perhaps not in a position to appreciate the philosophical skepticism which led him to concentrate on the means of persuasion but somehow felt, if we may believe Plato, that in mastering rhetorical style they were gaining control over a kind of magical force which would bring the world under their control. The general appeal of Gorgian rhetoric, it would seem, was not only unrealistic but even *escapist*.

Now the flying drapery style is obviously Gorgian in spirit, and appears to emanate from the same pressures as contemporary rhetoric. On the surface it is all elegance, but underneath it may reflect a despairing desire to retreat from the difficult intellectual and political realities of the age and to take refuge in gesture. Escapist wish-fulfillment is perhaps just as common a reaction to troubled times as overt agonizing. In the great depression of the 1930s the most popular motion pictures often centered on a stylish and carefree hero and heroine who tap-danced their way with unfailing elegance through a series of soothing, inconsequential episodes to an inevitably happy, if never very believable conclusion. The Nikai of 430–400 B.C. may seem to be swirling their way toward a similar goal, yet one can never quite forget what they are trying to leave behind.

Ancient cults in new shrines

Another effect of the psychological shocks which the Greeks experienced during the Peloponnesian War seems to have been a new direction in Greek religion. Many indications are discernable of a shift in attention away from the group-oriented state religion, in which the individual was important only insofar as he was a participant in the *polis*, toward cults which involved a personal and emotional relationship with the deity. The former reaches its supreme manifestation in the Parthenon, while the latter is perhaps epitomized by the importation from Epidauros to Athens in 420 B.C. of the cult of Asklepios, the god whose miraculous

intervention soothed and healed the afflicted. An unusual religious fervor, with strange mystical and personal elements, marked the god's arrival. His sacred serpent was paraded through Athens in a great procession, and the cult seems to have been temporarily housed in the residence of the poet Sophocles, who was said to have had a vision of the god.

The emotional and mystical tendencies which appeared at this time and which were to become the central focus of Greek religion in the Hellenistic period not only eventually produced new mystery cults, like that of Serapis, which offered the hope of personal salvation, but also spurred a revival of interest in ancient cults whose irrational and mysterious elements only enhanced their attraction. A mystical tradition, having its roots in the Bronze Age and represented in later times principally by the Eleusinian Mysteries and the cult of Dionysos, had always had a place in Greek religion, but the confident rationalism of the period between 480 and 430 B.C. had forced it into the background. That it began to surge to the foreground again in a period in which disillusionment was tinged with an urge to escapism is not surprising.

In the visual arts the beginnings of this new religious psychology are most apparent, appropriately enough, in temple architecture, above all in the temple of Apollo *Epikourios* ('Apollo who brings help') at Bassae in Phigaleia, a remote, mountainous corner of Arcadia [56]. According to Pausanias this temple was built for the Phigaleians by Iktinos and was intended as a thank-offering to Apollo for having stayed the plague of 429 B.C. While it is very unlikely that Pausanias' information is completely false, some of the observable details of the temple leave room for doubt as to whether it is completely true. The peripteral colonnade, for example, has much in common with the temple of Zeus at Olympia of *c.* 470–457 B.C. (its proportions and certain carved details of the columns; thickening of the end columns on the north; a recessed band at the bottom of each step; metopes over the *pronaos* and *opisthodomos*) but lacks the subtle horizontal curvature and other refinements of the Parthenon. Unless we assume that Iktinos consciously rejected his Parthenon experience and deliberately designed an old-fashioned temple based on Peloponnesian prototypes, it is difficult to believe that he designed the Bassae temple after his work in Athens. Furthermore, since an earlier temple dedicated to Apollo *Epikourios* had stood on the same site, the god's surname alone cannot be taken as proof of an association of the later temple with the plague described by Thucydides. If one must associate the name of an architect with the temple, Libon would be a better candidate.

The interior of the cella, on the other hand, is strikingly original and forward-looking in design [57]. Engaged in the walls of its main chamber on each side were

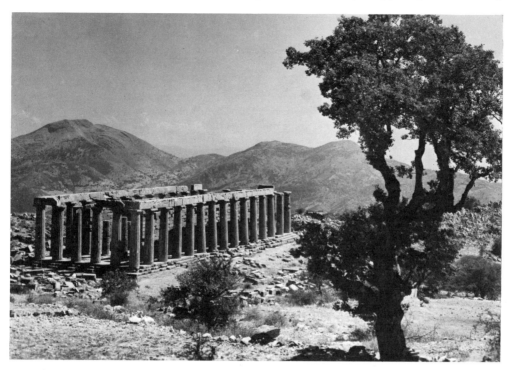

56. Temple of Apollo *Epikourios* at Bassae, from the northwest, *c.* 450–420 B.C. Height of columns: 19′ 6½″.

spur walls which culminated in half-columns. The first four opposing pairs of these columns as one entered through the main portal on the north were Ionic with wide flaring bases and soaring bow-shaped capitals. In the center of this room at its far end stood a Corinthian column, the first of its kind in Classical architecture; and the two diagonally projecting spur walls on either side of it may also have had Corinthian capitals.[4] All of these columns were set on the edge of a rise in the

[4] The Corinthian capital or capitals from Bassae are now lost. Modern graphic restorations of them are based on drawings made in the nineteenth century by the German architect Haller von Hallerstein. Since the drawings seem to show fragments of more than one Corinthian column, William Dinsmoor has proposed that there were, in fact, three such columns at the south end of the *naos* and claims that circular cuttings in the upper drums of the diagonally projecting spur walls confirm this: cf. 'The Temple of Apollo at Bassae', *Metropolitan Museum Studies* 4 (1933) 209–12; also *The Architecture of Ancient Greece* (London 1950) p. 157. A restoration of the interior of the temple by Fritz Krischen, *Die Griechische Stadt* (Berlin 1938) pl. 40, ignores Dinsmoor's proposal and shows only one Corinthian column. Krischen's restoration has sometimes been reproduced in more recent works (e.g. John Boardman *Greek Art* (London 1964) p. 139), but whether this is done simply out of convenience or as an indication of scepticism about Dinsmoor's proposal is not clear. The restoration with three Corinthian columns illustrated here was published by A. Mallwitz 'Cella und Adyton des Apollontempels in Bassai', *Mitteilungen des deutschen archäologischen Instituts, Athenische Abteilung* 77 (1962) pp. 140–77.

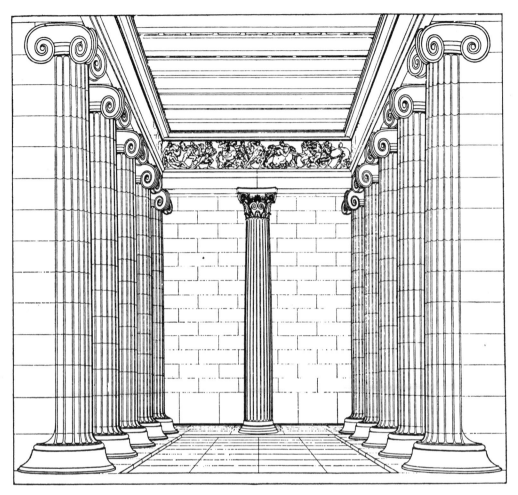

57. Temple of Apollo *Epikourios* at Bassae, reconstruction of the interior. From F. Krischen, *Die griechische Stadt* (Berlin 1938).

floor level, giving the impression of a stylobate for an interior court. Above the columns and their architrave ran a continuous Ionic frieze depicting familiar themes: Greeks fighting Amazons and Lapiths struggling with Centaurs [52]. Behind the Corinthian columns was a space which formed in effect a separate

chamber, like the *adyton* in the temple of Apollo at Delphi, and was illuminated by a door on its east side. Since the entrance to the temple faced north the eastern doorway may be an adaptative concession to the more common east–west orientation, and it is possible that a cult image was placed in this rear chamber so as to face the rising sun through the east door on the feast day of the god. The effect of these new and unusual forms must have been astonishing to those who first saw them: the Ionic columns soared up into the dimness of the ceiling where the wild fray of the frieze, sophisticated in design but strangely heavy and rustic in execution, stretched out in semi-darkness; at the far end a new, leafy column form dominated the central axis; and behind it hovered the *adyton* illuminated by an unfamiliar light. A new architectural language, perhaps designed to express a new feeling about religious experience, was taking shape.

Unlike the exterior of the temple, there are many reasons for believing that this arresting and carefully considered interior might have been designed by Iktinos after his work in the Periclean building program. It was he who first made extensive use of the Ionic column and frieze in the interior of a Doric temple. His exedral arrangement of the columns in the cella of the Parthenon (see p. 78) attests an interest in experimenting with the expressive effects of interior space. It is also known that he drew up, but was not able to execute, a design for the *Telestērion* at Eleusis, the great sacral hall in which the mysteries took place. The *Telestērion*, significantly enough, was one of the relatively rare Greek buildings in which interior space was all-important. And finally, the date suggested by the style of the frieze, 420 B.C. or even a little later, clearly indicates that at least part of the construction of the cella of the Bassae temple belonged to a period after the Parthenon and after the plague.

It is known that Greek architects erected the exterior colonnade of a temple first, then proceeded to the interior structure, and finally installed the roof. Perhaps the Bassae temple was begun *c.* 450 B.C. by a Peloponnesian architect, but for political or financial reasons was left incomplete for some years. After the plague the unfinished state of the structure would have seemed a dangerous sacrilege, and the Phigaleians might well have turned to the most prominent architect of the day to finish it for them. The Peace of Nikias of 421–415 B.C. would have made it possible for an Athenian architect and his assistants to travel to Arcadia to put the final touches on the building, in which case the inwardly directed, personal, mysterious interior of the Bassae temple might well be considered a reflection of the psychological disposition of Athens at that time.

The puzzling strangeness of the interior of the Bassae temple is inherent in its separate details as much as in its total arrangement. One wonders, for example,

whether the Corinthian capital was intended to have any religious or cultural connotations. There is a tradition that this type of column was invented by the sculptor Kallimachos, who conceived the idea for it after seeing acanthus leaves growing around a basket on top of a gravestone. Grave stelae with capitals consisting of floral ornament and volutes existed in Athens in the Archaic period, and what seem to have been cylindrical gravestones surmounted by acanthus ornament are represented on white-ground *lekythoi* of the late fifth century. Did the Corinthian capital, in the beginning, have some association with the worship of the heroized dead, an association not altogether inappropriate in a form conceived in the wake of the plague? Or was it supposed to call to mind forms which were ancient and half-forgotten like the floral capitals which were common in the ancient Orient and had sporadic use in Archaic Greece? Or did its formalized floral form, following the same line of thought, call to mind some of the primitive, agrarian, or at least un-Olympian, institutions of Greek religion, like the laurel associated with Apollo at Delphi, the oak sacred to Zeus at Dodona, and the olive tree of Athena on the Acropolis in Athens? In this connection it is interesting to note that Kallimachos devised, in the words of Pausanias, 'a bronze palm tree', perhaps something like a Corinthian column, in the chamber of the Erechtheion where the most ancient image of Athena *Polias* was kept. The 'bronze palm tree' served to carry smoke from a lamp which burned in front of the image up to the roof, but perhaps it was also in some way symbolic, like the olive tree, of Athena's ancient aspect as a nature goddess.

On the other hand, if one chooses to leave the speculative question of religious connotations behind, it is possible to see the Corinthian column as a purely formal architectural solution to the problem of combining the height of the Ionic column, especially useful in the interior of a building, with the unity of aspect which a circular column capital (e.g. the round Doric as opposed to the square Ionic capital) permits. Symbolic and practical functions of architectural forms, especially in religious art, are not, of course, mutually exclusive. The dome in Byzantine architecture made possible a large, unobstructed space for group worship; it also served as a symbolic dome of heaven overhead. We have already seen in the Parthenon how practical necessity was used as a touchstone in the search for new dimensions of expression (see p. 72). The same, as will be suggested, was true in the planning of the Erechtheion, and perhaps to a great extent of Greek art as a whole.

In the case of the frieze of the Bassae temple it is also difficult to determine where concessions to pragmatic circumstances leave off and deliberate manipulation of form begins. The frieze is very modern in design (see p. 118) but often heavy and

crude in execution. Is it deliberately made rustic and rude so as to connote, perhaps like the Corinthian column, the primitive forces which might seem to be present at this remote Arcadian site? Is it simply not completely finished? Or was the design of an Athenian master (Kallimachos?) executed by only moderately skilled local artisans?

The north–south axis of the temple also poses an interpretive challenge. The position of the earlier and presumably much smaller temple of Apollo dictated the site of the fifth-century temple, and the terrain at this point would have made an east–west orientation impossible without some elaborate terracing. One is inclined to doubt, however, whether this practical consideration alone would have prevented the architect from adhering to the more familiar orientation if he had been strongly inclined to use it, and it has therefore been suggested that there were religious factors which made the north–south axis desirable. A. W. Lawrence has suggested, for example, that the temple was intentionally aligned so as to face toward Apollo's primal shrine at Delphi; and Vincent Scully has argued that the position of the temple is calculated so as to link Mt Kotilion, sacred to Artemis and Aphrodite, on the northwest, Mt Ithome, sacred to Zeus, on the south, and Mt Lykaion to the east, in a visual and psychological complex 'which expresses a double reverence in its form: both for the mighty earth, with all its power, and for man, with the god who champions his lonely acts upon it'.[5] However one chooses to interpret its details, the temple of Apollo at Bassae seems to be measuring in all its forms the human intellect's ability to order and analyze against the ancient, mysterious, uncertain forces which are the intellect's substratum and, at times, its undoing.

Perhaps less startling than Bassae but no less complicated is the Erechtheion [29, 30, 58] on the Athenian acropolis, a building which must have been projected, in some form, by the original planners of the Periclean building program but was not actually constructed until 421–406 B.C. This structure was designed to replace the Peisistratid temple of Athens *Polias* (situated between the present Parthenon and Erechtheion) which was burned by the Persians. Dinsmoor has suggested that at first an Ionic tetrastyle amphi-prostyle temple was projected on the foundations of the old temple, but when a portion of the old cella was repaired and came to be used as a treasury, the new structure had to be moved to its present site on the northern edge of the Acropolis. The surface of the Acropolis in this area sloped sharply so that the foundations on the west end of the building were much lower than those on the east. This irregular terrain forced a redesigning of the east

[5] A. W. Lawrence *Greek Architecture* (revised edition, Harmondsworth 1962) p. 178. V. J. Scully *The Earth, the Temple, and the Gods* (New Haven and London 1962) pp. 124–5.

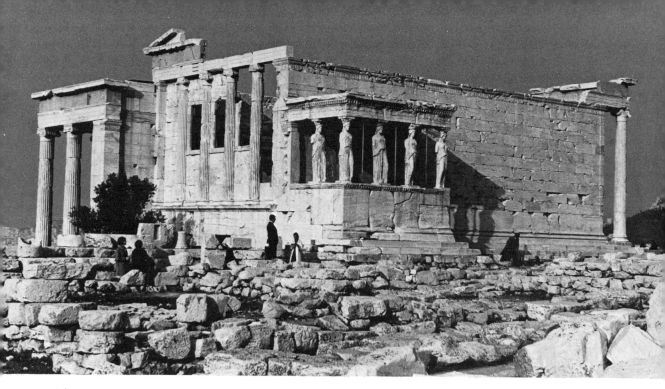

58. The Erechtheion from the southwest, *c.* 421–405 B.C. Height of the engaged columns on the west front 18′ 5″.

and west ends of the building: on the higher east end the Ionic columns were reduced in size and increased in number to six, while on the west Ionic half-columns engaged in piers between antae were made level with the eastern colonnade by being set on an ornamental ledge atop a sheer wall over ten feet high. Between the half-columns lattice-work screens admitted light into the western chambers of the building (the present marble walls and windows are a Roman alteration). Materials which had been prepared for one of the originally planned porches (but which could not be used because they were too large for the east end of the temple on its new site and would have interfered with important shrines and relics on the west) were used for a north porch, and the Caryatid Porch on the south was designed to balance it and relate the building as a whole to the Parthenon. These adjustments, not provable but not improbable, could be viewed simply as a skilled architect's adaptation to new and difficult circumstances.

But the details of the Erechtheion suggest that the designer did more than simply adapt; he seems in fact to have welcomed the opportunity which the new position of the building offered him to create a startling composite shrine in which, as at Bassae, cryptic and puzzling unorthodoxies confronted one at every turn. The area which the Erechtheion eventually occupied includes the most ancient shrines of the Acropolis, sites connected with fertility cults, chthonic deities, and hero

cults whose origins stretched into the remote Bronze Age and perhaps, in cases, even into the Stone Age. Here were the tombs of Kekrops, Erechtheus, and Bootes, early kings of Athens; the miraculous olive tree of Athena; the trident mark and saline springs left by Poseidon; the crevice in which the child god Erichthonios guarded the Acropolis in serpent form; a sanctuary of Pandrosos, the 'moistener of all', one of the three daughters of Kekrops who went mad and jumped from the Acropolis when they beheld Erichthonios in the form of a snake-legged child; and other shrines as well. Such a site, the architect (or architects) must have felt, defied enclosure in a rational, geometrical, symmetrical Classical structure.

Rather than reorganize and Olympianize the ancient traditions which he found, as had been done in the Parthenon, the architect decided to enclose them all in an expanding structure whose entrances, passages and levels were as mysterious as the ancient cults themselves. The east entrance of the temple led to a large chamber in which the ancient wooden statue of Athena, the one which tradition said had fallen from heaven, was housed along with the ever-burning lamp and bronze palm tree of Kallimachos. This shrine of Athena was completely separate from the three rooms in the western half of the main block of the temple which were situated at a lower level and could be entered from three sides: through a great ornamental doorway from the north porch, by a small stairway leading from the Caryatid porch, or through a simple doorway on the west. The smaller rooms of this western section were apparently the shrines of Bootes and Hephaestus, while the larger room contained an altar to Poseidon and Erechtheus and apparently overlay the saline pool sacred to Poseidon. The north porch was one of the most elegant and rich Ionic structures of Antiquity, but the architect did not hesitate to build a strange shaft into its floor so as to reveal the sacred trident marks of Poseidon and to leave a hole in its roof so that the trident marks could face the open sky. He also equipped the porch with a subterranean doorway on its east side leading down to a crypt and to a den for a sacred snake beneath the building; and he let its west end project beyond the end of the main block of the temple so that another door-way could lead into the irregularly shaped courtyard to the west. The junction of the north porch with the main block at this point seems so astonishingly uncanonical and even awkward as to make some scholars believe that the west wall was originally intended to project still farther to the west. But in a temple which enshrines irrationality, we cannot be certain that purely architectural irrationalities are not deliberate. The western courtyard enclosed the sanctuary of Pandrosos, the olive tree of Athena, and most strangely, the tomb of Kekrops, which was partly open and partly hidden beneath the southwest corner of the building and the south porch.

The Erechtheion, then, does not try to bring strict order out of pre-rational tradition; rather, in keeping with the spirit of its time, it is willing to yield to this tradition, to explore it, to merge into it. The extreme richness of the building's ornament gives it the feeling of what Gottfried Gruben has aptly called 'a luxurious reliquary on the scale of the temple'.[6] The rich Ionic mouldings which abound in the temple, especially the anthemion pattern crowning the walls and *antae* and running beneath the Ionic column capitals; the richly carved capitals and bases originally gilt and inlaid with multicolored pieces of glass; the rosettes of the entablature of the south porch and the ceiling of the north porch; and the frieze, which consisted of cut-out marble figures doweled to a background of dark Eleusinian limestone like ivory inlays on a piece of furniture – all help to give the impression of a grandiose ritual chest in which were preserved the sacrosanct symbols of a mystic rite.

If there were more well-preserved monuments, we undoubtedly could find still other examples of provocative architectural unorthodoxies, particularly in interior design, in the late fifth century. A temple to Apollo on Delos built by the Athenians around 425 B.C. (the 'Athenian temple'), for example, was hexastyle amphiprostyle and had a cella consisting of four pillars *in antis* leading to a main chamber with a large semicircular pedestal on which stood seven statues. The interior coffered ceiling of the temple followed the slope of the rafters and had two interior pediments. Here too architecture seems to have been turning inward.

Outside Athens

If this chapter has dealt primarily with the art of Athens or monuments created by artists trained in Athens, it is because Athenian political initiative and the experiences which that initiative brought to pass, gave the later fifth century its distinctive character, and because it was Athenian art and literature which embodied that character. Moreover, the other artistic centers which continued to exist in this period as they had in the past, seem to have come increasingly under the influence of the Athenian style. The disciples of Polykleitos at Argos, for example, who were very active later in the century, and whose independence from Athens is emphasized by the fact that they executed an elaborate votive monument at Delphi set up by the Spartans to commemorate their victory over the Athenians, seem to have specialized in superimposing an Athenian elegance and gracefulness on the master's austere architectonic formulae. At least this is what we must conclude if the Roman copies which are usually associated with this school – e.g. the 'Narcissus' type – are in fact products of it. Even Polykleitos

[6] H. Berve, G. Gruben *Greek Temples, Theatres, and Shrines* (New York 1962) p. 389.

himself, as we have noted earlier, seems to have come under Athenian influence in his later years (see pp. 108–10).

It is possible that migrant artists who were not necessarily Athenian citizens but had learned their trade in the palmy days of the Periclean building program played a role in spreading the Athenian style to other parts of Greece. The appearance of the full-blown flying drapery style on the Nereid monument, a tomb built for a barbarian prince in Lycia around 400 B.C., would only seem explicable on this basis. Like the footloose Greek warriors whose daredevil march into Asia is described in Xenophon's *Anabasis*, the sculptors of the Nereid monument may have been refugees from an age of bewilderment and destruction searching for new opportunities in a new country.

5 The world of the individual

The fourth century and its Hellenistic legacy

In the conventional terminology used to describe the significant phases in the development of Greek art, the phrase 'the fourth century' normally refers only to the period from about 400 B.C. to the death of Alexander in 323 B.C. The 'fourth century' is usually seen as the last phase of Classical Greek art, and is distinguished from subsequent 'Hellenistic' art, the art produced during the period from 323 to 31 B.C., when the Mediterranean world was at first dominated by the Macedonian royal dynasties founded by Alexander's successors and later by the growing power of Rome.

In many ways the conventional distinction between the fourth century and the Hellenistic period is justified. The general types of monuments which fourth-century artists were called on to execute tended to be similar to those of the fifth century, as were the sources which commissioned them. And many stylistic mannerisms – patterns of composition, methods of rendering hair, musculature etc. – represent logical extensions of fifth-century practices. But if one approaches the art of the fourth century from the standpoint of *what it expresses*, rather than from the standpoint of formal stylistic analysis, it is possible to make a case for its having more in common with the art of the succeeding Hellenistic Age than with its High Classical precedents. In fact, one might view the period from the early fourth century B.C. to the late first century B.C. as a continuum, with the major break between 'Classical' and whatever one chose to call the succeeding era occurring around the end of the Peloponnesian War.

High Classical Greek art, as represented by the Parthenon frieze, had taken group experience and a faith in the attainments of an entire culture as its principal theme. It was the product of an age which was inclined to believe that human beings through their own rational thought and action could perfect their environment. It was an art, one might say, which seemed to be trying to apotheosize the community and its values.

The Peloponnesian War, as we have seen, shattered this state of mind, and a

feeling of disillusionment and withdrawal followed. In line with this new state of mind, art in the succeeding centuries tended increasingly to reflect the experiences and values of man as an individual rather than man as a participant in the community.

Personal experience and the *polis*

What is remarkable about the political events of the first half of the fourth century is their demonstration of how little the Greeks learned from the Peloponnesian War and how little change there was in the corporate behavior of the city-states. The lessons of Athens' earlier mistakes, for example, seems to have been lost on the Spartans, who dominated Greece for the first two decades of the century and who proceeded to treat the 'liberated' cities of Athens' Aegean confederacy with even greater harshness. The cities of Asia Minor were turned over to Persia as payment for subsidies rendered to Sparta in the latter part of the Peloponnesian War, and elsewhere either oppressive pro-Spartan oligarchies, as at Athens, or direct Spartan governors were installed. Now securely in power, the Spartans also began to treat their former Peloponnesian and Boeotian allies with callous indifference, and when Cyrus the Younger's unsuccessful *coup d'état* revealed internal weaknesses in Persia, they turned against the Persians too. A series of Spartan campaigns in the early 390s under the ambitious leadership of King Agesilaus not only took back the Greek cities of Asia Minor but even raided the interior of Anatolia. To discourage Spartan ambitions the Persian king, Artaxerxes II, organized a fleet which was partly under the command of Conon, an Athenian admiral who had escaped from the disaster at Aegospotami, and also sent agents to Greece to bribe Corinth, Argos, and Thebes to turn against Sparta. While these events were in progress the democratic faction in Athens had re-asserted itself, and, without actually abrogating the peace agreement with Sparta, expelled the pro-Spartan oligarchic tyranny from the city. Together these four cities launched an attack on Sparta, and although they were defeated in a battle near Corinth in the spring of 394 B.C., Spartan expansion was checked.

In the following autumn the Persian fleet under Conon destroyed Sparta's budding naval power in a battle off Knidos. Agesilaus was forced to withdraw Spartan forces from Persia to face the allied cities in a second battle at Coronea near Thebes. The Spartans again won a victory of sorts but were afterwards compelled to withdraw to the Peloponnesos and assume a defensive strategy. Conon, with Persian support, sailed back to Athens as a hero, and, scarcely more than ten years after the end of the Peloponnesian War, the Athenians began to rebuild the long walls to Peiraeus and were re-established as an independent power.

After several further skirmishes in which, significantly, mercenary forces played an increasing part, a peace conference was arranged by the Spartans and the Persian King. In a manner which would have seemed humiliating in the previous century, delegates from Greece gathered at Sardis to hear the terms of a pact which returned the Greek cities of Asia Minor to Persian control and provided for the independence of most other Greek cities (387/386 B.C.).

Sparta interpreted this treaty, however, as a license to break up the alliance of other cities and restore oligarchies favorable to herself, and the next fifteen years of the century were occupied with resistance movements led by Thebes and Athens. The Thebans eventually organized a powerful confederacy of Boeotian cities, and Athens resurrected, on a more liberal basis, its old Aegean confederacy. The culmination of the resistance to Sparta came in a battle in 371 B.C. near the Boeotian city of Leuctra, in which the Thebans, using new tactics devised by their brilliant general Epaminondas, defeated the Spartans and irreparably shattered both their military reputation and their actual power. Thereafter, Thebes had its brief place in the sun. During the years 370–365 B.C. Theban expeditions raided Laconia and broke up Sparta's venerable Peloponnesian alliance. Democratic factions took control in many cities of the Peloponnesos, and new federal alliances of cities were formed. At the same time Athens, in an incredible but perhaps typical fashion, began to worry about Thebes' expanding power, and to soothe its anxiety, entered into an alliance with its ancient enemy Sparta (369 B.C.).

In the following two decades the various cities and leagues continually aligned and realigned themselves according to ephemeral notions of their self-interest. Athens began to abuse the members of its new confederacy just as it had those of the earlier Delian League, and the allied cities were driven into revolt. It would seem that if a new and different power had not appeared in Greece, this pattern might have repeated itself again and again.

That new and different power was the kingdom of Macedonia under Philip II. The Macedonians were ethnically related to the Greeks and spoke a dialect of Greek, but their loose feudal kingdom on the northern border of the Greek world had always been regarded as culturally backward. However, under Philip's aggressive leadership beginning in 359 B.C. the kingdom was reorganized, its control was extended over neighboring peoples in the Balkans and over the Greek cities in the Chalcidice and Thrace; and finally a contest for power with the cities of southern Greece was begun. Athens, spurred on by the rhetoric of Demosthenes, and Thebes led the resistance against Philip but were defeated without great difficulty in a battle at Chaeronea in Boeotia in 338 B.C. Philip then unified all the Greek cities except Sparta in an offensive and defensive alliance (the 'League of

Corinth') which was administered by a council of delegates from all the cities under his supervision.

With the long internecine struggles of the Greek cities finally brought to an end, the League declared its intention of attacking Persia under Philip's leadership. The motives for this were no doubt mixed. Orators like Isocrates and Lysias had long urged the Greeks to put aside their quarrels and unite against a common enemy. On the other hand, large autocratic and imperial states, like that which had been forged in the non-Catharginian parts of Sicily by Dionysios I of Syracuse and like the Roman hegemony which was forming in Italy, were an increasingly common phenomenon of the age. Philip must have sensed that these were the real powers of the Mediterranean world, and his decision to consolidate Greece and move against Persia must have been dictated as much by a desire to be a 'modern' power as by the need to avenge any ancient wrongs.

When Philip was assassinated in 336 B.C. his role fell to his son Alexander. From 333 until his death in 323 B.C. Alexander led an amazing campaign which carried him as far as the borders of India, toppling and fragmenting the Persian Empire as it went. His successors carved up the empire into large new autocratic states, like the Ptolemaic kingdom in Egypt and the Seleucid kingdom in the Near East, in which an aristocracy of Macedonians and Greeks ruled over vast Asiatic masses. New courtly cultural centers like Alexandria and Antioch grew up, and a veneer of Greek culture was spread over the former areas of the Persian Empire. In this expanded 'Hellenistic' world the old cities of Greece shrank into political insignificance.

In spite of its chaotic political history, however, the fourth century was anything but a decadent era. Not only was it the age of Plato and Aristotle and of Demosthenes, Lysias, Isocrates, and Xenophon, but it was also a period which produced many great artists. In painting, in fact, ancient writers imply that the fourth century was the greatest of all eras and that its most famous masters – Zeuxis, Parrhasius, Timanthes, Apelles and others – were without equal earlier or later. Sculpture too was marked by famous personalities like Praxiteles, Skopas, and Lysippos, whose reputations remained high throughout Antiquity. But aside from the orators, whose profession necessarily involved them in political affairs, the work of the greatest intellectuals and artists of the period from the end of the Peloponnesian War to the death of Alexander shows a distinct detachment from the tumultuous events of their time. The Peloponnesian War had been a shock, but the political events of the first half of the fourth century were too protracted and repetitive to produce shock. The reaction to them was less dramatic but more enduring than the agonies of Euripidean drama or even the escapism of late

fifth-century art. Aloofness, indifference, skepticism about the value of existing social institutions, all unthinkable in the High Classical period, found prestigious spokesmen.

The turbulent conditions of the late fifth and fourth centuries may have had a subtle influence on Plato, for example, as he formulated his cosmology and theory of knowledge. In addition to the general instability of Athenian politics during this period, events like the death of his master Socrates at the hands of political forces and his own ill-fated attempts to translate governmental theory into practice in Sicily may have convinced him of the pointlessness of attempting to discover or illustrate principles of truth and justice within the framework of contemporary civic life. His personal experience of worldly politics may have provoked an emotional zeal which reinforced his intellectual conviction that the sensible world was one in which illusion masked reality and opinion passed for knowledge. The reality of 'forms' or 'ideas' which was held to lie behind the world of sense experience could be known by the philosopher after prolonged and rigorous reasoning and contemplation, but the atmosphere which would facilitate such efforts was hardly to be found in the bustle of the Agora or in the squabbles of the Council and the Assembly. Unless society could be completely redesigned along the lines proposed in the *Republic*, there was little likelihood that it could serve as anything but a source of confusion and distraction in the search for knowledge. It is true that the process of dialectic by which the aspiring philosopher proceeded toward this knowledge required a certain give and take with other men's minds. Such an interchange of thought, however, could be most effectively achieved within a small, select group of kindred spirits – a kind of philosophical family, and even in those circumstances the final vision of the realm of ideas seems to have been thought of as a personal, not a group, experience. In Plato's most famous simile we find the philosopher alone in a cave contemplating mundane existence as a procession of shadows and then emerging to see the sun or reality.[1]

This need for a calm atmosphere in which the dialectic process could be pursued

[1] These epistemological ideas obviously had an effect on Plato's evaluation of the visual arts, but I have omitted a discussion of the Platonic view of art here because it is not really relevant to the theme of this book – i.e. how Greek art is an expression of Greek cultural experience. Plato's well-known conservatism with regard to art (e.g. *Laws* 656D–E), his critique of *mimesis* in the visual arts (*Rep.* 596E–603B), his distaste for *skiagraphia* (e.g. *Rep.* 602C–D) are undeniably of great interest for a history of aesthetic theory, but except for one or two dubious cases his views had little if any influence on the actual course of Greek artistic practice.

There are, on the other hand, intrinsic aspects of Plato's life and thought – e.g. his aloofness, his emphasis on abstractions – which are symptomatic of the intellectual climate of the fourth century and find expression in its art. It is these which I have attempted to focus upon in the present chapter.

with a minimum of disturbance must have been the principal reason which led Plato to found his school (Greek *schole*, a place where one makes use of leisure) in the grove called the Academy outside the walls of Athens. Once the effectiveness of such an institution had been demonstrated, others, like Aristotle's school in the Lyceum, followed. The schools in the Academy and the Lyceum were private, voluntary associations, unsubsidized and unsupervised by the state. Within them political questions might often be examined and data about governmental institutions were collected, but such activities were engaged in primarily for the private satisfaction of the members of the schools, not as a service to society in general.[2] Neither Plato nor Aristotle seems to have been concerned, as the earlier Sophists had been, with preparing pupils for public life in the usual sense.

A less profound but perhaps more dramatic exemplar of the aloofness of the fourth century was the Cynic Diogenes of Sinope (*c.* 400–325 B.C.), whose ideal of *autarkeia*, 'self-sufficiency', led him to adopt a life which was something like that of a mendicant friar without any particular religious dogma. To the average Greek of the fourth century there was perhaps no more astonishing sight than that of Diogenes flouting convention, ridiculing the institutions of the state, insulting grandees, and searching for an honest man with his proverbial lamp. He may have seemed a comic figure on the surface, but his influence was lasting. The ascetic withdrawal urged by Epicurus (contrary to popular notions) and the Stoic conception of a *kosmopolitēs*, 'citizen of the world' – both formulated toward the end of the century and dominant in the Hellenistic period – reflect the discontent with the life of the *polis* which Diogenes' flamboyant protests had brought out in the open.

This aloofness from the affairs of the group and the consequent concern with

[2] One can admittedly see an exception to this in the fact that several members of the Academy undertook to draw up new constitutions for various Greek cities. This type of activity, however, had the same strongly theoretical, reformist cast that characterized Plato's efforts in Syracuse and is really an example of the Academy's dissatisfaction with the existing conditions of society. All the Academics seem to have shared the same enthusiasm for the hypothetical potential of a completely redesigned society which marks the *Republic* and the *Laws*; but this is quite different from the belief in the value of society as it is which characterizes, for example, the Funeral Oration of Pericles.

The evidence for the political activities of the Academy is summarized in P. M. Schuhl 'Platon et l'activité politique de l'Académie', *Revue des Etudes Grecques* 59 (1946) 46–53, and C. B. Armstrong 'Plato's Academy', *Proceedings of the Leeds Philosophical Society* 7 (1953) 103–4. I am indebted for insights into this and other aspects of the Academy to Dr John P. Lynch, whose doctoral dissertation, *The Lyceum at Athens and the Peripatetic School of Philosophy* (Yale University 1970), is a study of fundamental importance for understanding how the Greek philosophical schools were organized and operated.

private emotional experience became the principal new motivating force behind the art of the fourth century. Even when a monument in question is designed for the public, like the temple of Athena *Alea* at Tegea, the designing artists speak as individuals to other individuals and not on behalf of, or to, the members of a *polis*.[3]

The Hellenistic Age too was a period of psychological readjustment in which community life and the ideals of a circumscribed, familiar society lost much of their force. Cities like Alexandria and Antioch were in some ways like modern cities in which the 'community' has become so large that it has become impersonal. And in an impersonal urban environment each man is thrown back by necessity upon the world of his private experience. He dwells either on those experiences which are intensely personal or on those which are universal and general – that is, those which can be comprehended by all men without their having to be 'conditioned' by a particular culture.

There are clear examples of this attitude in early Hellenistic literature. The *Characters* of Theophrastus, for example, sketches general types of human personalities – e.g. the boor, the snob, the man who talks too much – which would be familiar to anyone who lived in any kind of cultivated society. Likewise Menander's 'comedies', more often actually taking the form of what we would call 'melodramas', presented stock types of characters – love-sick young men, scheming servants, misers, prostitutes – in plots which involved variations upon a limited repertoire of very general human situations – frustrated love, mistaken identity, false accusations, and, inevitably, reconciliation. Unlike the earlier comedies of Aristophanes, Menander's were free of allusions to current Athenian, or any other politics.[4] One did not have to be an Athenian to respond with comprehension to dramatic representations of quarrels between parents and their children or misunderstandings between lovers. A citizen of a city in southern Italy, for example, could understand them equally well. The 'New Comedy' exemplified by Menander, in fact, enjoyed great popularity in Italy during the

[3] By this I do not mean that the subject matter of architectural sculpture in the fourth century was altogether devoid of political overtones. The sculpture of the Tegea temple, for example, contained unmistakable allusions to the religious and political history of Arcadia (cf. Picard's analysis in *Manuel d' Archéologie Grecque: La sculpture* IV, 1 (Paris 1954) pp. 155 ff.). The personal element in these sculptures makes itself felt not so much in what subjects they represent as in *how* they represent them.

[4] I would not deny that there may be an element of social criticism in the plays of Menander, as T. B. L. Webster *Studies in Menander* (second edition, Manchester 1960) pp. 55–102, has suggested, although it does not seem to me to play a significant role in them. In any case, it is probably fair to say that the particular social situation of which Menander, in Webster's view, was critical – the seduction of poor girls by irresponsible young men of high social position – is part of the general human condition and not limited to any one society or time.

Hellenistic period and served as the basis for the development of Latin comedy by Plautus and Terence.

Thus voluntary withdrawal in the fourth century and a far-reaching change in social conditions in the Hellenistic period brought both eras to the same point – a preoccupation with *personal* and *general* experiences rather than with *communal* experience.

The following sections suggest some ways in which this new state of mind was given expression in the art of the fourth century and also how many of the new artistic types which were developed at this time were taken over, either directly or with certain modifications, in Hellenistic art.

The exploration of personal experience: human emotion

The most obvious result of this trend toward personal experience as a subject for artistic exploration was a revival of the interest in representing specific human emotions, particularly basic human feelings like anguish, tenderness, and humor which are universal products of personal experience. In dealing with such subjects the art of the fourth century can be seen as continuing a tendency which had begun in the Early Classical period and had been interrupted by the dominant Olympian calm of the High Classical style, but the earlier trend was not resumed without a new shift in emphasis. *Pathos*, immediate personal reaction to experience, now receives more attention than *ēthos*, perhaps because conceptions of 'character' are inevitably bound up with the morals and ideals of a specific social group and the artists of the period preferred to avoid involvement in such questions.

Suffering, the experience of pain, was probably the first type of personal emotion to be explored by the artists of the fourth century. Significantly enough one of the earliest examples of the depiction of pain, untempered by Olympianism or heroism (as it would have been in the fifth century), occurs in the sculptures which decorated a new temple built for Asklepios, the assuager of pain, at Epidauros (*c.* 390–380 B.C.). A number of features link this temple directly with the Athenian sanctuaries of the fifth century. It contained a large gold and ivory image of Asklepios which must have been in the stylistic tradition of Pheidias, and it was also decorated with *akroteria*, representing various minor female deities[5] which carry on the flying drapery style in a somewhat less florid, perhaps even classicizing (see p. 170), way. The pedimental sculptures of the temple,

[5] The interpretation of these figures is debated. The female riders who seem to have been placed on the corner of each gable are usually identified as Nereids or Aurai ('Breezes'). The striding female who holds some type of bird in her hand and is perhaps to be assigned to the west gable, is thought by Crome (see below, p. 144, n. 6) to be Epione ('She who soothes'), the consort of Asklepios; the winged figure assigned to the peak of the east gable may be Iris.

however, although in very fragmentary condition, introduced a new tone. The east pediment seems to have represented the sack of Troy and may have been executed by a sculptor named Hektoridas.[6] One of the most striking fragments preserved from it is the head of an old man who is probably King Priam [59]. His hair is grasped by a hand which must have been that of Neoptolemos, the son of Achilles, who would have been depicted as delivering, or about to deliver, the death blow to the aged king. In his final moment Priam's eyes are dilated and asymmetrical, his brows are knit in undulating lines, his forehead wrinkled, his mouth apparently partly open, and his hair is expressionistically depicted in centrifugal radiating lines which convey a sense of hysteria. *Pathos* eclipses *ethos* in this face which projects a moment of unqualified pain and is the ancestor to a long line of agonized faces in fourth-century and Hellenistic art. The Hellenistic descendants are so well known that the point hardly need be labored. One need

[6] From a lengthy inscription (*I.G.* IV² 102) which records payments to the artists and contractors who worked on the temple we know that one set of *akroteria* was made by the sculptor Timotheus, while the other was done by an artist whose name is only partially preserved but which may have been Theon or Theodotos. We also learn from this inscription that one of the pedimental groups was assigned to a sculptor named Hektoridas; the name of the sculptor who undertook to do the other pediment is not preserved, but payments for his work are recorded. The inscription does not specify which of these groups belonged to the east end of the temple and which to the west, but its wording seems to suggest that it refers to each end in alternation. If the first reference applies to the east end, i.e. the entrance of the temple, then the next would refer to the west, the next to the east again, and so on. Following this not unreasonable principle, which was first suggested by H. Thiersch and is taken up in the basic monograph on the Epidauros sculptures by J. F. Crome (*Die Skulpturen des Asklepiostempels von Epidauros*, Berlin 1951), the west *akroteria* should be assigned to Timotheus, the east pediment to Hektoridas, and the other *akroteria* and pediment to the sculptors whose names are missing.

In the same inscription Timotheus is also recorded to have received a substantial sum for making 'typous'. Since literary sources attest that Timotheus attained, at least eventually, great prominence as a sculptor and was hired, along with Skopas, Bryaxis, and Leochares, to work on the sculptures of the Mausoleum of Halikarnassos, some scholars have felt that he should be assigned a greater role at Epidauros than the inscription seems to indicate. Those who hold this view are inclined to interpret the word *typos* as 'model' and to assume that Timotheus was the designer of all the pedimental sculptures, even though other artists may have done some of the carving. An overwhelming body of linguistic evidence indicates, however, that *typos* normally means 'relief' or 'mould' or occasionally 'mould-made figure' but never 'model' in the sense of a sculptor's *maquette*. Timotheus, if in fact the sculptor mentioned in the inscription is the same as the one who worked on the mausoleum, was probably a young man at the time when the temple of Asklepios at Epidauros was being constructed and not yet as prominent as he later became. If any sculptor at Epidauros was an overseer in the way that Pheidias had been at Athens, it was probably Thrasymedes, who executed the chryselephantine cult image of Asklepios.

In a recent monograph on Timotheus, Barbara Schlörb has proposed that the missing name of the sculptor who executed one of the pediments should be restored as 'Timotheus and that the pediment in question is the east one, which Crome had assigned to Hektoridas: cf. 'Timotheus' *Jahrbuch des deutschen archäologischen Instituts, Ergänzungsheft* 22 (1965) 17, 28–35. The ascription of the east pediment to Timotheus is based on her feeling that there is a stylistic similarity between the east pedimental figures and other works, mostly Roman copies, which have been attributed to Timotheus.

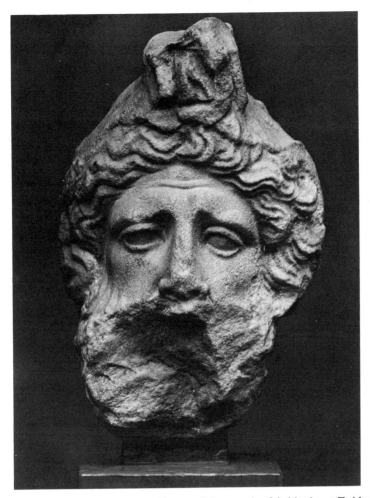

59. Head, probably Priam, from the east pediment of the temple of Asklepios at Epidauros, marble, *c.* 380 B.C. Height approx. 6″.

only cite the anguished faces of the Giants on the great altar at Pergamon (first half of the second century B.C.) or one of the many works produced under the influence of the Pergamene school, like the famous Laocoön.

Equally expressive, but through different means, is the figure of a fallen warrior [60] from the west pediment, which represented a traditional Amazonomachy.[7]

[7] The pedimental sculptures from Epidauros are now being thoroughly re-studied by Dr Nicholas Yalouris. His work has already produced many new joins in the extant fragments and, with these, further evidence for the composition of the pedimental groups. The fallen warrior illustrated here is now assigned to the right (south) side of the west pediment, rather than to the left as in Crome's reconstruction. A preliminary version of the new arrangement is published in Schlörb 'Timotheus', *beilage*.

The sprawling, twisted, and thoroughly lifeless body (perhaps corpse is a better word) forms a striking contrast with the noble dying warrior from Aegina a century earlier [7]. No force or resistance remains. The shoulder blades of the Epidauros warrior are pressed flat against the ground, as if pinned in a wrestling match, and his face seems to have stared vacantly into space. We are given not the *ethos* of the dying warrior, but the *pathos* of death. Again the kinship of such a figure seems closer to Hellenistic works like the fallen Gauls and Persians from the lesser Attalid dedication (*c.* 200 B.C.) on the south slope of the Athenian Acropolis than to fifth-century antecedents.

The sculptor who was apparently the supreme exponent of the *pathos* idiom which began to develop at Epidauros was Skopas of Paros. He was active in the middle decades of the fourth century and was an architect as well as a sculptor, since Pausanias mentions him as the designer of the temple of Athena *Alea* at Tegea (see p. 164). The heads preserved from the pedimental sculptures of this temple are not necessarily from Skopas' own hand but almost certainly reflect his influence, and are the best index of his style, which clearly cultivated facial expression to generate psychological excitement and tension. In two dramatic heads from the west pediment of the temple, one of them [61a] representing Herakles, the other [61b] possibly Telephos, we see the formal devices which Skopas developed to convey these qualities: eyes deeply cut and overhung, particularly on the outer corners, by the flesh above them so that the feeling of a concentrated gaze is created; neck and head turned to one side, as if attention has suddenly been called to some object; head tilted; the lips slightly parted. As at Epidauros the dramatic nature of this head is suited to its narrative context. Herakles was apparently depicted as the passionate witness of the fateful combat of Telephos, his son, with Achilles. It is instructive to compare Herakles with another 'involved' witness in

60. Warrior from the west pediment of the temple of Asklepios at Epidauros, marble, *c.* 380 B.C. Length approx. 3′ 8″.

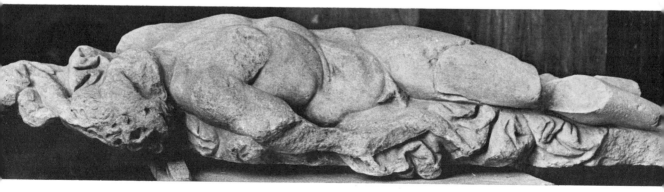

Greek sculpture, the 'old seer' from the east pediment of the temple of Zeus at Olympia [12]. In the earlier figure a disturbing philosophical anguish, sprung from awesome knowledge and moral complexities, is called to mind. He belongs to the world of Aeschylus. By contrast, in the Herakles we have the much more personal anxiety of a father for his son's welfare. The subject is legendary or mythical, but the meaning seems directed toward the world of private life, the family, personal affection and personal anxiety.

This exploration of pain and excitement as artistic subjects, as we have already pointed out (see pp. 43–4), was also prominent in the work of some of the great mural and panel painters of the fourth century, but their work is completely lost, and not much evidence survives which can help us to vizualize what the dramatic masterpieces of the period were like. Vases are of little help, since these developments were unfortunately beyond the scope of the mannered, elegant styles which characterized Greek vase painting, particularly Attic vase painting, during the early and middle years of the century. Perhaps our most useful insights come from literary descriptions of some of the more renowned paintings of the age. Pliny's short but vivid description, for example, of a work by Aristeides the Younger of Thebes (active *c.* 350–325 B.C.) – a painter famed for his ability to depict *perturbationes* – suggests that there was more emphasis on *pathos* than *ethos* in dramatic scenes: 'His works included [a picture of] the capture of a town in which a child is seen creeping toward its mother, who is dying of a wound; and one senses that the mother is aware of the child and is afraid that, with her milk being exhausted, the child may suck blood.' (*N.H.* xxxv. 98.) Not only was this an intensely emotional scene but it was again one in which a very personal, family relationship formed the basis of its tension.

Among the diffuse remnants of Hellenistic painting we are fortunate in having one work, a grave stele from Pagasai of a woman named Hediste and her child [62], which in its emotional tone and conceivably even in its style reflects the tradition represented by Aristeides' painting. The majority of the painted stelai from Pagasai seem to date from the third century B.C. and to perpetuate in painting patterns of composition which are familiar to us from Attic grave reliefs of the fourth century. The painter of the Hediste stele, however, departed from this dominant tradition and turned to an illusionistic mode of representation which had been developed primarily in and for the art of painting (see pp. 162–3). We are shown the interior of a bedchamber with a bed in the foreground upon which lies the haggard figure of Hediste, who has just died in childbirth. Behind her stands an old woman holding a child, apparently born dead. At the foot of the bed a man, presumably the husband of Hediste, stares gloomily at her, while through an open

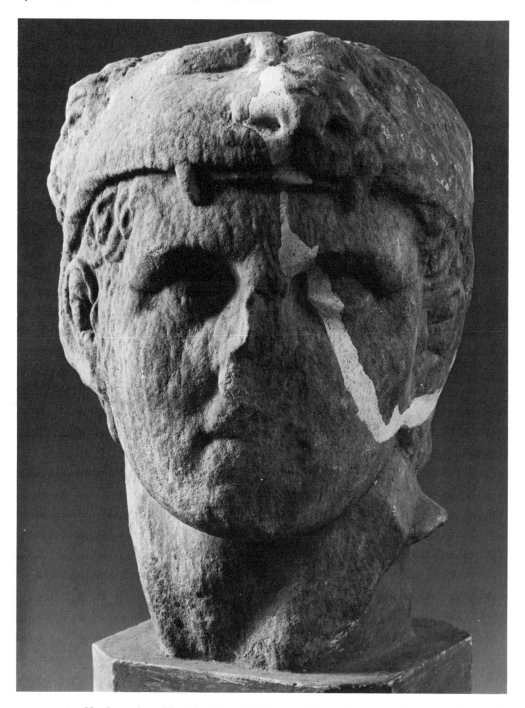

61. Heads, perhaps Herakles (*a*) and Telephos (*b*) from the west pediment of the temple

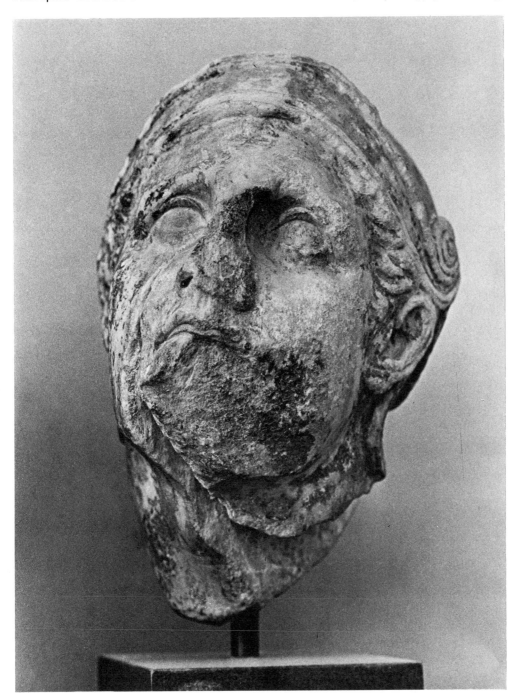

of Athena *Alea* at Tegea, marble, *c.* 340 B.C. Height of faces approx. 6½″ (*a*) and 7½″ (*b*).

62. Stele of Hediste from Pagasai, painted marble, *c.* 280 B.C. Height approx. 28¾".

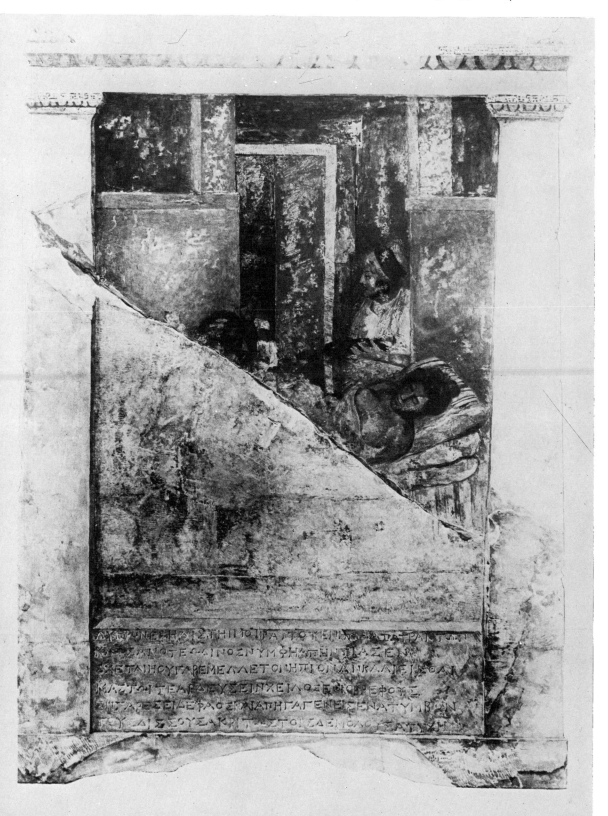

door at the rear of the chamber another woman peers in apprehensively. There can hardly be any doubt that the intent of the scene was to evoke an intense and intimate *pathos* in the viewer, and to make sure that the point was unmistakable, a poignant elegiac epitaph, related in spirit to Pliny's description of the painting of Aristeides, was added to the stele:

> A painful thread for Hediste did the Fates weave from
> their spindles when, as a young wife, she came to the
> throes of childbirth.
>
> Ah wretched one! For it was not fated that she should
> cradle the infant in her arms, not moisten the lips
> of her new-born child at her breast.
>
> One light looks upon both and Fortune has brought
> both to a single tomb, making no distinction when
> she came upon them.

Expression of personal human tenderness constitutes another subject which had made intermittent appearances in earlier vase painting (where, as we have said, the personal, transient fancies of individual artists could be expressed more readily than in monumental sculpture, which adheres more strictly to the norms of the age) but did not become institutionalized, so to speak, until the fourth century. Its appearance in a rather similar format in two well-known works of prominent Athenian sculptors, the Eirene and Ploutos ('Peace and Wealth') of Kephisodotos [63] and the Hermes with the Infant Dionysos by Kephisodotos' even more famous son, Praxiteles [64], suggests that it may have been a special achievement of their school. The Eirene and Ploutos was a public monument set up in the Agora in Athens in the late 370s, but its effect, achieved by the psychological interaction of the two figures, is oddly personal, as if both deities were oblivious of what went on around them. The goddess looks tenderly at the child which she holds on her left arm, and he extends his hand toward her with affection and trust. On the most immediate level this is simply an image of a mother and her child; only afterwards does one think of the abstract allegorical value of the group (see pp. 171–2). In the famous Hermes, which was found in 1877 in the temple of Hera at Olympia exactly where Pausanias saw it in the second century A.D.,[8]

[8] Since the early 1930s there has been an active debate as to whether the Hermes is an original, as was long assumed, or a Roman copy. The incomparably fine workmanship of the head seems far beyond the level of most copies, and yet many technical features – supporting strut, the unfinished back, tool marks, details of the drapery – do not seem to belong to the fourth century. The present writer is inclined to accept the recent verdict of Sheila Adam *The Technique of Greek Sculpture in the Archaic and Classical Periods* (*British School of Archaeology at Athens, Supplementary volume no. 3*, Oxford 1966) that the Hermes may be a Greek copy dating from about 100 B.C., but it must be admitted that the debate is far from over.

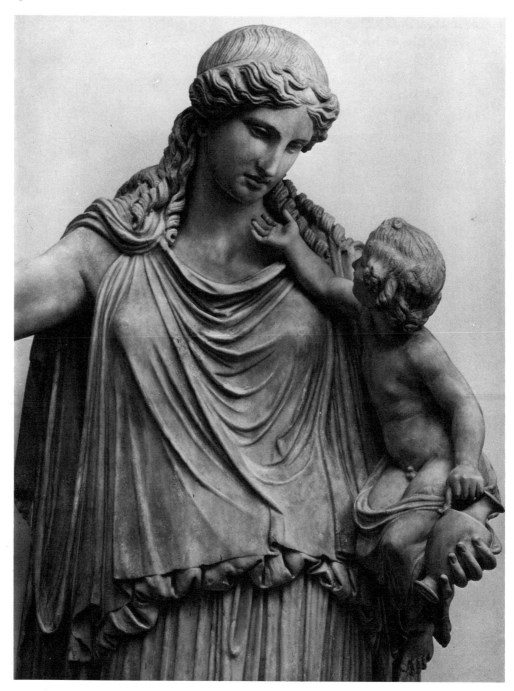

63. Eirene and Ploutos, Roman copy in marble of an original of *c.* 375 B.C. Height of complete figure approx. 6′ 6$\frac{3}{10}$″.

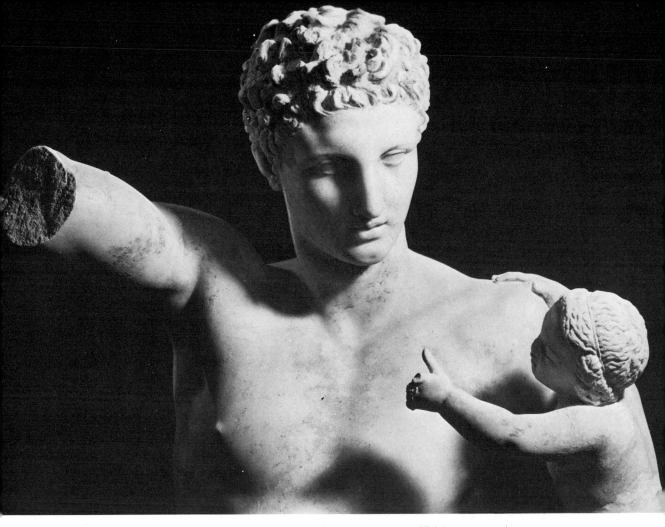

64. Hermes of Praxiteles, marble, copy of an original of *c.* 340–330 B.C. Height approx. 7′.

Praxiteles shows what he learned from his father but also projects his own sophisticated, *bon-vivant* personality. The same two-part composition with psychological communication between the figures is again in evidence: Hermes, the fun-loving, travelling god, kindly dangles a bunch of grapes over the head of the infant, who is the most recent product of Zeus' indiscretions and who, in order to protect him from the vindictiveness of Hera, is being conveyed to the Nymphs of Crete. Again the theme is the tenderness of an adult for a child, depicted in the divine realm but appealing to the strictly human.

Along with tenderness still another emotional dimension, humor, heretofore very seldom treated in Greek sculpture, can be detected in the Hermes. The infant Dionysos will grow up to be the god of wine and intoxication, and as he precociously reveals his inherent propensities by eagerly grasping at the grapes, a subtle smile

plays over the face of Hermes. Such genial, low-key humor was perhaps not un-common in the sculpture of Praxiteles. It also occurs in his Apollo *Sauroktonos* (the 'Lizard Slayer') [65], another work securely identified in Roman copies, in which Apollo has become an effete, soft youth who leans against a tree and is barely able to summon up enough energy to swat a small lizard. The group is clearly an urbane burlesque of the ancient myth, most vividly preserved in the Homeric hymn to Pythian Apollo, in which the mighty young god slays a ferocious, fire-breathing dragon in order to win control of Delphi. It seems to bring to art some of the spirit which Diogenes brought to social and political questions. In the playful hands of Praxiteles and in a jaded, sophisticated age which had been battered by a series of hard experiences and had become unable to take some of its traditional conceptions of divinity completely seriously, Apollo becomes almost hermaphro-ditic and the dragon becomes an everyday lizard.

The Hellenistic descendants of these works in which tenderness, personal affection, and humor are combined are sometimes among the most repellent of ancient sculptures, but they are very much in evidence. In a general way, the Hellenistic devotion to children as natural and engaging objects of adult affection (as, for example, in the well-known type of a boy strangling a goose, sometimes ascribed to the sculptor Boethos) should probably be seen as part of an inheritance from the fourth century. More specifically there are parallels in groups like the Pan teaching a boy to play the pipes in Naples or the Cupid and Psyche in the Capitoline Museum, or in the numerous *symplegma* types – works in which personal affection between individuals, in fact rather too much of it, without any narrative complexities, is the subject. On the humorous side, there are works like the clumsy but friendly group of Aphrodite warding off Pan with her slipper in the National Museum in Athens. The half-hearted blow with which the goddess threatens her assailant seems to echo the joke of the Apollo *Sauroktonos* two and a half centuries earlier.

Although the expression of personal emotions like anguish and tenderness may have been most vividly formulated in the works of the great sculptors of the age, it can also be seen in more modest, or at least more commonplace, anonymous monuments, like Attic grave stelae, and its presence in such works may be taken as an indication of its general appeal. A fine example of these qualities in Attic funerary art appears on a stele, dating from about 350–330 B.C., found in the channel of the Ilissos on the southwest outskirts of Athens [66]. In accordance with the trend of its time, it is carved in very deep relief, and the surrounding architectural frame (now missing) would have projected around the figures so as to give the impression that they were standing in a small shrine (*naïskos*) consecrated to the

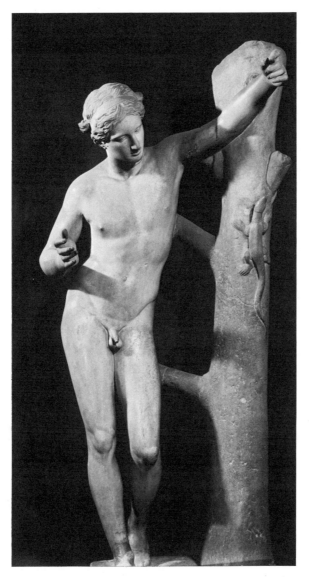

65. Apollo *Sauroktonos* of Praxiteles, marble, Roman copy of an original of *c.* 340–330 B.C. Height approx. 4′ 10$\frac{6}{10}$″.

heroized dead at the entrance to the underworld. The powerful looking young man in the center of the scene has deeply cut, anguished Skopasic eyes which give him a pained expression. To the right an old man, probably his father, regards him meditatively and affectionately; to his left a small boy, either a servant or a younger brother, is less able to control his feelings and openly weeps.

66. Attic grave stele found near the Ilissos, marble, *c.* 350–330 B.C. Height approx. 5′ 6″.

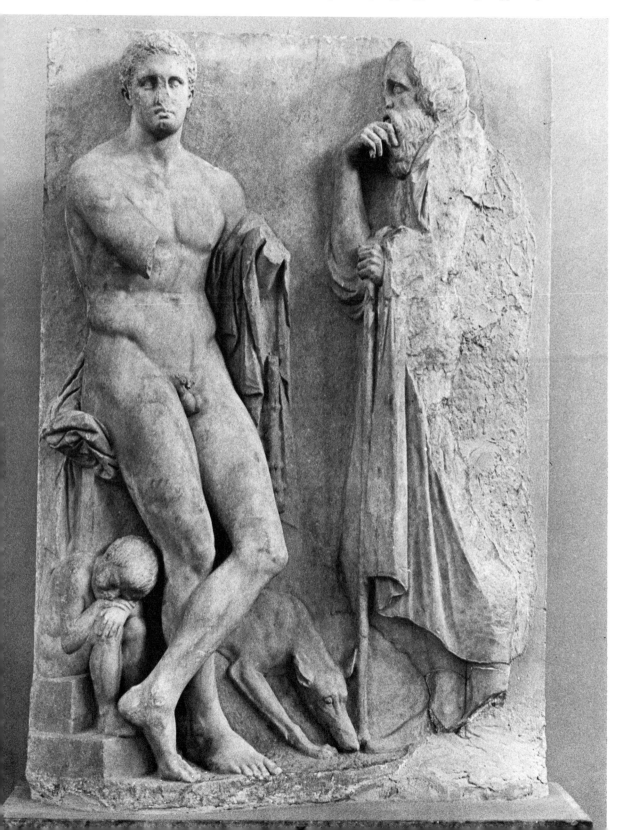

The exploration of personal experience: sensuousness and sense perception

Delight in the experience of the senses and the pleasure which results from it are also, like pain and other basic emotional reactions, personal and at the same time universal phenomena (in the sense that they apply to all men regardless of cultural conditions); and it seems to be again for this reason that sensuousness, often bordering on eroticism, becomes an increasingly important factor in the art of the fourth century.

In the cultivation of sensuous appeal no artist played a greater and more decisive role than Praxiteles. A languid, soft grace, which gives the impression of being deliberately anti-Polykleitan, and a dreamy atmosphere pervade most of the works which can be ascribed to him. The architectonic, clear structure of the *Doryphoros* [49] and its inner balance are replaced in works like the Hermes and the Apollo *Sauroktonos* by an almost feminine smoothness, by a de-emphasis of structure, and by an off-balance composition which at times required a secondary support.

Of all Praxiteles' works the one which had the most electrifying effect on its age and on the periods which followed was the Aphrodite of Knidos [67]. The nude female figure had played a minimal role in Greek art up to this time. In early red-figure vase painting, particularly on vessels which were designed for drinking bouts, such representations are not uncommon, but the women depicted seem in most cases to be courtesans; and in monumental art the social conditions of fifth-century Greece tended to discourage a romantic and sensuous view of women. The appeal of the Knidian Aphrodite was frankly, although not vulgarly, erotic, and the great fame which it enjoyed in Antiquity probably owed something to deep social and psychological changes in the fourth century as well as to the mastery of Praxiteles. The statue was apparently exhibited in a round temple or in an enclosed courtyard which seems to have been designed to facilitate the viewer's appreciation of it from all angles.[9] Visitors were supposed to think of the goddess as being surprised by an intruder while in the process of bathing and to note her reaction to the intrusion, which, as Lucian describes it, suggested a token modesty ('a very beautiful work of Parian marble, with a look of proud contempt and a slight smile which just reveals her teeth. The full extent of her beauty is unhidden by any

[9] That the viewer was able and encouraged to examine the statue from all angles is indicated by Pliny *N.H.* XXXVI. 21 and Lucian (or pseudo-Lucian) *Amores* 13–14. These references suggest that the statue stood in an open court or a circular *peripteron*. A Doric temple with a circular plan recently uncovered in the new excavations at Knidos has tentatively been identified as the building in which the image by Praxiteles stood. This temple is dated later than the fourth century, however, and the original location of the statue may have been elsewhere. Cf. Iris C. Love 'A Preliminary Report on the Excavations at Knidos', *American Journal of Archaeology* 74 (1970) 154–5.

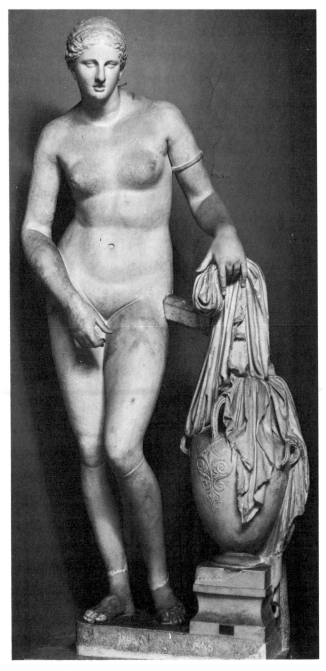

67. Aphrodite of Knidos by Praxiteles, marble, Roman copy of a Greek original of *c.* 340 B.C. Height with plinth, approx. 6′ 8$\frac{3}{10}$″. (The head is from a separate replica; the nose and parts of the body are restored.)

clinging raiment, for her nudity is complete except insofar as she holds one hand in front of her to hide her modesty' *Amores* 13) but also a hint of encouragement ('the dewy quality of the eyes with their joyous radiance and welcoming look' *Imagines* 6). In some of the better copies of the head of the Aphrodite we can perhaps still appreciate some of these qualities. The ancient world certainly did; in Hellenistic art the nude female figure becomes one of the most common forms of statuary.

The descendants of the Knidian Aphrodite in the Hellenistic period are legion. Both in Hellenistic originals, like the voluptuous Aphrodite of Cyrene and in the different 'types' established in Roman copies, like the kneeling Aphrodite of Doidalsas, or the Medici Aphrodite, we are confronted with what are really a set of variations on the Praxitelean theme.

Exploration of sensuous experience, particularly through representations of the female form, was also clearly an important factor in fourth-century painting, although here again the preserved monuments do not enable us to appreciate fully all the developments. Apelles of Kos, who was active primarily in the third quarter of the fourth century and was the most prominent painter of the age, seems to have played a role in painting equivalent to that of Praxiteles in sculpture. One of his most widely admired works was a sensuous Aphrodite, in this case an Aphrodite *Anadyomenē* ('Rising from the Sea'); and in a general way his style was famed for its *charis*, 'grace' or 'charm'. It seems likely that in the last distinct style of Attic red-figure vase painting, known as the 'Kerch style' after the site on the Black Sea where some of the earliest and best examples of it were found, we have at least a hint of what Apelles' work was like. Slender, elegant, mannered figures, mostly women, elegantly dressed or elegantly undressed and surrounded by hovering cupids, are among its distinguishing features. One of the finest examples is a *pelike* in the British Museum by the Marsyas Painter [69] dating from about *c.* 340 B.C. It depicts Peleus wrestling with Thetis, whose nude, white figure forms the central focus of the scene and is flanked by the not too dangerous looking figure of Peleus and several elegant, very self-conscious Nereids. There is still narrative coherence in the scene but the artist is clearly less interested in telling a story than he is in creating an atmosphere of feminity, a genteel drawing-room elegance, which continues a trend of the late fifth century (see pp. 122–3) and adds to it a mannered *charis*.

Some of the taste for mannered, elongated elegance, free of struggle and tension, even seems to invade Greek architecture at this time. The columns of the temple of Zeus at Nemea [70], for example, one of the last important Doric temples to be built in Greece (*c.* 330 B.C.), are so thin as to appear almost fragile, and the vertical

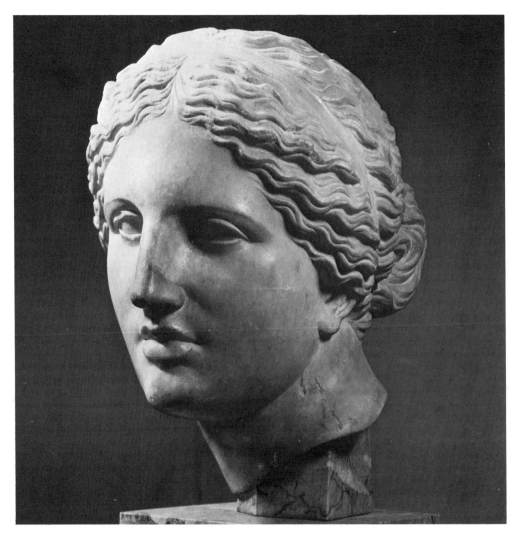

68. Roman copy of the head of Praxiteles' Aphrodite of Knidos, marble. Height approx. 10″.

profile of their capitals is so extreme that it becomes difficult to distinguish the capital from the shaft. The pressure, tension, and balance between component parts which had always been essential to the expressive power of Doric architecture is gone. Most of the first-rate Greek architecture which was to follow would be built in the more elegant and luxurious Ionic order, and at Nemea one feels that the architects may have been subconsciously attempting to put an Ionic soul into a Doric body.

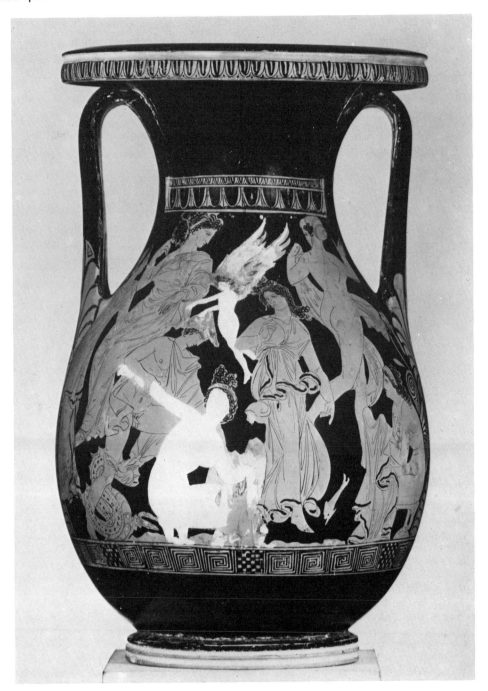

69. *Pelike* by the Marsyas Painter, *c.* 340–330 B.C. Height approx. 16¾″.

One last point should be made about the importance of sense experience in the art of the fourth century. Even when sensuousness, mannered elegance, and eroticism are not involved, an interest in sense perception *per se* is apparent, particularly in the efforts which were made to convey spatial depth in painting and even in relief. *Skēnographia*, the use of perspective to give the illusion of depth, and *skiagraphia*, the use of shading to suggest the optical impression of corporeal mass, were both fifth-century inventions, but they apparently did not become popular and widespread until the fourth century. Again, because of the paucity of monuments, one is forced to go somewhat far afield for illustrations. The most vivid examples of the use of perspective in the fourth century occur in the red-figure vase painting produced by Greek immigrants in South Italy, particularly in Apulia, where red-figure survived after its demise in Athens. On an Apulian volute *krater* in Naples illustrating the story of Iphigeneia and Orestes in the land of the Taurians [71], for example, a very makeshift but not ineffective perspective with a variety of theoretical vanishing points is evident. The cubic form of the

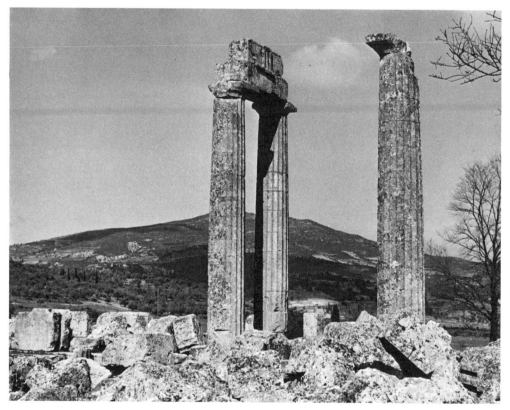

70. Temple of Zeus at Nemea from the southeast, *c.* 330–320 B.C. Height of columns 34′ ¼″.

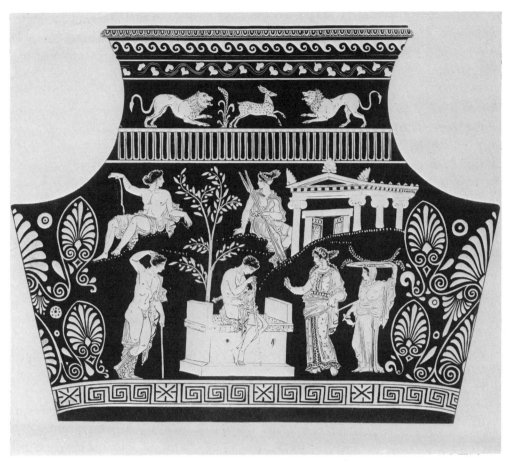

71. Redrawing of a scene on an Apulian *krater* depicting Orestes and Iphigeneia among the Taurians, *c.* 370–350 B.C. Height of vase 24⅘".

altar on which Orestes sits is not only conveyed by lines of diminution but also by appropriate shading; and the Ionic temple with open doors which appears behind a hill (which is, in turn, behind Iphigeneia and her servant) as well as the figures of Artemis and Apollo who seem to lounge on a hillside in the background, all successfully create the 'feeling' of receding space even when the details of scale etc. are not even remotely scientific.

Obviously in the great works of the time, the technical achievement in the use of both perspective and shading must have been far more sophisticated. Pausias of Sikyon, for example, painted a sacrificial scene, praised by Pliny, in which a bull was shown in a diagonal view and completely in black, and yet its corporeal mass was vividly conveyed. And among the monuments, the famous Alexander mosaic

in Naples, which seems to be a copy of a late fourth-century painting, and the Amazon sarcophagus in Tarquinia, used for an Etruscan burial around the mid fourth century but perhaps painted by a Greek, give some indication of what the major works of the time were like.

The exploration of personal experience: religious emotion

In the preceding chapter we noted that the rise of a personal and emotional approach to religious experience was discernible in the late fifth century and continued to grow in succeeding centuries. One indication of this development is the popularity which Iktinos' interior innovations in the temple of Apollo at Bassae, and all that those innovations suggest (see pp. 129 ff.), enjoyed in the fourth century. In two of the major Doric temples of the period, Skopas' temple of Athena *Alea* at Tegea and the temple of Zeus at Nemea, a Corinthian colonnade as well as other details undoubtedly suggested by the Bassae temple were incorporated into the interior of the cella. At Tegea the interior colonnade took the form of engaged half-columns, above which there was a blank space which might possibly have been decorated with a painted frieze equivalent to the sculptured one at Bassae; and the cella of the temple was also equipped with a lateral as well as a longitudinal entrance. At Nemea, in addition to the Corinthian columns, there was an *adyton*, with a secret chamber beneath it, separated from the main chamber of the cella, like its equivalent at Bassae, by a cross colonnade.

The stress on interior experience in fourth-century architecture is also apparent in the *tholoi*, temple-like structures with circular ground plans, which came into vogue in the first half of the century – the 'new *tholos*' at Delphi designed by Theodoros of Phocaea *c.* 390 B.C., the *tholos* at Epidauros designed by Polykleitos the Younger and begun around 370 B.C., and the 'Philippeion' at Olympia, initiated by Philip in 339 B.C. and finished under Alexander. All of these had rich exteriors (Doric at Delphi and Epidauros and Ionic at Olympia) and Corinthian colonnades [72] in the interior. The *tholos* at Epidauros in particular, with its black and white marble pavement, lavish Corinthian capitals and mouldings, ornate entablature, and elaborate ceiling with rosettes in the coffers calls to mind the jewelcase-like richness of the Erechtheion. The function of the *tholoi* is unknown, but the fact that the Philippeion in Pausanias' time contained statues of Philip and his family suggests that it and perhaps the other *tholoi* may have had something to do with the cult of the heroized dead. Also perhaps pointing in this direction is the fact, already mentioned (p. 130), that the Corinthian column seems to have developed in funerary art. And it is remotely possible that the circular plan of the structures could hark back to the Mycenaean *tholoi*, some of which, in later

72. Remains of the Tholos at Epidauros, *c.* 350 B.C.

times, are known to have become the sites of hero cults. Possibly also of significance are the facts that Asklepios, with whom the Epidaurian *tholos* must be associated, was actually in Greek mythology a human physician who had been raised to the level of a divinity, and that one of his principal attributes was the snake, a creature traditionally associated with the world of the dead and with heroes. Beneath the *tholos* at Epidauros there are labyrinthine passages which, it has been suggested, may have been intended for sacred snakes of the god.

In any case, whatever their function, the ornate, sensuous appeal of the *tholoi*, and the mysterious aura which surrounds them, are very much in the spirit of their time. In subsequent Hellenistic architecture this concentration on interior experience continues to make itself felt, particularly where the mysterious and miraculous forces of divinity were enshrined. The most overwhelming building of this sort was the great temple which marked an oracular seat of Apollo at Didyma near Miletus, begun *c.* 300 B.C. and worked on for centuries. It consisted of a huge and sumptuously carved Ionic hypaethral structure, inside of which was another smaller Ionic temple, the actual shrine of the god. One reached this inner shrine from the *pronaos* of the outer structure by passing through dark, vaulted, descending tunnels, from which one emerged into the startling light of the court-yard. Facing the small shrine at the opposite end of the courtyard was a grand staircase leading to an oracular chamber. From either side of this chamber covered passageways (called 'labyrinths' in inscriptions found on the site) whose ceilings were carved with a large maeander design (undoubtedly of esoteric significance) led upward to the roof of the temple. The courtyard itself was enriched with huge pilasters surmounted by capitals decorated with, among other things, heraldic griffins and lavish floral designs. Superhuman richness, surprise and mystery must have been impressed upon the worshipper by these and other decorative details. The structure itself became a kind of religious experience.

A trend toward thinking of religious experience in more personal terms can also be detected in some of the important cult images of the period, particularly those of Asklepios, whose compassionate aspect calls to mind later images of the bearded Christ and may conceivably even have served as a prototype for such images. One of the finest renditions of the god is the head known as the 'Asklepios Blacas' in the British Museum [73], a work which perhaps owes something to the cult image made by Thrasymedes for the temple at Epidauros and is in the general tradition of the Olympian Zeus of Pheidias. It was originally composed of three pieces stuccoed and doweled together. From evidence provided by the dowel holes and other cuttings it has been determined that the head would have inclined downward on the torso so that 'instead of gazing into the distance, oblivious of mankind, the

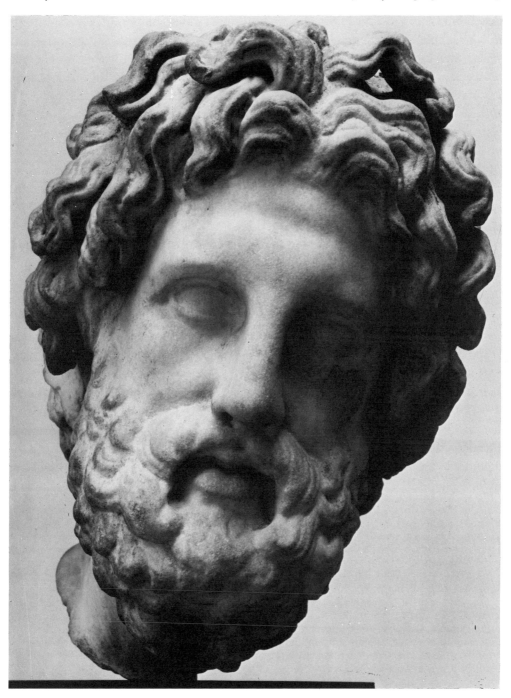

73. 'Asklepios Blacas', marble, *c.* 350–330 B.C. Height approx. 23″.

god bends forward and looks into the eyes of his worshippers' (B. Ashmole).[10]

Where the Asklepios types are personal and compassionate, another great cult image of the later fourth century, the Serapis of Bryaxis [74], was awesome and mysterious. The circumstances under which Bryaxis executed this image, now known through an extensive series of Roman copies and variants, have been a subject of debate. It may have been commissioned in the last quarter of the fourth century when Ptolemy I introduced the cult in Alexandria; or it may have been made for the Serapeion in Memphis where the cult seems to have originated; or there may be some validity to an ancient tradition that the image was made by Bryaxis in Sinope and transferred to Egypt by Ptolemy I (who was alleged to have had a vision of the god) somewhere around 285 B.C.[11] If the last of these possibilities is correct, the statue might have been made as early as 350 B.C. when Bryaxis, who seems to have been a Carian but to have worked in Athens as well as Asia Minor, is known to have been active.

According to a late description by Clement of Alexandria, several types of metal, including silver and gold, were used in the construction of the image; sapphires, emeralds, and other precious gems studded its surface; and the whole figure had a bluish-black hue stemming from the use of a sacred dye which was applied to its basic material (perhaps wood and stucco). Bryaxis seems to have represented the god as seated on a throne with a sceptre in one hand and a *modius* (a basket which held a measure of grain and symbolized his lordship over the earth – both over the plants that grow from it and the souls that go beneath it) on his head. His cascading beard and the wreath of hair surrounding the head like a dark cloud, both of which were enhanced by the mysterious dark color which perhaps connoted the underworld, seem to have conveyed a majestic, awe-inspiring otherworldliness. The responses which this mysterious image called forth could

[10] Cf. Bernard Ashmole 'The Poise of the Blacas Head', *Annual of the British School at Athens* 46 (1951) 2–6.

[11] Clement of Alexandria (*Protrepticus* IV. 48), writing around A.D. 200, expressed the opinion that the Bryaxis who worked on the Mausoleum of Halicarnassus was not the same sculptor who made the Serapis, and some modern scholars hold to this view (e.g. M. Bieber *The Sculpture of the Hellenistic Age* (revised edition, New York 1961) p. 83). Archaeological evidence suggests that the Serapeion in Alexandria was not established until the time of Ptolemy III (reigned 246–221 B.C.). (The evidence may be connected, however, with a reconstruction of the sanctuary rather than its origin.) If the image in question was made in the time of Ptolemy III, it could obviously not be by the same Bryaxis who worked on the Mausoleum. The cult of Serapis was first developed in Memphis, however, probably during the time of Ptolemy I but perhaps even under Alexander. Bryaxis' image may have been made for the Serapeion of Memphis and later transferred to, or copied for, the sanctuary in Alexandria.

On the problems posed by the literary sources about the cult of Serapis and the image of Bryaxis cf. G. Lippold 'Serapis und Bryaxis', *Festschrift Paul Arndt* (Munich 1925) pp. 115–27 and C. Picard *Manuel d'Archéologie Grecque: La Sculpture* IV. 2 (Paris 1963) pp. 871 ff.

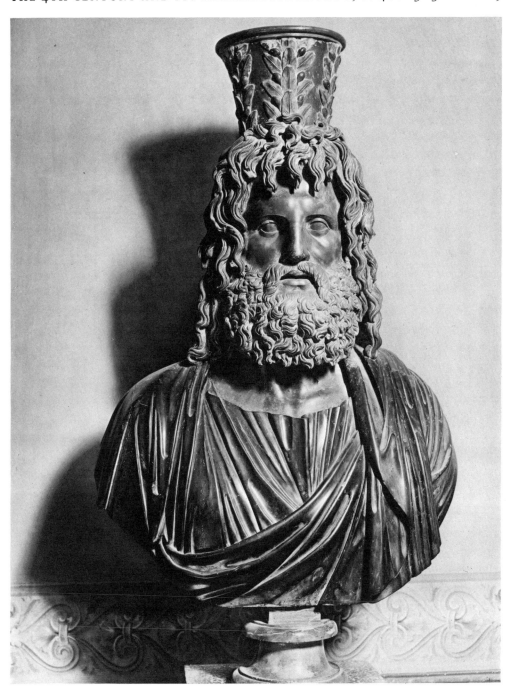

74. Head of Serapis, Roman copy of a type attributed to Bryaxis, *c.* 320–300 B.C., basalt. Height: colossal (dimensions unpublished).

only be measured by each man in the depths of his own psyche where his nature as a political animal was eclipsed by a very private consciousness of his own mortality. As Apuleius later made clear, Serapis, like Asklepios, was a deity with whom one's relationship was essentially a personal matter.

All later images of Serapis seem to have borne the mark of Bryaxis' initial creation. Asklepios too retained his fourth-century look in later times. In these cases it was the actual images of the fourth century, and not just the impetus which led to their creation, which lived on in the Hellenistic period. And one suspects that the atmosphere of these types must have infected also images of the new Dionysos, Isis, and the other deities of the Hellenistic mystery religions whose hidden rites gave meaning to personal life in a confusing and unpredictable age.

Idealism and abstraction

At the beginning of this book it was suggested that Greek art habitually attempts to represent the specific in the light of the generic and hence to favor the representation of ideal types, rather than random aberrant examples, of men and things. It should be emphasized that the fourth century, in spite of its interest in personal experience, is not really an unqualified exception to this principle. The emotions depicted in most fourth-century sculpture are obviously personal, but they are not idiosyncratic; on the contrary, they are universal experiences, and they are presented as universal types. One Skopasic head does not differ markedly in its component features from another; rather all fall under a certain category – the 'anguished man' – which becomes as much of a type in its own time as the *kouros* had been earlier. Toward the end of the century, particularly in portraiture, this emphasis on generic types begins to lose some of its force (see pp. 176 ff.), but it never really vanishes altogether.

One of the simplest and most eloquent examples of the continuing proclivity for abstraction and the creation of generic types may be seen in the development of the Greek theatre. The basic elements required in a Greek theatre were an *orchestra* (dancing floor), a hillside which would enable a large audience to witness what took place on the *orchestra*, and in developed drama a backdrop for the *orchestra*. In the fifth century the Greeks had begun to monumentalize these natural forms in architecture, but the earliest theatres are obscured by later construction, and it is really at Epidauros [75] that we first see the Greek theatre reach the canonical form which, with only slight variations, it would henceforth keep. The Epidaurian theatre, the date of which is disputed but which probably belongs to the very end of the fourth century,[12] is one of the simplest, yet most expressive of

[12] The theatre is ascribed by Pausanias (II. 27. 5) to an architect named Polykleitos. Most scholars have assumed that the reference is to Polykleitos the Younger, who also designed the *tholos* at

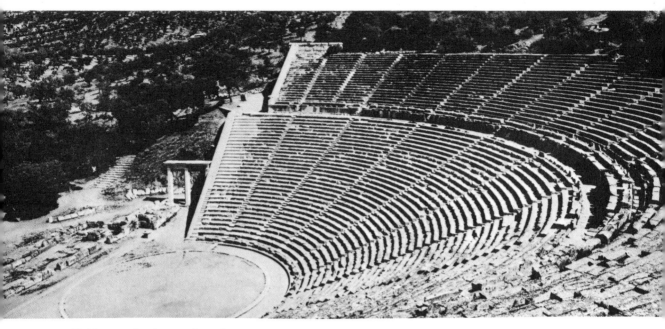

75. Epidauros, the theatre, from the east, *c.* 300 B.C.

ancient buildings. It is as if, by the human mind's capacity for abstract thought, nature has been transmuted into geometry. The orchestra becomes a perfect circle, the hillside the interior of a truncated cone, the backdrop a simple cubic form.

But while the tendency toward idealism and abstraction remains strong in the art of the fourth century, it now often appears in a new, consciously intellectual, even scholarly form, which must owe something to the philosophical climate of the period and at times seems rather forced when compared to the spontaneous fusion of abstraction and observation of the High Classical period. The formal divorce of the apparent and the ideal in Platonic thought and the consequent exaltation of ideas (in both the transcendental and everyday sense) at the expense of 'objects' of the physical world, for example, perhaps accounts to an extent for the increasingly frequent appearance of personifications and allegory in the

Epidauros, and if this assumption is correct, the theatre should date from somewhere between 370 and 330 B.C. Recently, however, A. von Gerkan and W. Müller-Wiener have questioned the reliability of Pausanias' information (cf. *Das Theater von Epidauros* (Stuttgart 1961) pp. 77–80). Pausanias, they feel, may simply have been repeating a popular tradition which ascribed the theatre to the famous sculptor of the fifth century. Basing their conclusions on the nature of re-used material in the foundations of the theatre, on the style of certain decorative details on the scene building, and other evidence, they would date the theatre not earlier than 300 B.C.

However, the evidence of other theatres which are either not well-preserved (Megalopolis) or marred by later construction (Delphi) supports the contention that the standardization of the Greek theatre type seems to have come about in the course of the fourth century.

art of the fourth century. It is not unlikely that the artists of the time, eager as ever to demonstrate that they too were intellectuals, able to cope with new currents of thought, and not simply manual laborers, saw in personificatory statues a way of demonstrating their own capacity to comprehend and formulate abstractions. If Plato in the *Crito* was willing to turn an essentially abstract concept like 'the laws' into embodied beings capable of arguing with Socrates, artists like Kephisodotos and Skopas could feel a certain dignity in giving physical form to such ideas as 'peace and wealth' [63] or 'yearning'. Personifications of this sort became increasingly common as the century progressed and once again seem to be the ancestors of a long line of such figures in Hellenistic and Roman art.[13] (See pp. 184–7.)

Another aspect of this intellectualistic trend in fourth-century idealism is the beginning of what might be called 'classicism' – the conscious repetition of features which were characteristic of the High Classical style of the fifth century – at the very least, its Olympian calm and balanced patterns of composition – as if they now constituted formal, established, and approved types. As we have suggested earlier, there has probably been no single, more influential artistic style in the history of art than that of fifth-century Greece. Since then – often in the Hellenistic and Roman periods, at times even in the Middle Ages, and, of course, with an almost continuous passion between about 1400 and 1900 – European art has been marked by a series of 'Classical revivals' which seem intended, consciously or intuitively, to recapture something of the confident humanism and harmony of forces which the style developed in the Periclean era embodies. The Classical Greeks managed to put Archaic art almost completely behind them, but the post-Classical Greeks (and their followers) were never quite able to forget their Classical past.

Since the fourth century is still in many ways within the mainstream of Classical experience and is not primarily an era of conscious artistic revival, its budding classicism is something which it is easier to feel than to spell out in a didactic way. It is normally apparent in the more modest monuments of the age, grave reliefs and votive reliefs for example, than in more ambitious works. The stately processional confrontation of Asklepios and his entourage with a group of worshippers on a votive relief in Athens [76] of about 360–350 B.C., for example, seems intent on re-creating both the forms and the atmosphere of the Parthenon frieze. The god himself, leaning on a serpent-entwined staff in the center of the scene, seems in

[13] Personifications were not a completely new phenomenon in Greek art at this time, but their number, diversity, popularity, and complexity all show an increase in the fourth century. For a survey of personifications in Greek art from the Archaic period onward see L. Deubner, s.v. 'Personifikationen', in W. H. Roscher *Ausführliches Lexicon der Griechischen und Römischen Mythologie* (Leipzig 1902–9) cols. 2110–45.

particular to revive the Athenian 'elders' of the east frieze, while the relaxed figures of his sons hark back to the mounted riders of the west; and the contrast of the relaxed goddesses on the far right of the scene with the sombre female worshippers on the left echoes a similar confrontation on the Parthenon. Classicism is also a factor on the reliefs on a three-sided base from Mantineia dating from perhaps around 320 B.C. which seems to have supported a group representing Leto and her children by Praxiteles. The base, which depicts the musical contest of Marsyas and Apollo in the presence of the Muses, may have been executed by Praxiteles' workshop assistants or perhaps by local sculptors completely unassociated with him. Each figure on it has an independent, self-contained and obviously decorative quality, as if it has been drawn from a classical pattern book. One senses something of the same forces at work in the reliefs on the Mausoleum of Halicarnassus, traditionally executed by *ateliers* working under the supervision of a group of great masters (Skopas, Leochares, Bryaxis and Timotheos or, according to a variant tradition, Praxiteles). One can of course point to details in all these figures which are specifically characteristic of the fourth century, such as their deeper relief, an emphasis on diagonal patterns in the drapery, generally slender proportions, the higher belting of the chiton, but as motifs they belong to a conventional classicizing language of forms which has its roots in the fifth century.

Classicism, too, is an aspect of fourth-century art which lives on in the Hellenistic

76. Athenian votive relief, marble, *c.* 350 B.C. Height approx. 20". The deities (larger figures, left to right) are Asklepios, his sons Podaleirios and Machaon, and three daughters, Iaso, Akeso, and Panakeia.

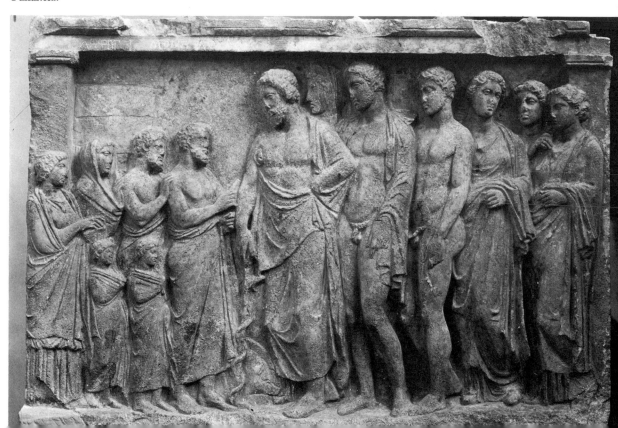

period. Its heyday occurred after 150 B.C. when a variety of forces – principally a general retrospective and nostalgic attitude toward the Classical era (equally apparent in the philosophy and literary criticism of the time) and the taste of Roman collectors – resulted in the Neo-Attic style of sculptors like Pasiteles and his pupils, who not only produced actual copies of Classical types but also attempted to apply the fifth-century style to new works, like the 'Stephanos youth'. But even before this overtly classicizing period, quotations from the Classical style had been not uncommon in Hellenistic art. Beneath the excited 'Hellenistic baroque' surface of the altar of Zeus at Pergamon, for example, are patterns of composition which had their origin in Periclean Athens.

Lysippos: an end and a beginning

The features of fourth-century sculpture which I have thus far examined – the emphasis on various types of personal emotion, the appeal to basic sense experience, the exploration of personal religious feeling, classicism – all flow more or less directly into the Hellenistic period.

There are certain other aspects of Hellenistic sculpture, however, which though they have their roots in the fourth century, do not survive without certain significant mutations. And wherever these mutations occur, they seem to be connected with the activity of the great sculptor Lysippos of Sikyon.

Lysippos had a long, active, and varied career. His earliest works may have been produced as early as the 360s B.C.; at the height of his career he became the court sculptor of Alexander the Great; and he seems to have produced a portrait of King Seleucus I as late as 306 B.C. His first works were thus produced at a time when Sparta, Athens, and the other *poleis* were still 'powers' of a sort, while the last of them were produced in the world of the Hellenistic monarchs; and it was apparently not only in time that he formed a bridge between the Classical and Hellenistic worlds but also in his evolution as an artist. A sculptor who was active for so long and who was also remembered as a very prolific artist (Pliny records a tradition that he produced as many as 1,500 works) might be expected to have gone through a number of stylistic phases. Even with the limitations imposed on us by the scanty evidence of Roman copies and literary testimonia, at least two such phases, an earlier traditional one and a later Hellenistic one, seem traceable.

In his early maturity he seems to have been a traditionalist, in the sense that he continued to be concerned with the artistic problems of proportion and composition which had been of concern to his fifth-century predecessors. Literary references inform us, for example, that he was particularly interested in the art of Polykleitos, especially in Polykleitos' principles of *symmetria*, and used the Polykleitan style as

a point of departure for his own work. Within the scope of these traditional interests, however, it is clear that his own work was highly original, even revolutionary. We are fortunate in having an unusually detailed description of just what was traditional and what was original in Lysippos' earlier works in an analysis preserved by Pliny from an earlier source, perhaps the writings of an early third-century sculptor named Xenokrates, who was a member of the Lysippean school.

Lysippos is said to have contributed much to the art of casting statues by representing the hair in detail, by making his heads smaller than earlier sculptors had, and by making the bodies slenderer and more tightly knit, as a result of which the height of the statues seems greater. There is no Latin word for the term *symmetria*, a quality which he preserved with the utmost precision by a new and previously unattempted system which involved altering the 'square' figures of earlier sculptors; and he often used to say that by them [earlier sculptors] men were represented as they really were, but by him they were represented as they appeared. (*N.H.* xxxiv. 65)

The information given in this passage is both internally coherent and also in harmony with what we know about developments in the fourth century from other sources. It suggests that Lysippos developed a kind of optical *symmetria*, in which the artist's concern focused not so much on actual proportions (when measured with a caliper) as with apparent proportions, i.e. with seeing things not 'as they really were but ... as they appeared'. The effect produced by reducing the size of the head (8:1 in proportion to the body, as opposed to the 7:1 ratio of Polykleitan figures) was to make Lysippos' figures *look* slenderer than those of the fifth century. It took into account optical illusion as well as objective measurement.

Lysippos' cultivation of purely optical experience in sculpture can admittedly be seen as only one reflection among many of the general interest in the nature of pure sense experience which occupies much of the art of the fourth century (see pp. 157 ff.). Other literary sources suggest that the problems posed by optical illusion became a concern to other sculptors as well. Plato, for example, preserves a rather critical description of how the sculptors of his day distorted 'real' proportions in order to compensate for appearances (*Sophist* 235 ff.), and Diodorus seems to be referring to a similar process when he observes that the proportions of Egyptian sculpture were fixed by an unvarying grid, whereas among the Greeks proportions were calculated 'according to the appearance presented to the vision' (I. 98. 7). Likewise the trend to slenderer proportions in Lysippos' work can be seen as part of a broader trend which appears elsewhere in the art of the fourth century.

Lysippos is distinguishable from his contemporaries, however, not only because of the traditional, theoretical mould in which he formulated and presented these new qualities in fourth-century sculpture, but also by the extent to which he

applied them. His interest in the optical experience of sculpture, for example, seems to have been reflected not only in his use of proportions but also in his approach to composition in space. He was apparently intent on making the viewer encounter in art the same foreshortening and overlapping of parts which are encountered in everyday optical experience, and to achieve this end he was willing to let his figures break out of the neat spatial cube in which the stable figures of Polykleitos [49] could be contained. It is perhaps this innovation which Pliny is referring to, among other things, when he tells us that Lysippos altered the squarish or block-like statures (*quadratas staturas*) of the figures of his predecessors, since in another passage he specifically singles out the works of Polykleitos as being *quadrata* (*N.H.* XXXIV. 56).

We can see all of these technical aspects of Lysippos' work developing or developed in the Agias in Delphi [77] and the *Apoxyomenos* ('Youth scraping himself with a strigil') in the Vatican [78]. The former belonged to a group set up at Delphi representing the Thessalian royal family and is thought to be a contemporary copy in marble of a posthumous portrait in bronze done by Lysippos at Pharsalos (Agias was a famous athlete of the fifth century B.C.); the latter is a Roman copy of an original bronze which is known to have been transported to Rome by the time of Tiberius. In both, the small proportion of the head and the compactness of the musculature produce the effect of slenderness and height, while the turning of the torso, tentative in the Agias, which perhaps dates from around 350 B.C., and fully developed in the *Apoxyomenos*, which probably belongs to the period just before Lysippos began to work for Alexander, asserts their liberation from Polykleitan conceptions of balance and harmony. In the *Apoxyomenos* this torsion and the bold thrusting of its right arm out into what might seem to be the viewer's space asserts a new spatial independence for the statue. It does not 'pose' for the viewer like a figure in a painting; rather it challenges him to move through space and explore many angles of vision in order to understand it fully.

Perhaps significantly Lysippos seems not to have played a great role in the development of the characteristic fourth-century themes mentioned earlier in this chapter. Praxiteles was more important and so was Skopas. Lysippos was above all a technician. His career had been based on technical innovation, on making new variations on established types (just like most of his predecessors in the fifth century); and since the emotion, sensuousness, and religious feeling of fourth-century sculpture were qualities that could be passed on to the Hellenistic period without mediation or transmutation, he seems not to have been overly concerned with them. On the other hand he was particularly active in the problem of creating new categories of Hellenistic sculpture, those categories which satisfied needs

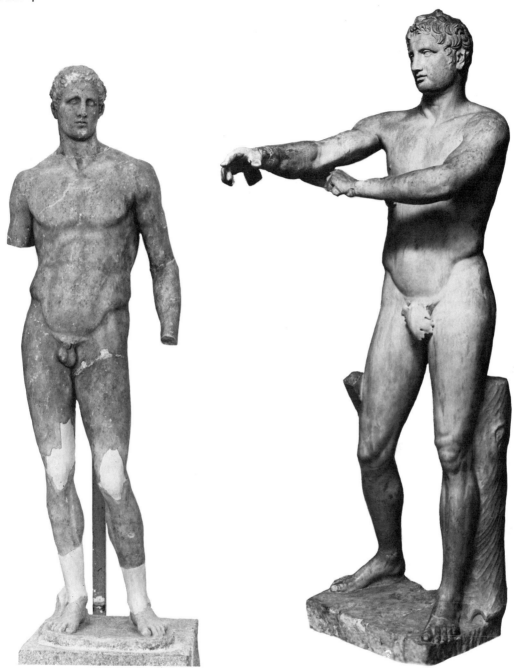

77. Agias, possibly a contemporary copy of Lysippos, marble, 340–330 B.C. Height approx. 6′ 5½″.

78. *Apoxyomenos*, attributed to Lysippos, marble, *c.* 330 B.C. Height approx. 6′ 8$\frac{7}{10}$″.

which the existing art of the fourth century could not. He did this characteristically by taking features out of previous fourth-century developments and giving them a new twist, a new direction suitable for the new era. His traditionalist yet innovative temperament must have given him a particular insight into the character of the art which already existed and into what had to be done.

What were the needs of the Hellenistic world which even the personalized art of the fourth century could not directly satisfy? First there was the fact that the sources which initiated the production of major works of art were now often individuals, powerful individuals, the great Hellenistic monarchs and generals whose individual wills had to be expressed through art. One of the focal points of Hellenistic art became the 'royal theme': what the leader envisioned, what he had done, what he stood for. The artist of the city-state had, of course, not faced this problem, but Lysippos was obviously obliged to treat it seriously, and his solutions were spectacularly successful. Plutarch tells us that only the Lysippean Alexander portraits captured the full effect of Alexander's melting gaze and yet preserved his heroic leonine essence. They established an heroic ruler type which lived on not only through the Hellenistic and Roman periods but even in later European art.

While we need not assume that these works were produced under conditions of slave-like drudgery (they must have embodied to some extent Lysippos' own personal convictions about the nature of his patron) they obviously must have been exactly what Alexander wanted – in fact, demanded. Not only did they fulfill his own vision of himself as the semi-divine hero but they also propagated this self-vision among his subjects. Their effectiveness may be gauged by another anecdote told by Plutarch. Some years after Alexander's death, Cassander, his sometime rival and successor as king of Macedonia, was strolling in the sanctuary of Delphi and came upon a portrait of Alexander, presumably one by Lysippos. The sight of the image, Plutarch tells us, struck him 'with a shuddering and trembling of the body from which he barely recovered, and caused a dizziness which blurred his vision'. (*Life of Alexander* LXXIV. 4.)

In order to appreciate the effectiveness of the Lysippean ruler portrait (and of other types which were derived from it) we should look for a moment at the typical features of the portraiture which preceded it in the fourth century. In most earlier Greek portraits, even those of the fourth century, the function of a man, his professional category, seems to have been felt more important than his individual idiosyncrasies. In the Lateran portrait of Sophocles [79], for instance, the concentrated gaze which seems to look outward into the distance, its tense diagonals formed by the stretching of the *himation* against the poet's legs, hips and elbows, create the feeling of an exocentric force. The figure captures the poet at the height

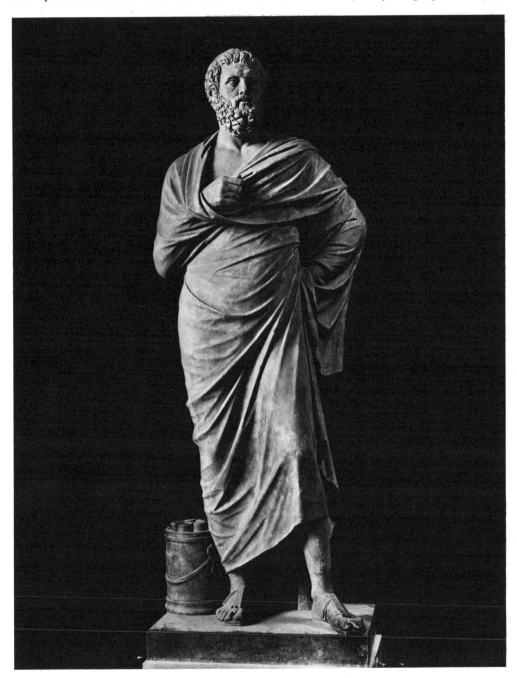

79. Sophocles, 'Lateran type', marble, Roman copy of an original of *c.* 340 B.C. Height approx. 6′ 8$\frac{3}{10}$″. (The feet, base, and details of the face, of the right hand, and of the drapery are restored.)

of his powers, thinking but above all proclaiming, which is the duty of a dramatic poet. This portrait was set up about 340 B.C. in the new theatre in Athens, well after Sophocles' death. It may represent his actual appearance and it may not. The point is that the portrait is what Sophocles was and to a Classical Greek that was what really mattered.

Lysippos in his Alexander portraits seems to have tipped the balance in Greek portraiture more toward the personality than the role. He did this not only by heeding the personal demands of his subject but also by forcing the viewer to dwell more on the subject's temperament. It was, after all, the temperament of the Hellenistic ruler which was crucial. His personality could be imposed on an entire civilization. Plutarch describes the typical features of the Lysippean Alexander portraits as a dramatic turning of the neck, and an upward, aspiring glance. On the surface these characteristics conveyed Alexander's heroism and Herculean aspirations. But they also gave a hint of his impetuousness and irritability when his will was challenged – factors which were individual and unpredictable but which could have great practical consequences. This impetuousness and latent danger are strongly felt in the well-known portrait of Alexander from Pergamon [80], which is often viewed as a typical work of the Pergamene style, but which accords well with literary descriptions of Lysippos' Alexander portraits and may well be much closer to the mature Lysippean product than it is usually credited with being. It is also felt, although perhaps less strongly, in the 'Azara herm' [81] and the 'Alexander with a lance' statuette, both apparently based on a single original. One wonders if, over the decade or more during which Lysippos produced portraits of Alexander, there might not have been a development beyond the type represented by the Azara herm toward an increasingly dramatic rendering of the characteristic features.

This new emphasis on personality of the Lysippean Alexander portraits probably reflects a broader aspect of the sculptor's style and was not confined to his royal portraits. Even in the Agias and the *Apoxyomenos*, presumably products of his earlier traditional phases, there seems to be an attempt to use physiognomical features to create an appropriate personality for the figures. The Agias is almost certainly an imaginary portrait, and there is no evidence as to whether the *Apoxyomenos* represented a particular person or not; but if we compare either one of them with the *Doryphoros* of Polykleitos of a century earlier [49], it is clear that Lysippos tried to shape faces which expressed not just ideal youth but the nature of athletes who undergo tensions and strains and even endure a few hard knocks.

The 'personality portrait' which Lysippos developed became one of the most effective genres of Hellenistic art. One example which can suffice as a representative

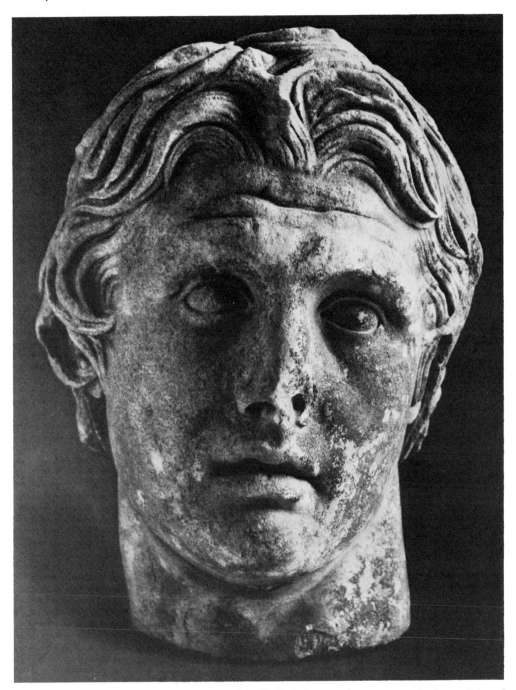

80. Head of Alexander from Pergamon, marble, Hellenistic portrait, *c.* 200 B.C., in the tradition of the Lysippean portraits of Alexander. Height approx 16″.

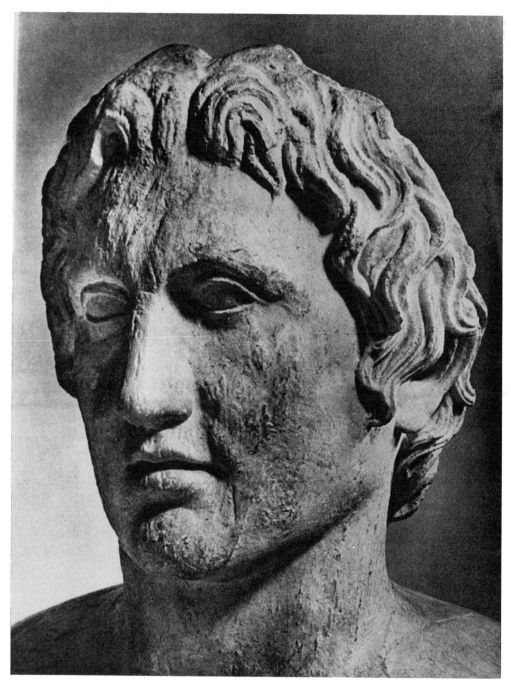

81. The 'Azara herm', Roman copy of the head of a Lysippean portrait of Alexander, marble, *c.* 333–323 B.C. Height of head approx. 10$\frac{1}{4}$".

of the whole movement is the insight-filled and moving portrait type of Demosthenes [82], the original of which was made by the sculptor Polyeuktos and was set up in the Agora in Athens around 280 B.C. As with the Sophocles portrait it is not certain whether the Polyeuktos portrait is based on an actual likeness of Demosthenes (who died in 322 B.C.) or is essentially imaginary, but it would be difficult to envision a more effective picture of the tense and temperamental Athenian orator – idealistic but querulous, frail but brave, with a haunted and even neurotic look which conjures up his disastrous final years and his ignominious death. The Demosthenes portrait is linked in spirit with a portrait type of Aristotle, probably some fifty years earlier in date [83]. Here too there is a haggard look produced by the wrinkled brow and the stringy locks around the forehead, but in this case it calls to mind the prolonged concentration of a man who was both a visionary contemplative and a painstaking logician. There is some reason to think that this Aristotle portrait may have been a work of Lysippos.[14] If so our respect for his versatility as well as his insight must be all the greater.

The perfection of the personality portrait and of a kind of royal iconography for the Hellenistic kings[15] almost certainly occurred during the time when Lysippos

[14] A headless herm which once bore a portrait of Aristotle and is now in the Epigraphical Museum in Athens has an inscription stating that 'Alexander' had the portrait set up. Presumably the herm-portrait was a Roman copy of an original commissioned by Alexander the Great. Since Lysippos was Alexander's court sculptor, it is not unreasonable to assume that he made the portrait. Cf. G. M. A. Richter *The Portraits of the Greeks* II (London 1965) pp. 170–5.

[15] In fact, Lysippos' influence may have extended beyond the Hellenistic period to the propagandistic state art of the Roman Empire. His renowned 'Granikos Monument' at Dion in Macedonia, produced at Alexander's command in commemoration of the King's companions who had fallen at the battle of the Granikos in 334 B.C., included as many as twenty-five equestrian figures as well as some infantrymen and a portrait of Alexander himself. Its dramatic but perhaps also didactic historicity had ample opportunity to influence Roman thinking, since the entire monument was transported to Rome by Metellus *Macedonicus* in the second century B.C. It seems likely that the battle between Greeks and Persians on the 'Alexander Sarcophagus' in Istanbul is a reflection of it and that many other Hellenistic equestrian monuments echoed it. What Lysippos seems to have done in the Granikos Monument was to have perpetuated the emotional confrontation of individuals in the art of the fourth century – like that in the pedimental sculptures of the temple of Athena *Alea* at Tegea, where Herakles was witness to the combat of his son Telephos with Achilles – but to have made the confrontation historical.

We can only guess at what the Granikos Monument was like in detail. Exactly how the figures of the companions were arranged is not known; nor is it known whether or not the opponents were represented. It was normal practice in Greek art to show two opposing forces when depicting a battle scene; in sculpture such scenes usually took the form of a linked series of individual combats. It is not improbable, therefore, that the monument as a whole was subdivided into groups of Macedonians and Persians represented in dramatic moments of close combat which revealed the psychological state of each figure – as in the confrontation between Alexander and a Persian on the Alexander Sarcophagus or between Darius and Alexander in the Alexander Mosaic. The faces of the Macedonians must certainly have been recognizable portraits. Perhaps there were portraits of some of the prominent Persian opponents too. It is just this combination of historical verisimilitude and dramatic psychological interchange between figures which

was working for Alexander. After 323 B.C. we know that he continued to be active, but it seems likely that his attention began to turn more to the nature of the newly-forming Hellenistic society as a whole and not only to its leaders. He seems to have sensed that in the great new Hellenistic centers like Alexandria which had attracted huge new populations with a variety of nationalities and cultural traditions it was increasingly difficult for an artist to appeal to a common background of under-standing among his viewers. Sculptors and painters could not always take it for granted that the public which viewed their works would understand the subtle meaning of mythological subjects, the meaning of formal gestures, or the originality involved in creating a slight variation on an established type. They had to appeal now to a more basic and general level of understanding; it probably could be expected, for example, that their viewers would be interested in the exotic, in exaggerated emotions, in obvious sensuousness, in the inevitable vagrancies of urban life, and also in obvious technical virtuosity – like colossal statuary – none of which required much cultural indoctrination in order to be understood. But the problem of devising works to appeal to this new public was complicated by the fact that along with and amid the uprooted and transplanted populations of the Hellenistic world there also arose another and almost contradictory figure – the scholar-intellectual, the librarian, the hyper-learned man, who tabulated detail. In the new Hellenistic cities private reading and study to a great extent had replaced community functions (like the earlier Greek drama) as the source of intellectual stimulation, and as a result the 'man of learning' and the ill-informed masses became polarized.

Devising works which would satisfy both of these contradictory tastes was prob-ably the sort of challenge which appealed to Lysippos. His solution to the problem seems to have been didactic art, art which would satisfy the learned man sensitized to complex allusions, indulge his love of learning, and at the same time 'inform'

characterized the greatest Roman historical reliefs, like those on the column of Trajan in Rome.

The Alexander Sarcophagus has recently been republished with excellent photographs by Karl Schefold *Der Alexander-Sarkophag* (Frankfurt am Main, Berlin 1968). In fairness it should be noted that Schefold de-emphasizes its connection with Lysippos because the style of the individual figures seems Attic rather than Sikyonian. But at this period in the history of Greek sculpture (*c.* 320–310 B.C.) there is no reason to assume that sculptors whose formal training was in the Attic tradition would have been oblivious of or insensitive to the Granikos Monument, which must have been one of the best-known and often discussed monuments of its time. If the sarcophagus was, in fact, made for King Abdalonymos of Sidon (died 311 B.C.), one of Alexander's allies and associates, an allusion to the Granikos Monument, which commemorated the death of other prominent companions of Alexander, would almost seem to be required. The Alexander Mosaic from the House of the Faun at Pompeii (now in the National Museum in Naples) dates from the second century B.C. but is generally agreed to be a copy of a painting done by one of Lysippos' contemporaries, perhaps Philoxenos of Eretria. Cf. Bernard Andreae *Das Alexandermosaik* (Bremen 1959).

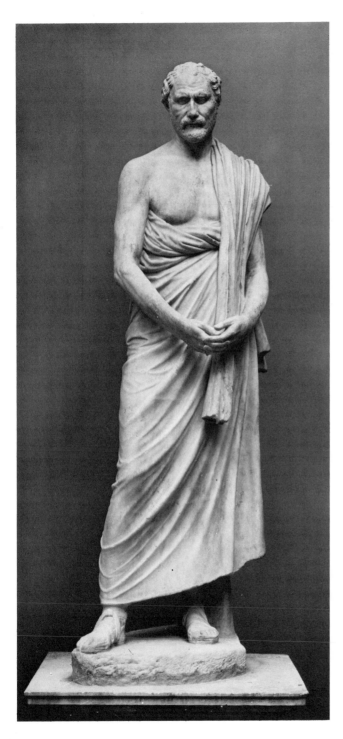

82. Demosthenes by Polyeuktos, Roman copy in marble of a bronze of 280 B.C. Height with plinth approx. 6′ 7½″. (The hands are restored on the basis of other replicas and literary evidence. The nose and details of the feet are also restored.)

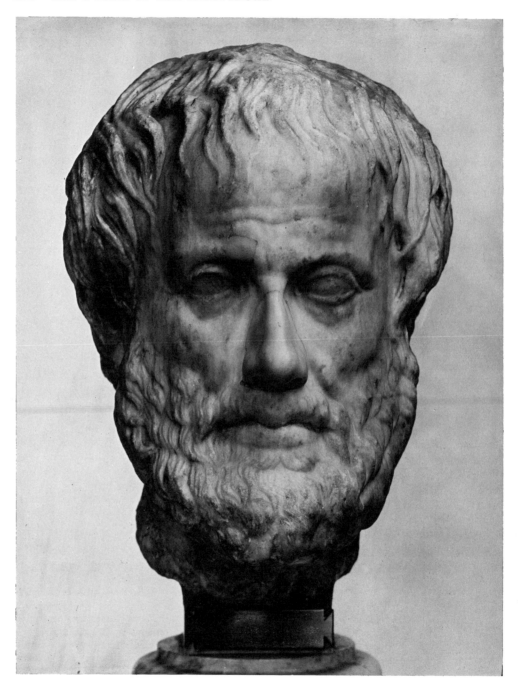

83. Portrait of Aristotle, marble, Roman copy of an original of *c.* 330 B.C. Height approx. $11\frac{2}{5}''$. (The nose is restored.)

others. The work most clearly aimed at doing this was his *Kairos*, 'Opportunity', a bronze statue described in literary references[16] and at least partly reflected in a Roman relief from Tragurium now in Spalato. Its details symbolically presented a lesson in conventional wisdom. The face of *Kairos* was covered with hair because Opportunity is hard to recognize. The back of his head was bald because once Opportunity has slipped by there is no way of seizing it. He had wings on his feet because he passes so swiftly, and a razor in his hand because his appearance is as abrupt as a razor is sharp. And so on.

What we have here is a drawn out allegory in the tradition of the simple allegorical figures of the fourth century – the 'Peace and Wealth' of Kephisodotos [63] and the *Pothos* of Skopas, figures which themselves reflect, as we have seen, the growing academic, studious atmosphere of the fourth century and its rather Platonic taste for formalized abstractions. But in Lysippos' hands the allegory became more complex, appealing, one feels, to the book-learned and to the teacher's irresistible urge to instruct.

Similarly complex appeals to a formally learned group of viewers appear in much Hellenistic sculpture. Behind the titanic struggle of the gods and giants on the great altar at Pergamon, for example, there was an almost scholarly program, undoubtedly emanating from the nearby library, in which different groups within the vast assemblage of deities (many of them nearly as obscure as their rivals) symbolized elemental cosmological forces – e.g. the sources of light, the heavens, the earth, and the waters. But perhaps the most vivid example of this literary taste in Hellenistic sculpture is the relief executed by Archelaos of Priene around 200 B.C.[17] to commemorate the victory of an anonymous poet in an Alexandrian literary contest [84]. On the bottom register of the relief we see Homer seated on a throne flanked by figures symbolizing the *Iliad* and the *Odyssey*. He is being crowned by Ptolemy IV and his Queen Arsinoë III who appear as personifications of *Chronos* ('Time') and *Oikoumenē* ('the Inhabited World'). Before Homer is an altar at which Myth and History offer sacrifice. To the right of them is Poetry holding two torches, and behind her come Tragedy and Comedy in theatrical

[16] The texts and translations of these references are collected in F. P. Johnson *Lysippos* (Durham, N.C. 1927) pp. 280–6.

[17] The accession of Ptolemy IV in 221 B.C. provides a *terminus post quem* for the date of the relief. Basing his opinion on dated parallels for the shapes of the letters in the inscription, M. Schede proposed a date of about 125 B.C. for the relief (cf. *Mitteilungen des deutschen archäologischen Instituts, Römische Abteilung* 25 (1920) 165 ff.), and this date has been accepted in most subsequent publications. A recent re-assessment of the inscription and other factors, however, has suggested to some that an earlier date is more likely (cf. Richter *The Portraits of the Greeks* I, p. 54), but the question is undecided. In a recent (1965) republication of the relief, D. Pinkwart adheres to Schede's dating (*Antike Plastik* IV, pp. 55–65).

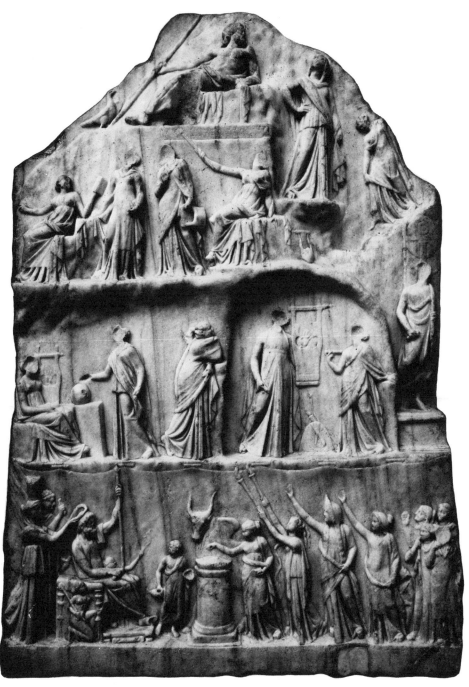

84. Commemorative or votive relief by Archelaos of Priene, marble, *c.* 200–125 B.C. Height approx. 45″.

dress. At the far end a child, Human Nature, gestures to figures personifying the noble virtues derived from literary study – Courage, Good Memory, Trustworthiness, and Wisdom. At the top of the relief Zeus is shown seated on a mountain which may be Helikon or Parnassus, for dispersed beneath him are Mnemosyne ('Memory', to the right), the nine Muses, and Apollo (standing, with the lyre) – the gods of poetic inspiration. At the far right edge the figure standing on a pedestal before a tripod, the price of victory, is perhaps the victorious poet. In all, a literary cosmos which invited a limited, educated public to linger over its details.

But more often the Hellenistic artist in designing work for public exhibition had to eschew subtlety for more obvious efforts to surprise and dazzle the viewer, to arrest his interest by some technical achievement, which in itself would impress him whether he happened to be a learned man or not.

It is in this regard that the Herakles figures of which Lysippos was particularly fond and of which he made a fair number were extremely influential. In these images, in particular, Lysippos seems to have been the instigator of what one might call Hellenistic 'shock tactics' in the use of scale. There is something intrinsically astounding about either extreme bigness or extreme smallness, and Lysippos in his Herakles figures seems to have exploited both. With them he seems to have been personally responsible for bringing colossal sculpture back into vogue. It had been common in the early Archaic period, when Greek sculpture was still strongly under the influence of oriental prototypes, but aside from a few cult images, it had been rejected in the Classical period. With Greece and the Orient once again in close contact, Lysippos and his pupils revived it. His bronze image of Herakles at Tarentum, for example, was forty cubits high. On the other hand, at the other end of the spectrum his Herakles *Epitrapezios*, one of the most famous miniature statues of Antiquity, was only one cubit in height. [85]

This manipulation of scale was intended to do more than simply overwhelm or amaze the onlooker. It was also intended to stimulate curiosity and thought by confounding expectations. For example, the Herakles Farnese type [86], which is ascribed to Lysippos on the basis of an inscribed copy,[18] presents the traditional

[18] This copy is in the Uffizi in Florence. The copies of the Farnese type vary greatly in scale and in surface details (see the catalogue in F. P. Johnson *Lysippos* pp. 197–200, to which an example recently found at Salamis in Cyprus should be added, cf. E. Sjöqvist *Lysippus* (Cincinnati 1966) pp. 30, 31). Because of this variety there has been considerable discussion about what the scale and the style of 'the original' was. The exaggerated, deep, heavy carving of the Herakles Farnese in Naples is sometimes ascribed to the copyist, Glykon of Athens, who appears to have made the work for the baths of Caracalla (where it was found) rather than to the Lysippean original. But one is inclined to wonder if there were not many 'originals'. Lysippos is said to have made 1,500 works. Even if we allow that this figure might be exaggerated by 50 per cent and acknowledge that Lysippos had a long career, his *œuvre* seems incredibly large. One explanation of its magnitude

hero as well over life-sized, astonishingly muscle-bound and powerful, yet he is barely able to stand. He is exhausted, has no physical strength. The tiny *Epitrapezios*, on the other hand, radiates energy. What the scale might lead us to expect is surprisingly contradicted by the conception. The big Herakles is unexpectedly weak; the little one is mighty. Something of the same unpredictability is said by Pliny to have been characteristic of the colossal bronze Herakles at Tarentum. It is said to have been so stable that even the most violent storm could not dislodge it; and yet it could be moved by the properly applied pressure of one hand. In each of these Herakles figures we are forced to discount appearances; to look and think twice.

Surprise effects produced by an unusual or unexpected scale were generally important in Hellenistic sculpture, but they seem to have been particularly important in the first part of the third century B.C. which was dominated by the Lysippean school. The most famous and the largest (over 120 cubits high) colossus of Antiquity, for example, that of Helios on Rhodes, was by Chares of Lindos, a pupil of Lysippos.

We probably have to give Lysippos himself, however, credit for being something more than simply an artist who used technical surprises for theatrical effects. He was, as we have seen, one of the more thoughtful Greek sculptors, and if we turn to the Herakles *Epitrapezios* again we can perhaps see that for the people of his own time who could understand, or perhaps just for his own sake, he invited the viewer not just to think twice but even three times. Statius and Martial attest that this figure was a miniature, about a cubit high, which was originally made by Lysippos for Alexander and that after Alexander's death it passed through various hands until, in their time, it came into the possession of a Roman collector. The fact that thirteen copies, all on a miniature scale and all more or less fitting Statius' description of the figure, are known leaves no doubt that a tiny *Epitrapezios* really existed in Antiquity. For many years scholars assumed that the name *Epitrapezios* might mean 'on the table', assuming that the little image was named after its function as an ornament for a banqueting table.

In 1960, however, the Belgian excavators at Alba Fucens, a Roman colonial settlement in central Italy, unearthed a colossal version of the *Epitrapezios* [87]

may be that Lysippos' workshop produced many versions on different scales of one design by the master. There is some reason for believing this to be the case, as will be seen, with the Herakles *Epitrapezios*. If among the Lysippean versions of the Farnese type there was a colossus, it seems not unlikely that some of the heaviness of the Naples statue must stem from it. The colossal version of the *Epitrapezios* (see below) and a bearded head in Taranto, apparently a copy of a colossal bronze by Lysippos (cf. Bieber *The Sculpture of the Hellenistic Age*², fig. 83), also show a tendency to deep, dramatic carving, which may have been characteristic of colossal statues in general.

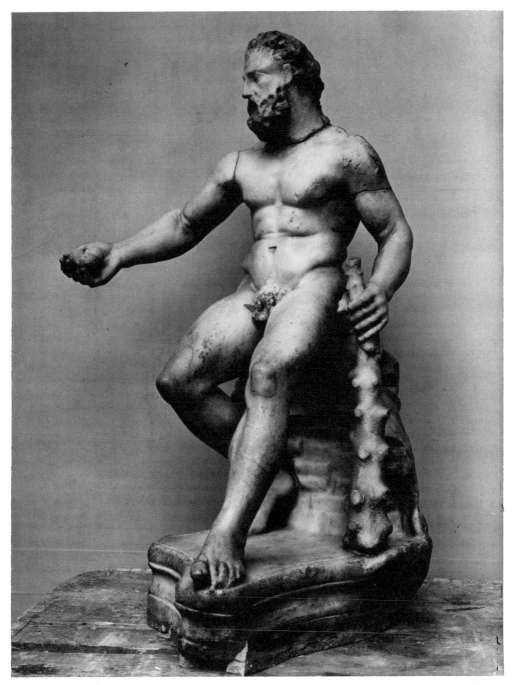

85. Herakles *Epitrapezios* of Lysippos, marble, Roman copy of an original of *c.* 325 B.C. Height approx. 21⅗″. (The hands and part of the arms are restored.)

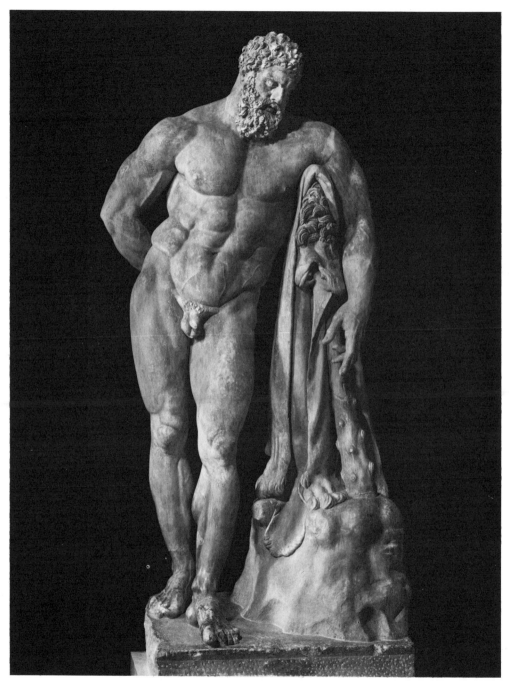

86. Herakles Farnese, version of a Lysippean type of *c.* 320 B.C., by the sculptor Glykon of Athens (third cent. A.D.?), marble. Height approx. 10′ 4⅘″.

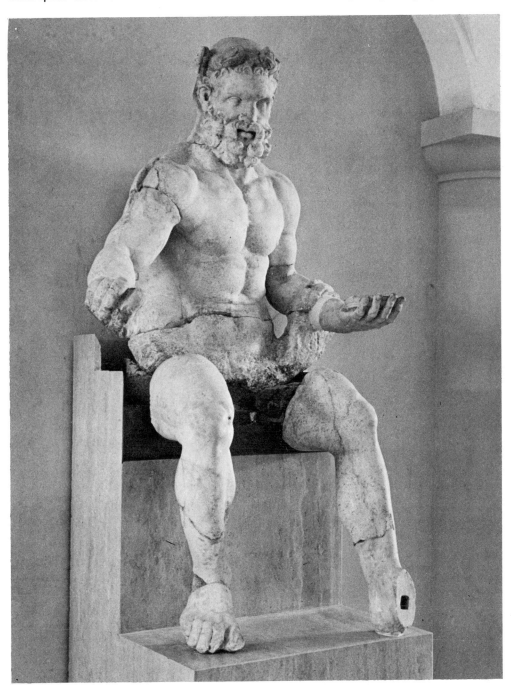

87. Colossal version of the Herakles *Epitrapezios* type, from Alba Fucens, marble, *c.* 200 B.C. Height of head, approx. 18″.

in a small sanctuary of Herakles. It seems likely, as the Belgian excavator de Visscher has suggested in a thoughtful study,[19] that Lysippos originally made two figures of Herakles in this format, one a small image to grace the table of Alexander, the other a large cult image for a temple, and that the surname *Epitrapezios* means not 'on the table' but 'at the table', i.e. the banqueting Herakles. Perhaps in fact the name is a pun. De Visscher assembles a body of evidence to suggest that after the period of the Peloponnesian War Herakles came increasingly to be appreciated as 'l'incarnation du courage dans l'adversité', the mortal who by his own struggles had attained immortality. He further suggests that the *Epitrapezios* type, the seated Herakles dining, depicts Herakles in a state of 'sweet and serene euphoria' at the end of his labors, a symbol of the ultimate triumph of the higher aspirations of humanity like the hero of Seneca's *Hercules on Oeta*. But in thinking about this heroic interpretation of the banqueting Herakles, another, rather different image, inevitably comes to mind — the boisterous, boorish, good-natured adventurer whose banqueting occupies a major portion of Euripides' *Alcestis*. Which cf these did Lysippos have in mind? Perhaps, in creating both a miniature and a colossal *Epitrapezios* he was being intentionally ambiguous and raising a question for us. Alexander and other Hellenistic rulers after him identified themselves with Herakles. They saw themselves in the role of the hero who through great deeds became divine, became greater than life. Lysippos, like his contemporary Aristotle, who was a mentor of Alexander, must have had a good deal of time to observe the King, the original Hellenistic hero. He undoubtedly saw Alexander's virtues; perhaps he also saw his faults. And Lysippos like Aristotle was a Classical man. Aristotle in his later years is said to have had some doubts about Alexander and perhaps Lysippos, who probably knew Aristotle (and, as we have seen, may even have made a portrait of him), did too. In the *Epitrapezios*, then, he seems to be asking us this question, or at least hinting that such a question could be asked. Was Herakles, and by analogy a ruler who saw himself as Herakles, a small figure, in the sense that he began as a mere man, who did great things? Or was he a great figure who did trivial things? Does he belong in a temple or at a table? We are forced to find the answer for ourselves.

In the end Lysippos seems to have preferred the essentially Classical aloofness of the fourth century to the Hellenistic dynamic individualism which he helped to create.

[19] F. de Visscher *Héraklès Epitrapezios* (Paris 1962), reprinted from *L'Antiquité Classique* 30 (1961). The circumstances of discovery, the reconstruction of the figure from the surviving pieces, and the general significance of the type are all dealt with in this study. The Alba Fucens statue is of Pentelic marble and is tentatively assigned to the third or second century B.C. Assuming that this date is correct, it must be viewed as a Hellenistic replica of a Lysippean type.

Epilogue

In the prologue with which this book began it was proposed to let the term 'classical' define itself by demonstration. Are we now in a position, then, to identify any single element which can be said to characterize the art of the Classical period as a unit and to distinguish it from earlier and later phases of Greek art?

From the standpoint of at least two of the levels on which we normally seek to analyze and understand an art – its formal development and the specific content which its forms are used to express – the answer might seem to be no. The diversity of styles and themes within the period is perhaps more striking than any common, unifying thread. Dramatic tension, moralistic austerity, mannerism, visionary aloofness, a passion for elegance, academicism, sensuousness, and pathos can all be found at one stage or another; and in purely formal terms the Aspasia [16], the Nike of Paionios [54], and the Aphrodite of Knidos [67] perhaps seem to have at best only a distant familial relationship.

There is, however, still another fundamental level on which artistic expression is analyzable, namely, the way in which it conveys a general conception of reality and implicitly describes the nature of existence. The stained glass windows and the sculpture of Gothic cathedrals, for example, seem to have been designed with the assumption that the real nature of existence is most vividly apparent in a state of mystical emotion. Some artistic movements in the twentieth century, on the other hand, seem intent on convincing us that sense experience and instinctive reactions, freed from the fetters of the reasoning mind, are the stuff of reality.

Approaching the art of the Classical period on this level of comprehension, one can see, I think, a unifying basis within it. This is its tendency, which I have already described in discussing 'The Parthenon and the Classic Moment' (see pp. 94–7), to find a balance between the representation of the specific and the generic and to make the viewer acutely conscious of both. In a number of philosophical and religious traditions – one might take as exemplars Platonism, with all it variants, in the West and the Vedantic tradition in the East – two dimensions of

being are recognized as knowable, or at least conceivable, by man. One is the
absolute dimension, the unchanging substratum, called 'the ultimate reality, the
realm of ideas, God, the one' and the like, which is the background, so to speak,
against which the changes of the finite world are judged. The other dimension, of
course, is the world of immediate experience itself, the world of coming into being
and passing away. In the first chapter of this book I suggested that in Archaic
Greek art and thought there was a tendency to convey a sense of the absolute, or
the generic, by ignoring the relative, or the specific, as much as possible. In the
Hellenistic period, by contrast, a fascination with mirroring the changing states of
the relative world – e.g. sleep, rage, drunkenness, fear, mirth, lust and so on – can
often be noted. The Hellenistic works which express these states have sometimes
been described as 'rococo',[1] but in fact they represent the most intense drive
toward realism which ever appeared in Greek art. The artists of the Classical
period seem to fall between these two extremes not only in time but also in inten-
tion. Whether it was by conscious decision or through a subconscious inclination,
one senses that they strove to evoke an awareness of both the ideal and the actual
in their work, to convey what in philosophical terms might be expressed as a
consciousness of the absolute inherent in and pervading the relative.

[1] A sample of such works may be found in Bieber *The Sculpture of the Hellenistic Age*[2], pp. 136 ff.
The notion of a rococo phase in Hellenistic art was first formulated in detail by Wilhelm Klein
Vom Antiken Rokoko (Vienna, Hölzel 1921).

Supplementary references for illustrations

For practical reasons it has not been possible to illustrate every work mentioned in the text of this book. The following list suggests some sources in which photographs of works not illustrated here may be found. Wherever possible, reference has been given to easily accessible handbooks and picture books.

The following abbreviations have been used:

AH Arias, P., Hirmer, M. *Greek Vase Painting* (New York 1961).
BG Berve, H., Gruben, G. *Greek Temples, Theaters, and Shrines* (New York 1962).
BSHA Bieber, M. *The Sculpture of the Hellenistic Age* (revised edition, New York 1961).
LH Lullies, R., Hirmer, M. *Greek Sculpture* (New York rev. edn. 1960).
LP Lippold, G. *Die Griechische Plastik* (*Handbuch der Archäologie* III, 1, Munich 1950).
PMS Picard, C. *Manuel d'Archéologie Grecque, La Sculpture* III and IV (Paris 1948–63).
RHB Richter, G. M. A. *A Handbook of Greek Art* (sixth edition, London and New York 1969).
RSSG Richter, G. M. A. *The Sculpture and Sculptors of the Greeks*⁴ (New Haven 1970).

Numbers refer to photographic plates or figures. When preceded by 'fig.' the numbers refer to line-drawings which are counted separately from the photographic illustrations.

pp. 18 ff., sculptures from Aegina – see p. 19, n. 1; also LH 72–7, 82–7.

pp. 27 ff., sculptures from the temple of Zeus at Olympia – see 'Further Reading', p. 199.

p. 36, late archaic *korai* – in general G. M. A. Richter *Korai* (London, 1968) 317 ff.; for examples: LH 70, 80–1; RHB 91–3.

p. 41, Temple of Hera II at Paestum – BG 115–21; RHB 18.

p. 41, Temple E at Selinus – BG 130–1.

p. 50, metope of Zeus and Hera from Temple E at Selinus – LH 127–9; BG 132; RSSG 410.

pp. 51–3, 'Tyrannicides' of Kritios and Nesiotes – RSSG 571–7.

p. 56, pattern for running figures in Archaic sculpture – RSSG 76–83.

p. 58, Herakles as an archer from Aegina – LH 86–7; RHB 113.

p. 63, fragment of a cup by the Pistoxenos Painter – AH 167.

pp. 71 ff., Parthenon sculptures – see 'Further Reading', p. 200.

p. 100, Athena from Peiraeus – G. Hanfmann *Classical Sculpture* (Greenwich, Conn., 1967) 171.

p. 103, white-ground *lekythoi* by the Achilles Painter – AH XXXVIII–XXXIX, 185–7; RHB 466; see also 'Further Reading', p. 200.

p. 108, *Diadoumenos* of Polykleitos – RSSG 695–7; RHB 156.

p. 118, rider relief in the Villa Albani – LH 179; RHB 169.

p. 122, *lekythos* by the Eretria Painter – R. M. Cook *Greek Painted Pottery* (Chicago 1960) 47; E. Pfuhl *Malerei und Zeichnung der Griechen* (Munich 1923) 560.

p. 122, *hydria* by the Meidias Painter in Florence – *Corpus Vasorum Antiquorum* (Italia XIII, Firenze, *Museo Archeologico* II) 60, 1 and 62–3; Pfuhl *Malerei und Zeichnung* 594.

p. 134, 'Temple of the Athenians' at Delos – BG fig. 57; F. Courby *Exploration archéologique de Délos* 12 (1931).

p. 134, Narcissus type – LP 60, 2.

p. 135, Nereid Monument – RSSG 318–20, RHB 180.

p. 143, *akroteria* from Epidauros – see p. 144, n. 6; also RSSG 757–60; RHB 184–5.

pp. 144–5, Altar of Zeus at Pergamon – general: Evamaria Schmidt *The Great Altar of Pergamon* (Leipzig 1962); examples: LH 251–9.

p. 145, Laocoön – LH 262–3; RSSG 831, 768–9; RHB 236.

p. 146, copies from the 'lesser Attalid dedication' in Athens – BSHA 430–7, LP 127.

p. 154, Boy playing with a goose, possibly by Boethos – RSSG 820; BSHA 285; LP 117, 2.

p. 154, Pan teaching a boy to play the pipes – BSHA 628; LP 113, 2.

p. 154, Cupid and Psyche – BSHA 638.

p. 154, *symplegma* types – BSHA 626–7; LP 113,1.

p. 154, Aphrodite warding off Pan – BSHA 629–30; LP 135,3.

p. 159, Aphrodite of Cyrene – RSSG 54; BSHA 396–7.

p. 159, Aphrodite of Doidalsas – RSSG 822; BSHA 290–3.

p. 164, *tholos* at Delphi – A. W. Lawrence *Greek Architecture* (rev. edn. Harmondsworth 1962) 86; BG 78–9.

p. 166, Didyma, temple of Apollo – BG 164–9 and figs. 129–35.

p. 170, *Pothos* of Skopas – RHB 201; PMS III 277–84; LP 91,3.

p. 173, Mantineia base – RSSG 726–8; LP 85, 1–3.

p. 173, Mausoleum frieze – RSSG 744–9, 767–9, 776–7, 783; LH 214–17; PMS IV 11 ff.

p. 174, Stephanos youth – RSSG 851; BSHA 784–6.

Supplementary suggestions for further reading

The following references are intended to supplement the bibliography already given in the notes and have been selected for their particular relevance to the themes, problems, and monuments examined in this book. A general, basic bibliography for the study of Greek art may be found in G.M.A. Richter *A Handbook of Greek Art* (sixth edition, London and New York 1969) pp. 399–410.

PREFACE – On the interconnections of Greek art and Greek literature: T. B. L. Webster *Greek Art and Literature, 700–530 B.C.* (New York 1960); *Greek Art and Literature, 530–400 B.C.* (Oxford 1939); *Art and Literature in Fourth-Century Athens* (London 1956); *Hellenistic Poetry and Art* (London 1964).

PROLOGUE – Three particularly interesting studies of the qualities of the Classical style and of the changing evaluations of it are: Bernard Ashmole *The Classical Ideal in Greek Sculpture* (*Lectures in Memory of Louise Taft Semple*, Cincinnati 1964); Ernst Langlotz *Über das Interpretieren griechischer Plastik* (*Bonner Universitäts-Schriften* 7, 1947); Vincent J. Scully 'The Nature of the Classical in Art', *Yale French Studies* 19/20 (1957–8) 107–24. This subject has been a particular preoccupation of German scholars since the time of Winckelmann, and discussions of it are often characterized by a blend of classicism and romanticism in the tradition of Goethe: e.g., recently, Karl Schefold *The Art of Classical Greece* (New York 1966) pp. 11–19.

CHAPTER 2 – On the sculptures from the temple of Zeus at Olympia: Bernard Ashmole, Nicholas Yalouris *Olympia* (London 1967); Bernard Ashmole 'Some Nameless Sculptors of the Fifth Century B.C.' (London 1962; from *Proceedings of the British Academy*, vol. XLVIII; published separately).

On the formal analysis of the Early Classical style in Greek sculpture and regional variations in the style: Vagn Poulsen *Der strenge Stil* (Copenhagen 1937); Brunilde S. Ridgway *The Severe Style in Greek Sculpture* (Princeton 1970).

Proportion and the effect of proportion in Classical temple architecture are particularly well-treated in Gottfried Gruben *Die Tempel der Griechen* (Munich 1966; an expanded and revised version of the text of Berve–Gruben *Greek Temples, Theatres, and Shrines*) *passim*.

On the Niobid Painter and the Louvre *krater*: T. B. L. Webster *Der Niobidenmaler*

(Leipzig 1935); Erika Simon 'Polygnotan Painting and the Niobid Painter', *American Journal of Archaeology* 67 (1963) 43–62.

On the historical background of the Charioteer of Delphi: François Chamoux *L'Aurige de Delphes* (Paris 1955).

On *rhythmos* in Greek sculpture: Eugen Petersen 'Rhythmus', *Abhandlungen der K. Gesellschaft der Wissenschaften zu Göttingen, Phil.-Hist. Klasse*, N.F. 16 (1917) 1–104; J. J. Pollitt 'Professional Art Criticism in Ancient Greece', *Gazette des Beaux Arts* 64 (1964) 317–30.

On the 'Tyrannicides' group: S. Brunnsåker *The Tyrant-Slayers of Kritios and Nesiotes* (Lund 1955).

On the Pan Painter: Sir John Beazley *Der Pan-Maler* (Berlin 1931).

CHAPTER 3 – Periclean Athens: A. R. Burn *Pericles and Athens* (London 1948).

'On the intellectual background of the Periclean period: John H. Finley *Thucydides* (Cambridge Mass. 1942; reprint Ann Arbor 1963), chap. II.

On Protagoras and the Sophists: Milton C. Nahm *Early Greek Philosophy* (fourth edition, New York 1964) pp. 208–29; Werner Jaeger *Paideia*, vol. I (second edition, New York 1945) pp. 286–331.

The Parthenon: An interesting collection of essays on political, religious, and artistic aspects of the Parthenon appears in G. T. W. Hooker, ed. *Parthenos and Parthenon* (*Greece and Rome*, supplement to volume X, Oxford 1963). On the sculptures: A. H. Smith *The Sculptures of the Parthenon* (London 1910); P. E. Corbett *The Sculpture of the Parthenon* (Harmondsworth 1959); D. E. L. Haynes *An Historical Guide to the Sculptures of the Parthenon* (revised, Brit. Mus. 1965).

On the Athena *Parthenos* and the Olympian Zeus of Pheidias: literary testimonia are collected in J. Overbeck *Die antiken Schriftquellen zur Geschichte der bildenden Künste bei den Griechen* (Leipzig 1868; reprint Hildesheim 1959) nos. 645–90, 692–754; translations of some of the more important sources can be found in the present writer's source-book (see p. 51, n. 12). For bibliography on problems relating to the reconstruction of the two statues see G. Becatti s.v. 'Fidia' in the *Enciclopedia dell'Arte Antica* III (sources up to 1959), to which add: N. Leipen 'The Athena Parthenos by Pheidias', *Phoenix* 17 (1963) 119–22; E. B. Harrison 'The Composition of the Amazonomachy on the Shield of the Athena Parthenos', *Hesperia* 35 (1966) 107–33.

On the Achilles Painter and white-ground *lekythoi*: Sir John Beazley 'The Master of the Achilles Amphora in the Vatican', *Journal of Hellenic Studies* 34 (1914) 179–226; and *Attic White Lekythoi* (London 1938).

On Polykleitos: P. Arias *Policleto* (Milan 1964); C. Vermeule *Polykleitos* (Boston 1969).

On Pythagoreanism: In general see G. S. Kirk, J. E. Raven *The Presocratic Philosophers* (Cambridge 1962) pp. 216–62, 307–18; in connection with Polykleitos, J. E. Raven 'Polyclitus and Pythagoreanism', *Classical Quarterly* 45 (1951) 147–52.

CHAPTER 4 – General background: E. R. Dodds *The Greeks and the Irrational* (Berkeley and Los Angeles 1951; paperback edition, Boston 1957), especially chapter VI.

On the Meidias Painter and his style: G. Nicole *Meidias et le style fleuri dans la*

céramique attique (Geneva 1908); W. Hahland *Vasen um Meidias* (Berlin 1930); G. Becatti *Meidias: un manierista antico* (Florence 1947).

Gorgias: On the philosophical works see Nahm *Early Greek Philosophy* pp. 229–39. An amusing and revealing translation by Larue Van Hook of the *Encomium on Helen* is reprinted in volume III of the Loeb edition of Isocrates, pp. 55–7.

On the temple of Apollo at Bassae: For the observations of early visitors see Charles Robert Cockerell *The Temples of Jupiter Panhellenius at Aegina, and Apollo Epicurius at Bassae near Phigaleia in Arcadia* (London 1860). On the plan of the temple and the role of Iktinos add to the references given on p. 127, n. 4: W. Hahland 'Der Iktinische Entwurf der Apollontempels in Bassae', *Jahrbuch des deutschen archäologischen Instituts* 63/4 (1948–9) 14–39; H. Knell 'Iktinos: Baumeister des Parthenon und des Asklepios-tempels von Phigalia–Bassae', *ibid.* 83 (1968) 100–17; Frederick A. Cooper 'The Temple of Apollo at Bassae: New Observations on its Plan and Orientation', *American Journal of Archaeology* 72 (1968) 103–11.

On Iktinos' plan for the *Telesterion* at Eleusis: F. Noack *Eleusis, die baugeschichtliche Entwicklung des Heiligtumes* (Berlin and Leipzig 1927) pp. 139–201; George Mylonas *Eleusis and the Eleusinian Mysteries* (Princeton 1961) pp. 113–29.

On the Erechtheion: In general see J. M. Paton, G. P. Stevens, L. D. Caskey, H. N. Fowler *The Erechtheum* (Cambridge Mass. 1927); L. B. Holland 'Erechtheum Papers', *American Journal of Archaeology* 28 (1924), 'I, The Remains of the Pre-Erechtheum' pp. 1–23; 'II, The Strong House of Erechtheus' pp. 142–69; 'III, The Post-Persian Revision' pp. 402–25; 'IV, The Building Called the Erechtheum' pp. 425–34. For a highly technical analysis of the literary and epigraphical evidence relating to the history and plan of the Erechtheion see William B. Dinsmoor 'The Burning of the Opisthodomos at Athens', I and II, *American Journal of Archaeology* 36 (1932) 143–73, 307–26.

CHAPTER 5 – In general, on the emotional climate of the period: André-Jean Festugière *Personal Religion Among the Greeks* (Berkeley and Los Angeles 1954) *passim* but especially chapters III and IV.

On Skopas: P. Arias *Skopas* (Rome 1952).

On the stelae from Pagasai: A. S. Arvanitopoulos *Painted Stelae from Demetrias-Pagasai* (in Greek; Athens 1928); a summary of the basic information appears in Mary Swindler *Ancient Painting* (New Haven 1929) pp. 346–9.

On Praxiteles: G. E. Rizzo *Prassitele* (Milan–Rome 1932). The most recent contribution to the Hermes controversy, with references to earlier discussions, is: Rhys Carpenter 'A Belated Report on the Hermes Controversy', *American Journal of Archaeology* 73 (1969) 465–8. On the Aphrodite of Knidos: C. S. Blinkenberg *Knidia* (Copenhagen 1933).

On *tholoi* and their significance: F. Robert *Thymélè* (Paris 1939).

On the career of Bryaxis note especially: J. H. Jongkees 'New Statues by Bryaxis', *Journal of Hellenic Studies* 68 (1948) 29–39.

On the portraits of Alexander: Margarete Bieber *Alexander the Great in Greek and Roman Art* (Chicago 1964).

ADDENDA – The following became available while the present book was in production: G. M. A. Richter *Perspective in Greek and Roman Art* (London and New York 1970);

Rhys Carpenter *The Architects of the Parthenon* (Harmondsworth/Baltimore 1970). The former supplements the references given above, p. 56, n. 15; the latter hypothesizes a Kimonian as well as a pre-Persian and a Periclean Parthenon and will undoubtedly be controversial.

Additional suggestions for further reading (1999)

GENERAL BACKGROUND – Martin Robertson, *A History of Greek Art* (Cambridge 1975); John Boardman, *Greek Sculpture, The Classical Period* (London and New York 1985); Susan Woodford, *An Introduction to Greek Art* (Ithaca, N.Y. 1986); Andrew Stewart, *Greek Sculpture, An Exploration* (New Haven 1990); John Boardman, *Greek Sculpture, The Late Classical Period* (London and New York 1995).

PREFACE – Jeffrey Hurwit, *The Art and Culture of Early Greece* (Ithaca, N.Y. 1985); H. A. Shapiro, *Myth Into Art* (New York 1994).

CHAPTER 2 – **On the Kritios Boy:** Jeffrey Hurwit, 'The Kritios Boy: Discovery, Reconstruction, and Date', *American Journal of Archaeology* 93 (1989) 41–80.
On the temple of Zeus at Olympia: Marie-Louise Säflund, *The East Pediment of the Temple of Zeus at Olympia* (*Studies in Mediterranean Archaeology*, 27) (Göteborg 1970).
On the Early Classical style in sculpture: Evelyn B. Harrison, 'Early Classical Sculpture: The Bold Style', in C. G. Boulter, ed., *Greek Art, Archaic into Classical* (Leiden 1985) 40–65.
On *rhythmos*: J. J. Pollitt, *The Ancient View of Greek Art* (New Haven 1974) 218–28.

CHAPTER 3 – **On Periclean Athens:** Donald Kagan, *Pericles of Athens and the Birth of Democracy* (New York 1991).
On Protagoras and the Sophists: Ira S. Mark, 'The Gods on the East Frieze of the Parthenon', *Hesperia* (1984) 289–342.
The Parthenon. On the pediments: Olga Palagia, *The Pediments of the Parthenon* (Leiden 1993). **On the frieze:** In addition to the references given in the supplement to the footnotes, see Ian Jenkins, *The Parthenon Frieze* (Austin,

Texas 1994). **On the Athena Parthenos and Pheidias:** Neda Leipen, *Athena Parthenos, A Reconstruction* (The Royal Ontario Museum 1971): Evelyn B. Harrison, 'Pheidias', in Olga Palagia and J. J. Pollitt, *Personal Styles in Greek Sculpture* (Cambridge 1996) 16–65.

On the Achilles Painter and white-ground lekythoi: John Oakley, *The Achilles Painter* (Mainz/Rhein 1997); Donna Kurtz, *Athenian White Lekythoi* (Oxford 1975).

On Polykleitos: Warren Moon, ed., *Polykleitos, the Doryphoros, and Tradition* (Madison, Wis. 1995); Adolf Borbein, 'Polykleitos', in Palagia and Pollitt, *Personal Styles* (see above) 66–90.

On Pythagoreanism: Ned Nabors and Susan Ford Wilshire, 'The Athena Temple at Paestum and Pythagorean Theory', *Greek, Roman, and Byzantine Studies* 21 (1980) 207–15.

CHAPTER 4 – **On the Meidias Painter:** Lucilla Burn, *The Meidias Painter* (Oxford 1987).

On the Nike Temple Parapet: For a quite different interpretation (ritual and chthonic) from the one presented here, see Erika Simon, 'An Interpretation of the Nike Temple Parapet', in *Interpretation of Architectural Sculpture*, 127–43. For a recent analysis of the date of the parapet sculptures which divides their development into several chronological phases: Evelyn B. Harrison, 'Style Phases in Greek Sculpture from 450 to 370 B.C.', in *Praktika tou XII Diethnous Synedriou Klassikes Arkhaiologias*, 3 (Athens 1988) 99–105.

On the Erechtheion: Some scholars now argue that the building which is now commonly called the 'Erechtheion' was, in fact, exclusively a temple of Athena and that the Erechtheion described by Pausanias was an altogether different building. This was first proposed by Kristian Jeppesen in a series of articles and booklets, the most recent of which is: *The Theory of the Alternative Erechtheion* (*Acta Jutlandica* LXIII:1) (Aarhus 1987). See also Noel Robertson, 'Athena's Shrines and Festivals', in Jenifer Neils, ed. *Worshipping Athena* (Madison, WI 1996) 27–77, especially 37–44.

CHAPTER 5 – **On the sculpture of the fourth century in general:** Brunilde S. Ridgway, *Fourth Century Styles in Greek Sculpture* (Madison, WI 1997).

On the Aphrodite of Knidos and its tradition: Christine M. Havelock, *The Aphrodite of Knidos and her Successors* (Ann Arbor 1995).

On the portraits of Alexander the Great: Andrew Stewart, *The Faces of Power* (Berkeley, Los Angeles, and Oxford 1993).

Supplementary references to the footnotes

Note that the following work: Diana Buitron-Oliver, ed., *The Interpretation of Architectural Sculpture in Greece and Rome* (*Studies in the History of Art 49, Center for Advanced Study in the Visual Arts, Symposium Paper XXIX*, National Gallery of Art, Washington 1997), is here abbreviated as *Interpretation of Architectural Sculpture*.

P. 19, note 1: A thorough restudy of the east pediment, based in part on new German excavations in the 1960s, appears in Dieter Ohly, *Die Aigineten. Die Marmorskulpturen des Tempels der Aphaia auf Aegina. Band I. Die Ostgiebelgruppe* (1976). It is now thought that there are remains of two earlier pedimental groups, both of which were replaced by the sculptures that are now in Munich. For a convenient summary of the new evidence and its possible historical implications, see Andrew Stewart, *Greek Sculpture, An Exploration* (New Haven 1990), 137–8.

P. 22, note 2: In general, on the relationship between the paintings of Mikon and Early Classical vase painting, see John Barron, 'New Light on Old Walls: The Murals of the Theseion', *Journal of Hellenic Studies* 92 (1972) 20–45.

P. 51, note 12: There is now a revised and expanded edition of my source book: *The Art of Ancient Greece, Sources and Documents* (Cambridge 1990).

P. 60, note 18: Although the question is not resolved beyond all possible doubt, scholarly opinion now generally favors the identification of the statue as Zeus. For a useful review of the question see Raimund Wünsche, 'Der "Gott aus dem Meer",' *Jahrbuch des Deutschen Archäologischen Instituts* 94 (1979) 77–111.

P. 61, note 19: As a matter of conscience, I should note that there has been some debate about whether certain works of the Pan Painter, notably the Marpessa psykter in Munich, are really archaistic or whether they are genuinely late Archaic. See L. Byvanck-Quarles van Ufford, 'Le psykter de Marpessa à Munich', *Bulletin antieke beschaving* 44 (1969) 124–35 (archaistic) and A.-B. Follmann, *Der Pan Maler* (Bonn 1968) (late Archaic).

P. 66, note 1: Ira S. Mark's recent thorough study of the sequence of structures on the bastion of the Nike temple on the Athenian acropolis provides, in my opinion, strong archaeological evidence for the genuineness of the oath. See *The Sanctuary of Athena Nike in Athens, Architectural Stages and Chronology (Hesperia Supplement XXVI)* (Princeton 1993).

P. 71, note 2: In a more recent review of the design problem Nikolaus Himmelmann has raised the interesting question of what role overseer boards of the Athenian government played in sanctioning the subjects of the Parthenon sculptures and of how free Pheidias and Pericles really were to impose their own ideas on it. See 'Plannung und Verdingung der Parthenon-Skulpturen' in *Bathron (Festschrift Heinrich Drerup)* (Saarbrücken 1988) 184–207.

P. 88, note 8: As noted in my new preface, the subject of the Parthenon frieze has recently become a controversial topic. I have reviewed some of the problems, cited much of the important recent literature, and given my own view in 'The Meaning of the Parthenon Frieze', in *Interpretation of Architectural Sculpture,* 51–65. Perhaps most controversial of all is the view of Joan Connelly in 'Parthenon and *Parthenoi*: A Mythological Interpretation of the Parthenon Frieze', *American Journal of Archaeology* 100 (1996) 53–80, who argues that the frieze depicts the sacrifice of the daughters of Erechtheus and Praxithea. Of special importance, although not yet widely

known and discussed, is Burckhardt Wesenberg, 'Panathenäische Peplosdedikation und Arrephorie. Zur Thematik der Parthenonfrieses', *Jahrbuch des Deutschen Archäologischen Instituts* (1995) 149–78, who believes, as I do, that the frieze incorporates a variety of Athenian civic and religious institutions.

P. 94, note 10: Harrison's article revived interest in what the center of the east pediment looked like and how it was to be interpreted; it also stimulated a number of subsequent studies, notable among which is Ernst Berger, *Die Geburt der Athena in Ostgiebel des Parthenon* (Basel 1974). The various interpretations are summed up in Olga Palagia, *The Pediments of the Parthenon* (Leiden 1993) pp. 18–39 and 60.

P. 107, note 12: I have expanded my thoughts on the possible relationship between Polykleitos and Pythagorean ideas in 'The *Canon* of Polykleitos and Other Canons' in Warren Moon, ed., *Polykleitos, the Doryphoros, and Tradition* (Madison, Wis. 1995) 19–24. On Pythagoreanism and Greek art in general see above under 'Additional Suggestions for Further Reading'.

P. 118, note 1: The view of Evelyn Harrison, 'The South Frieze of the Nike Temple and the Marathon Painting in the Painted Stoa', *American Journal of Archaeology* 76 (1972) 353–78, that the south frieze of the Nike temple represents the battle of Marathon is now widely accepted. More recently Harrison has proposed that the frieze as a whole presents a combination of mythical, legendary, and historical subjects. See 'The Glories of the Athenians: Observations on the Program of the Frieze of the Temple of Athena Nike', in *Interpretation of Architectural Sculpture*, 109–25. The possibility that the Trojan War is one the frieze's subjects is argued by Florens Felten, *Griechische tektonische Friese archaischer und klassicher Zeit* (Waldsassen-Bayern 1984) 118–31.

P. 127, note 4: The recent thorough study of the Bassae temple by Frederick A. Cooper and his colleagues has made a strong case for there having been only one Corinthian column in the cella. The fragments once supposed to belong to other Corinthian capitals apparently belong to other architectural details of the temple. See Frederick A. Cooper, et al., *The Temple of Apollo Bassitas* (Princeton 1992–).

P. 141, note 2: John P. Lynch's dissertation on the Lyceum has been published as a book: *Aristotle's School* (Berkeley and London 1972).

P. 142, note 3: On the Tegea sculptures and Arkadian history and politics see now Andrew Stewart, *Skopas of Paros* (Park Ridge, N.J. 1977) 66–69.

P. 143, note 5: The west akroteria are now generally believed to represent Nike in the center and Aurai on the flanks. The subject of those on the east is less clear. Yalouris (see the citations below) proposes a central group depicting Apollo raping Koronis and identifies the figures on the flanks as Nikai.

P. 144, note 2: On the literary and linguistic evidence on the *typos* question, see my *Ancient View of Greek Art* (New Haven 1974) 272–93.

P. 145, note 7: Nicholas Yalouris' long-awaited publication has now appeared: *Die Skulpturen des Asklepiostempels in Epidauros* (Antike Plastik 21 [1992]). See also his 'Die Skulpturen des Asklepiostempels von Epidauros' in H. Kyrieleis, ed., *Archaische und klassische Griechische Plastik* II (Mainz/Rhein 1986) 175–86.

P. 168, note 10: In fairness, I should note that at least one scholar, Adolf Borbein, has argued at length that the Asklepios Blacas dates from the Hellenistic period: 'Zum <Asklepios Blacas>' in *Kanon (Festschrift Ernst Berger) (Antike Kunst, Beiheft* 15) 211–17.

P. 168, note 11: A useful review of the problems concerning the identity of Bryaxis and the date and location of the Serapis is included in John Stambaugh, *Sarapis under the Early Ptolemies* (Leiden 1972). See also my *Art in the Hellenistic Age* (Cambridge 1986) 279–80.

P. 172, note 13: On personifications see now H. A. Shapiro, *Personifications in Greek Art* (Zürich 1993) and, specifically on the fourth century, Amy C. Smith, *Political Personifications in Classical Athenian Art* (diss. Yale; University Microfilms, Ann Arbor, 1997).

P. 183, note 15: Add the important monograph by V. van Graeve, *Der Alexandersarkophag und seine Werkstatt (Istanbuler Forschungen* 28, Berlin 1970). A useful review in English of scholarship on the sarcophagus can be found in Brunilde S. Ridgway, *Hellenistic Sculpture I, The Styles of ca. 331–200 B.C.* (Madison, WI 1990). For a recent thorough study of the Alexander Mosaic see Ada Cohen, *The Alexander Mosaic* (Cambridge 1997).

P. 196, note 1: See now also my chapter on rococo and realism in *Art in the Hellenistic Age* (Cambridge 1986) 127–47.

Index

Academy, 141
Achilles, 20, 21, 22
Achilles Painter, 102–3
Acropolis, *see* Athens
Aegina, temple of Aphaia, 72; sculptures of, 18–20, 36, 48, 58, 60, 146
Aeschylus, 14, 23, 26, 27, 55, 69, 147; *Oresteia* of, 27–31, 32, 35, 36, 43
Agatharchos, 54, 56 n.15
Agorakritos, 100
Alba Fucens, Herakles from, 190–4
aletheia and *phantasia*, 78, 83
Alexander the Great, 9, 136, 139, 164, 190, 194; portraits of, 178, 180
Alexander Mosaic, 163–4, 183 n.15
Alexander Sarcophagus, 183 n.15
Alexandria, 142, 184
Alkamenes, 100
allegory, 187
Anaxagoras, 55, 97
Antenor, 51
Apelles, 139, 159
Aphrodite, *Anadyomene*, 159; (?) figure from Agora in Athens, 118; Hellenistic types, 159; of Knidos, 157–9, 195; A. and Pan, in Athens, 154
Apollo, *Sauroktonos*, 154, 157; Tiber, 100; *see also* Olympia, temple of Zeus, W. pediment, and Strangford Apollo
Archaic period, 3, 24, 31, 68, 112; art of, 6, 9, 36, 43, 48, 54, 56, 96, 122, 172
archaism, 60–3
Archelaos, relief by, 187–9
Archilochos, 3
Argos, 105–6, 108, 113
Aristeides of Thebes, 44, 147, 151
Aristophanes, 3, 142
Aristotle, 5, 44, 107, 139, 141, 194; portrait of, 183, 194
Artemiseion, bronze god of, 48, 60
Ashmole, Bernard, 33, 168
Asklepios, 125, 143, 166, 170; Blacas, 166–8; votive relief of, 172
Aspasia type, 26, 36, 37–8, 195
atē, see hybris

Athena, Aegina, W. ped., 48, 60; Lemnia, 100; Met. Mus., 48; Olympia metopes, 50; *Polias*, in Athens, 130, 133; *see also* Pheidias
Athens, 10, 13, 24, 26, 64–8, 70, 79, 87, 105, 106, 108, 111–13, 125–6, 134–5, 137, 174
 Acropolis, 71, 84, 96, 131, 132, 146; Athena *Nike* temple, 115, and parapet, 118, 119, 122, 123; Athena *Polias* temple, 71, 131; Attalid dedication, 146; Erechtheion, 71 n.2, 89 n.9, 130, 131–4, 164; *see also* Parthenon
Azara herm, 180

Bassae, temple of Apollo, 126–31, 164; frieze of, 118, 122, 128–9, 130
Berlin Painter, 20–1
'Blond Boy', 27, 39–41
Boethos, 154
Bryaxis, 144 n.6, 168–70, 173

Carpenter, Rhys, 40, 119
Carrey, Jacques, 90
Cassander, 178
Chares of Lindos, 190
Charioteer of Delphi, 26, 45–8
charis, 159
Cicero, 100
classical, meaning of, 1–2, 95–7, 195–6
classicism, 172–4
Clement of Alexandria, 168
Corcyra, 67, 112
Corinth, 10, 13, 67, 137
Corinthian Order, 127–8, 130–1, 164
Croesus, 12
Cupid and Psyche (Capitoline Mus.), 154

Delian Confederacy, 25, 26, 65, 66, 138·
Delos, 25; temple of the Athenians, 134
Delphi, Apollo temple, 129, 131; Knidian club-house, 44, 54; oracle, 11; Spartan victory monument, 134; Thessalian portrait group, 176; *tholos*, 164; *see also* Charioteer of Delphi
Demokritos, 55
Demosthenes, 138; portrait of, 183

Didyma, temple of Apollo, 166
Dinsmoor, William B., 131
Dio Chrysostom, 99
Diodorus Siculus, 176
Diogenes Laertios, 58, 107
Diogenes of Sinope, 141
Diskobolos, 58
Doric Order, 36, 78–9, 129, 130, 159–60
drama, 27–36
drapery, style of, 37–9, 115–22, 123, 135

Eirene and Ploutos, *see* Kephisodotos
Eleusis, *Telesterion*, 129
Epicurus, 141
Epidauros, 125; temple of Asklepios, 143–6; theatre, 170–1; *tholos*, 164–6
Erechtheion, *see* Athens, Acropolis
Eretria Painter, 122
ethos, 43–50, 60, 63, 143, 144, 146, 147
Euphranor, 106
Euripides, 98, 114, 123, 139, 194
Exekias, 6

Geometric style, 5, 6, 106
Gorgias, 125
Granikos Monument, 183 n.15
grave stelae, 130, 154–5
Gruben, Gottfried, 134

Harrison, Evelyn, 94
Hediste stele from Pagasai, 147–51
Hektoridas, 144
Hellenistic Age and art, 61, 136, 139, 142–4, 144, 145, 146, 154, 159, 166, 170, 172, 173–4, 176–8, 184, 189, 196
Herakles, from Aegina, E. ped., 58; Lysippean types, 189–94; on metopes from Olympia, 24, 50; from Tegea, W. ped., 146–7
Hermes of Praxiteles, 151–4, 157
Herodotus, 7, 13, 23
Hesiod, 11, 98
Homer, 99
hybris, atē, nemesis, 23, 24, 26, 113

Iktinos, 71, 72, 75, 78, 126, 129, 164
Ionic Order, 71, 78–9, 129, 130, 133–4, 160
Isokrates, 139

Kalamis, 39
Kallikrates, 71, 75
Kallimachos, 130, 131, 133
Kephisodotos, 151, 172, 187
Kerch style, 159
Kimon, 25, 26, 39, 65
Kleobis and Biton, 7–8, 64, 90
Kleophon Painter, 105
korē type, 36, 38
kosmos, 5, 68
kouros, kouroi, 6–7, 15, 17, 20, 43, 170

Kresilas, 100
Kritios Boy, 15–18
Kritios and Nesiotes, 53, 58

Laocoön, 145
Lawrence, A. W., 131
lekythoi, white ground, 103, 130
Libon, 32, 126
Lucian, 39, 157
Lyceum, 141
Lydia, 11, 12
Lyric poetry, 3, 9
Lysias, 139
Lysippos, 106, 139, 174–94; Agias of, 176, 180; *Apoxyomenos*, 176, 180; Herakles at Tarentum, 189–90; Herakles *Epitrapezios*, 189–94; Herakles Farnese, 189–90; Kairos, 187; *see also* Alexander, portraits of

Macedonia, 138–9
mannerism, 63
Mantineia, base from, 173
Marsyas Painter, 159
Mausoleum of Halicarnassus, 144 n.6, 173
Meidias, 122–3
Melos, 113
Menander, 142
Mikon, 22 n.2
Milesian philosophy, 5, 6, 9
Miletus, 13
Mimnermos, 4
Minoan art, 5
Myron, 58, 82

Narcissus type, 134
Nemea, temple of Zeus, 159–60, 164
nemesis, see hybris
Nereid Monument, 135
Nike, Nikai, 115–18; of Paionios, 118–19, 194; Nike parapet, *see* Athens, Acropolis
Niobid Painter, 45, 54

Olympia, site, 42; Philippeion, 164
 temple of Zeus, 41–2, 72, 79, 126; sculpture, general, 27, 32–3, 82, metopes, 24, 50, 102; E. pediment, 33–5, 36; W. pediment, 35–6, 42, 63, 83

Paestum, temple of Hera II ('Neptune'), 41
Paionios, 118, 122
Pan and Boy in Naples, 154
Pan Painter, 61
Panathenaic procession, 85–9
Pandora, 98
Parrhasius, 106, 139
Parthenon, 71, 72, 74–9, 123, 125, 126, 129, 130, 133, 195; pre-Persian, 72
 sculptures, general, 69, 79–80, 90, 99, 108; frieze, 70, 78, 83–90, 102, 115, 136, 172–3; metopes, 80–3; pediments, 90–5, 115

Pasiteles, 174
pathos, 43–5, 143, 144, 146, 147, 151
Pausanias, 44–5, 99, 126, 130, 151, 164
Pausias, 163
Peisistratos, Peisistratids, 10, 32
Peloponnesian War, 9, 66, 68, 112–14, 136, 137, 139
Penthesileia, 20
Penthesileia Painter, 22, 61
Pergamon, altar of Zeus, 145, 174, 187; portrait of Alexander from, 180
Pericles, 25, 26, 63, 64–8, 82, 112; Funeral Oration of, 68, 79, 87, 97, 103, 111; Periclean building program, 66, 70, 71, 129, 135; portrait of, 100
Persians, Persian Empire, 9, 11–12, 13, 24, 25, 65, 131, 137, 138, 139
Persian Wars, 13–14, 27, 32, 64, 70, 112
personification, 172, 187
perspective, 54–6, 60, 162
phantasia, see aletheia
Pheidias, 63, 64, 70, 71, 72, 78, 79, 83, 97–100, 102, 105, 108, 143; Athena *Lemnia* of, 100; Athena *Parthenos* of, 71, 72, 78, 83, 85, 97, 98–9, 100; Olympian Zeus of, 78, 97, 98, 99, 100, 166
Philip II, 138–9, 164
Pindar, 45, 48
Pistoxenos Painter, 63
Plataea, Oath of, 65–6
Plato, Platonic thought, 4, 6, 11, 69, 96, 107 n.12, 125, 139, 140–1, 171, 172, 175, 187, 195
Pliny the Elder, 44, 58, 147, 163, 174, 175, 176
Plutarch, 178, 180
polis, 10, 24, 69, 94, 97, 137, 174
Polyeuktos, 183
Polygnotos, 44, 45, 54
Polykleitos, 58, 105–10, 134, 157, 174, 175, 176; *Diadoumenos* of, 108, 110; disciples of, 134; *Doryphoros* of, 107–8, 110, 157, 180; Hera at Argos, 110
Polykleitos the Younger, 170 n.12
portraiture, 50, 178–84
Praxiteles, 139, 151–4, 157–9, 173, 176
Priam, 144
proportion, 40–2
Protagoras, 69, 70, 78, 97
Ptolemy I, 168
Pythagoras (philosopher), Pythagoreans, 5, 78, 106, 107
Pythagoras (sculptor), 58, 107

Quintilian, 58, 83, 99, 100

religion, Greek, changes in, 125–6
Rhodes, colossus of, 190
rhythmos, 6, 54, 56–60, 107

Scully, Vincent, 131
Selinus, Temple E, 41; metopes from, 50, 63
Semonides, 4
Seneca, 194
Serapis, 126; by Bryaxis, 168–70
severe style, 36, 50
Scicily, 113, 139, 140
Simonides, 4
skenographia, 56, 162
skiagraphia, 140 n.1, 162
Skopas, 139, 144 n.6, 146, 164, 170, 172, 173, 176, 187
Socrates, 10–11, 140, 172
Solon, 4, 11
Sophists, 68–9, 141
Sophocles, 34, 64, 70, 98, 114; portrait of, 178–80, 183
sōphrosynē, 11
Sosandra, 39
Sparta, 10, 13, 25, 26, 65, 67, 106, 113, 119, 137, 138, 174
Statius, 190
Stoicism, 141
Strangford Apollo, 15
symmetria, 6, 72, 75, 106–8, 174–5
symplegma, 154

Tarquinia, Amazon sarcophagus, 164
technē, 69, 94
Tegea, temple of Athena *Alea*, 152, 146–7, 164, 183 n.15
Telephos, 146–7
theatre buildings, Greek, 170
Thebes, 137, 138
Themistokles, 10; portrait of, 53–4, 100
Theodoros of Samos, 50
Theophrastos, 142
tholos, tholoi, 164–6
Thrasymedes, 144 n.6, 166
Thucydides, 65, 68, 79, 97, 98, 111–12, 113, 126
Timotheus, 144 n.6, 173
Tyrannicides group, 17, 51, 58

vase painting, 3, 61–3, 100–2, 122, 147; Apulian, 162–3; red-figure, 20, 61, 100, 159
Visscher, F. de, 194
Vitruvius, 55, 75

Xenokrates, 175
Xenophanes, 12, 79 n.6
Xenophon, 44, 113, 135, 139
Xerxes, 13–14

Zeus, from Mylasa, 100; *see also* Pheidias